Visual Impact

Visual Impact

Culture and the Meaning of Images

Terence Wright

Oxford • New York

English Edition
First published in 2008 by
Berg
Editorial offices:
1st Floor, Angel Court, 81 St Clements Street, Oxford, OX4 1AW, UK
175 Fifth Avenue, New York, NY 10010, USA

Berg is the imprint of Oxford International Publishers Ltd.

Library of Congress Cataloguing-in-Publication Data
Wright, Terence, 1952-
Visual impact : culture and the meaning of images / Terence
Wright. — English ed.
p. cm.
Includes bibliographical references and index.
ISBN-13: 978-1-85973-468-1 (cloth)
ISBN-10: 1-85973-468-5 (cloth)
ISBN-13: 978-1-85973-473-5 (pbk.)
ISBN-10: 1-85973-473-1 (pbk.)
1. Visual anthropology. I. Title.

GN347.W75 2008
306—dc22 2008039860

British Library Cataloguing-in-Publication Data
A catalogue record for this book is available from the British Library.

ISBN 978 1 85973 468 1 (Cloth)

ISBN 978 1 85973 473 5 (Paper)

Typeset by Avocet Typeset, Chilton, Aylesbury, Bucks
Printed in the United Kingdom by Biddles Ltd, King's Lynn

www.bergpublishers.com

In memory of Daphne Reta Wright
(1920–2003)

Contents

List of Figures

Cover photograph: Nāga serpent, temple Wat Sisaket, Vientiane, Laos. Photograph by Terence Wright 2003

Nāga serpents appear in Hindu and Buddhist myths and legends, where they link the human world to the world of the gods. Consequently their images are placed at temple entrances. In Laos, people living along the Mekong River believe the nāgas rule the river and ceremonies are held to honour them to ensure prosperity and protection from danger.

Preface

Scientists and historians of the future ... will study the visual arts not as mere passive reflectors of great ideas, but as active promulgators of those ideas.

Samuel Y. Edgerton, 1980:211

In today's media age the visual image has become the predominant mode of communication. Indeed, for most people, pictures have become the primary channel though which we gain knowledge of the world. Some theorists of the psychology of perception (e.g. Heft, 2001:350–352) make a distinction between *direct* and *indirect* knowledge. The former is based on immediate information from the world we see around us, the people and objects with which we interact; the latter is by means of visual representation. This mode of perception provides us with a dual experience: our immediate information of the picture or screen as an object in its own right, together with information about another object or environment portrayed in mediated form. One clear example of this is the activity of reading a text. At the same time as we sit in a deckchair with the sun setting behind the palm trees, an author can take us into different realms of experience. We can be guided across the USA (Bryson, 1999), imagine the innermost thoughts of Roman emperors (Graves, 1934), or get a glimpse of speculated futures (William Gibson, 1984). As far back as 1950, with these thoughts in mind, the literary critic Walker Gibson (1950:1–2) suggested that 'every time we open the pages of another piece of writing, we are embarked on a new adventure in which we become a new person'. Possibly anticipating the theoretical standpoints of (his namesake) James J. Gibson, Heft and others, Walker Gibson proposed two modes of experience, 'two readers distinguishable in every literary experience': 'the "real" individual upon whose knee rests the open volume' and the fictitious reader 'whose mask and costume the individual takes on in order to experience the language'. But is this 'fictitious reader'[1] exactly as Walker Gibson described: 'an artifact, controlled, simplified, abstracted out of the chaos of day-to-day sensation'? Or does our reader have more self-determination? Perhaps this reader is involved in a more dynamic interaction with the book – weighing up the real-life relevance that the text may have for his or her everyday life and experience?

This revised standpoint is closer to the view of the philosopher Richard Rorty (1989:xvi), who holds that 'the novel, the movie and the TV program have, gradually but steadily, replaced the sermon and the treatise as the principal vehicles of moral change and progress'. In contrast to Walker Gibson's position, the two modes

of experience become interrelated. Rorty suggests that novels as well as other media forms have the power to move people and stir them into action. More specifically, Midge Ure, co-founder of Band Aid, relates: '[Bob Geldof] asked me if I had seen Michael Buerk's report on the famine in Ethiopia. I hadn't. Bob said I needed to see it, and together we needed to do something about the situation over there.'[2] Now, in this particular instance, there certainly had been something poetic about Buerk's report. His words had been carefully chosen to attract the viewer's attention, to awaken the imagination and to stir the emotions: 'Dawn, and as the sun breaks through the piercing chill of night … it lights up a biblical famine, now in the twentieth century. This place, say workers here, is the closest thing to hell on Earth' (Michael Buerk, BBC Television News, 24 October 1984, quoted in Fielding, 1994:97). Nonetheless Buerk's report did not rely on words alone. The tragic images on screen that accompanied his voice-over narration operated in conjunction with verbal narrative to create a strong emotional impact. Indeed it has been suggested the juxtaposition of word and image creates a 'third meaning' (Barthes, 1977:52–68) Much of the news reporter's skill lies in an ability to combine these for maximum effect, though in today's 'new media age' increasingly it is the visual side that predominates. According to David Shukman, BBC News World Affairs Correspondent (1999–2003): 'As someone who works in a visual medium, I think it quite proper for the media to seek out the strongest possible images … . If that provokes a deluge of aid, all well and good' (Shukman and Nutt, 2001). If it is *impact* we are looking for, the types of images that are likely to create the greatest visual impact are those depicting humanitarian disasters. And from Shukman's perspective, this is 'all well and good' and fairly straightforward. If the images of the catastrophe are able to inspire, cajole or embarrass the general public and governments to make large financial donations to relieve the effects of the disaster, the images that stimulate such responses should not be seen as essentially problematic. However, in contrast to this view, the motivations, on the part of the promulgators as well as the consumers, can be called to question. Why do people have such a desire to see pictures of disasters? As Susan Sontag (2003:37–38) has pointed out: 'Perhaps the only people with the right to look at images of suffering of this extreme order are those who could do something to alleviate it … or those who could learn from it. The rest of us are voyeurs, whether or not we mean to be.'

So while the new media age brings us closer to some of the tragedies of human existence, it leaves us at a safe distance from the depicted events. We might have been put in touch with scenes from Ethiopia, but with the option of retaining the detachment of unconcerned bystanders. As W.H. Auden (1940) reminds us in his poem '*Musée des Beaux Arts*', suffering takes place 'While someone else is eating or opening a window or just walking dully along'. And it's on this immediate human level that when someone collapses in the street we decide to rush to help them, walk on by or stand and watch events as they unfold: *direct* perception yet

adopting the role of the detached spectator. Of course, there always has been a sense of spectacle and spectatorship in human life with an inherent demarcation between spectator and participant (as examples, consider Greek theatre or the Roman Coliseum); however, it is a differentiation that has widened with the advent of the media age. For instance, David Cannadine (1983) describes the differences between the coronation of Queen Victoria in 1837 and that of her successor, Edward VII, in 1901 in terms of an increased interest in ritual and ceremony. During the nineteenth century across Europe major cities were subject to 'a thickening forest of monuments ... that almost threatened to choke the city squares' (M. Trachtenberg, 1977:100). As part of this general trend, beginning in the 1880s, London witnessed the refurbishment of Westminster Abbey, the re-fronting of Buckingham Palace (1906–1913), the building of the Victoria monument and Admiralty Arch, and the widening of the Mall. Thus a triumphal ceremonial way (still very much in use today) had been created to link Monarch, Church and Parliament. The concern was to create contemporary spectacle founded upon the embroidering (and, where deemed necessary, manufacturing) of a heroic past. And it is no coincidence that these developments were taking place alongside the growth of photography and cinema. Such stage-sets were thought to befit and take advantage of the new media age.[3] In other periods of history, icons and heroic imagery of the past were not treated so respectfully. An example of reversing the process described by Cannadine is cited by T.F. Mathews (1993:6). Accompanying the establishment of Christianity in the Roman world, the fifth century AD witnessed a mass destruction of classical imagery: 'The gods and goddesses, nymphs and heroes were roughly thrown aside; their mutilated and decapitated statues were interred in the foundations of Christian churches.'

Since the age of Rationalism in the seventeenth century. there has been a marked tendency to consider our everyday visual perception of the world as something of a 'spectator sport'. In this context the perceiver's relationship to his/her environment has been considered analogous to looking at a picture – after all, it was thought that our view of the world is already mediated in picture-form by means of the image on the retina of the eye. This brings us to our embarkation point: how do we acquire information from visual images? Do pictures simply look like the things they represent? Or is there a greater degree of complexity of thinking processes involved? How do we explain the vast range of styles of picture-making across the world and throughout the centuries? What does the future hold for communication through visual images? This book has two central concerns: the visual image and the context of the image. At the same time it aims to consider how the nature of the image changes by its context – whether this is determined by its cultural setting, its mode of delivery or the expectations placed upon it or initiated by the viewer. In this sense the book has the practical function of addressing the nature of the image in such a way as to provide a meaningful theoretical framework for visual arts and media practitioners who are facing the

challenges of visual communication in a world of rapid social and technological change. As such it is intended to be neither a history nor an anthropology nor a psychology of art, though it draws heavily on all these areas of study. Rather its aim is to provide the reader with an understanding of the visual image's power to communicate as well as to provide a fertile unification of theory and practice.

The last fifty years has seen dramatic changes in the status of the visual image. People have begun to take seriously the power of the image to communicate and to influence its viewers. This was not totally innovatory: images have always had something of a propaganda function. From a British perspective we can see a changing agenda in the films of Humphrey Jennings, for example. His *Spare Time* (1939) provided an observational/poetic perspective view of British working-class life between the World Wars. Three years later, Jennings' *Listen to Britain* (1942)[4] made a significant contribution to the war effort and was instrumental in encouraging the US to enter the war. The film, which could quite justifiably be cited as piece of government propaganda, used a kind of 'visual poetry'[5] to suggest and highlight aspects of culture that the two countries held in common. By contrast, Jennings' *Diary for Timothy* (1945) took an anticipatory standpoint: presenting a vivid picture that advocated the type of post-war society that Britain should expect. This helped pave the way for the founding of the welfare state. But this is not all. Jennings and others helped to create a visual image that creeps into our concept of nationhood. Jennings' 1940 film *London Can Take It!* has helped shape the image of the stoical Londoner which can surface from time to time, especially in the face of adversity and disaster. As James Chapman (1998:162) put it: 'The cheerful and phlegmatic spirit of the British people under bombardment in films like *London Can Take It!* has become part of the national consciousness.' One might argue that such media images go much further and provide a blueprint indicating how people should react to and cope with such situations. Most recently, while such sentiments were very much in evidence in the press reports of the terrorist bombings of the London transport system on 7 July 2005, they also surfaced in the personal testimonies of Londoners. Maureen Thomas, a friend, colleague and life-long Londoner, wrote to me shortly after the terrorist attacks that

> people seemed to have a very strong residual image of WW2 tube-station bomb-sheltering behaviour, and acted remarkably (and without panic) as though they were participating in an Ealing tragedy or remake of 'London Can Take It'. Resilience and cheerful, sensible behaviour with sound-bites of wit that Michael Balcon or Humphrey Jennings would have approved of. It was rather moving, especially as the actual constituents of 'Londoners' are so strikingly different from what they were in 1941.

Aside from this, perhaps it has been the proliferation of television in the post-war era that has gradually but increasingly focused serious attention on the visual. The social role of the image has been explored by various writers, from Elizabeth

Eastlake (1857) to John Roberts (1998), and during these sometimes haphazard investigations, structuralism and semiotics have been thought to hold the key to our understanding of the visual image. At best, semiotics provides valuable insights enabling us not only to gain an informed view of images of mainstream Western art (Barthes, 1977), but also to understand marginalized cultures (Munn, 1973; Morphy, 1980). At worse, it can bind the visual practitioner in a linguistic straitjacket, consequently afraid to commit pen to paper, brush to canvas or finger to shutter or touchpad until all the possible theoretical ramifications have been pre-empted.

The concerns of this book have their own socio-historical context. During the late 1960s and early 1970s a significant number of people involved in visual arts education were expressing dissatisfaction with the lack of conceptual and theoretical depth to visual arts practice. This state of affairs has been expressed by John Willats. Working as an art school teacher in the 1960s, he found 'that when we attempted to discuss these pictures with the students, we literally had no words with which to describe the representational systems on which they were based' (see Willats, 1997:xi). From my own perspective in 1977, it led to my work with Alan Costall (then of the Psychology Department of Southampton University) and we began a research project, 'Perceiving the Photographic Image'. This association laid the foundations for many of the ideas expressed in this volume. Since then, attempts to come closer to the nature of the visual image have included discussions and work with the staff and students of the Architectural Association School of Architecture; Marcus Banks and colleagues (Institute of Social and Cultural Anthropology, University of Oxford); Barrie Vince (formerly of the National Film and Television School); Maureen Thomas (Cambridge University Moving Image Studio); David Turton (Refugee Studies Centre, University of Oxford); Charlie Meacham (University of Bradford); artist and raconteur, Nick Malone; and my present colleagues in the School of Art and Design at the University of Ulster. To them and others, I give my thanks and appreciation. Part of my interest in looking at how refugees feature in fiction film arose from my working at the Refugee Studies Centre (RSC) at the University of Oxford. During my time there (1999–2002), I convened a series of screenings, 'Refugees on Screen', for the students of the MSc in Forced Migration. The series had benefited from a legacy of interest at the RSC that had been bequeathed by David Turton and Peter Loizos. More recently, at the University of Ulster, I became a member of the NM2 (New Media for a New Millennium) consortium, exploring and developing the strategies and software that could deliver interactive stories and narratives via broadband. This three-year research project (part-funded by the European Union) in collaboration with thirteen academic and industrial partners[6] across Europe provided the opportunity to produce *The Interactive Village*, an experimental ethnography. The production, which offers a documentary profile of the Czech village Dolní Roveň, allows users to piece together an individual viewing based on their

own interests and choices. These can be selected through interaction with the user interface, which facilitates navigation through the village to meet the inhabitants and to determine the subject and the depth of the information. The project, described in the final chapter of this book, has led me to engage in a radical reconsideration of the power of images to communicate and to re-think the narrative contexts in which visual stories are delivered and perceived. This project would not have been possible without the friendship and expertise of Petr Skalník and Hana Novotná from the University of Pardubice and, of course, the openness and generosity of the villagers of Dolní Roveň. I should l like to express thanks to my editors at Berg, Hannah Shakespeare and Helen Swain, and to Janice, who provided invaluable support through the writing of the book as well as assistance with the picture research.

Talking about images is difficult. Nowadays with the increased proliferation of computer-based imagery and mobile media, the situation is more so. Strangely enough the crisis of visual representation has revolved more around the still image than the moving. I hope that the present volume will make some contribution to investigating the area further and taking into account contemporary issues in visual communication. At the same time, I hope that the issues discussed in the following pages will help enable the development of new systems of representation facilitated by the new digital media. The book provides me with the opportunity to explore in greater depth some of ideas raised in my *The Photography Handbook* (1999) and to re-visit, combine and re-contextualize in a broader theoretical framework papers that appeared as 'Collateral Coverage: Media Images of Afghan Refugees, 2001', *Visual Studies* 19 (1), 2004, 97–111; 'Moving Images: The Media Representation of Refugees', *Visual Studies* 17 (1), 2002, 53–66; and 'Systems of Representation: Towards the Integration of Digital Photography into the Practice of Creating Visual Images', *Visual Anthropology* 2, 1998, 207–220.

Introduction

Realism and Representation

Human beings have been communicating and representing their world by means of visual images for the last 35,000 years. The fact that so many pictures (tens of thousands) have survived from the Palaeolithic period suggests that painting and drawing were widespread. By 10,000 BC, the activity of creating depictions had developed independently in locations as far apart as Australia, Africa, the Near East and Europe. In all these cases, we can safely assume that the images produced had some sort of communicative function, which in itself implies that visual images were understood by the members of the cultures that produced them, yet from a contemporary viewpoint our own understanding of this work is limited. The early cave paintings may have been formative attempts at creating a realistic record, perhaps used as simulations for 'virtual reality' hunting exercises,[1] or functioned in broader educational roles aiding recognition and recall. They could have had magical significance as 'sympathetic magic' intended to increase the productivity of the hunt, where they may have operated as totemic religious icons. Or perhaps they were able simply to liven up day-to-day life (Ucko and Rosenfeld, 1967; Ross and Davidson, 2006).

> The Western viewer has usually asked questions about Bushman paintings such as: What were they painted for? The answers have generally been, on the one hand, simply to delight the eye, or, on the other, to secure by magical means either success in the hunt or the fertility of the animals depicted. ... It would be better to eschew the instrumental bias to the question and ask: What do the paintings say? (Lewis-Williams 2003:47)

Although the Bushman art discussed by J.D. Lewis-Williams is much more recent in its production, this new question led him to focus on the paintings' relation to social structure, 'indeed all aspects of culture' (2003:47). Although the exact purposes of these images remain obscure, pictures in general, with their changing functions over the time-span of history, have formed an integral part of human culture. However, we can take a further step to propose that the ability to get information from visual images is inextricably entwined with human nature. 'Pictures

can no longer be seen as an artefact of the development of a particular culture. They now seem likely to be a defining characteristic of our species' (Cutting and Massironi, 1998:137).

Among other uses, images have been employed as conveyors of information, symbols of devotion and sites of social interaction, or they have provided means of discovering aspects of physical as well as psychological worlds. As Anthony Forge (1966:23) suggests, we should 'regard art and "visual communication" as something more than a decorative icing on the heavy cake of social, economic and linguistic structures'. From today's point of view, visual images have retained their status as playing a central role in contemporary life. In their symbolic role, as road signs, they guide us through the urban environment or, as video images, they can offer us an apocalyptic new realism by transmitting a cruise-missile's- eye-view as it reaches its target (see Ritchen, 1991).

During the time-span from the Old Stone Age to the present day, we have seen a wide range of styles, principles and criteria involved in the production and reception of these images. Traditionally, art historians[2] have regarded early artistic endeavour as amounting to crude attempts at transcribing a three-dimensional world onto a flat, two-dimensional surface. According to this view, artistic representation has 'evolved' in its accuracy and complexity to result in a gradually developing record of the ways that society and the environment were viewed by those cultures. Not only did late nineteenth-century theorists make much of superficial similarities to the images of the so-called 'primitive' cultures of today, but also, in support of theories of 'recapitulation', Palaeolithic 'art' was identified with

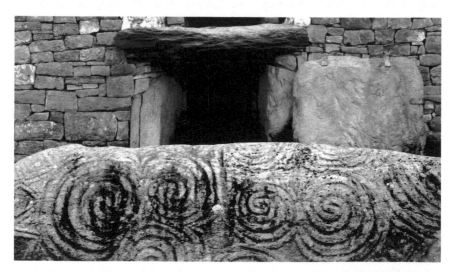

FIGURE 1 Entrance stone to Brú na Bóinne, Newgrange (about 3100 BC). Photograph courtesy of the author

the paintings and drawings of children. This view, with its roots in nineteenth-century evolutionism, is based on the belief that the development of visual depiction culminated in the pinnacle of realism characterized by systems of mechanical reproduction such as photography, movie film and today's experiments with virtual reality and the so-called 'immersive' media forms (see Ryan, 2001). While Robert Layton (1981:3) describes this as the notion of 'a single grand movement towards the art of the Renaissance or industrial society', John Willats (1997:350) portrays the agenda of nineteenth-century art history as an 'evolutionary progress from savagery to civilization, savagery being equated with the art of earlier stages, and civilization with the use of perspective and the art of the High Renaissance'. Since the early fifteenth century (the period of Alberti's famous window metaphor), the majority of visual representation has been based on the theoretical principles of linear perspective. Generally it had been considered that perspective had gradually evolved over the preceding centuries and it was not until the period of the Renaissance that artists had finally achieved the representational goal that former artists had failed to reach. From a twenty-first-century viewpoint we can see that although certain transformations in pictorial representation emerged as a response to social and technological change, rather than achieving the pinnacle of pictorial realism, in effect they offered a different system. The decision to use that one system in preference to another might be based on choice governed by social, cultural and historical factors rather than any necessary 'improvement' or achievement of greater verisimilitude.

The popular notion that 'seeing is believing' had always afforded special status to the visual image. So when the technology, in the form of photography, was developed, not only was it considered to provide a record of vision, but the fact that it was able to produce the image as a permanent tangible object accounted for the extent of the medium's social and cultural impact. The chemical fixing of the image enabled the capture of what was considered to be a natural phenomenon: the visual array projected in the camera obscura. In short, it was held to reproduce 'with a perfection unattainable by the ordinary methods of drawing and painting, equal to nature itself'.[3] The invention of photography during the early nineteenth century offered the promise of a truthful visual record that (it was assumed) did not rely upon human agency or intervention. Photography not only produced images that were based on the rationale of linear perspective, characteristic and seemingly upholding the canons of Western visual representation, but the camera was considered to function by the same principles as the human eye. Throughout the history of visual representation, questions have been raised with reference to the supposed accuracy (or otherwise) of the visual image, as well as its status in society. Ideas connected with how we perceive the world and how this affects the status of its pictorial representations have been central concerns from the time of Plato to the present-day technical revolution of the new media communications. Vision and representation have pursued interdependent

trajectories, influencing each other throughout the history of Western culture. Indeed, ideas derived from the characteristics of representational systems have become central in determining our culture's theory of visual perception. In many cases, where visual imagery is used to help realize concepts – in such fields as architecture, engineering and graphic communication – the type of visualization provided by the camera is not appropriate and at worst can be totally misleading. The artist and designer have to resort to a range of representational strategies to fulfil the requirements of the task in hand. However, the use of a visual 'system' does not depend upon function alone. There may be social, cultural, philosophical or religious criteria that can play an important role in determining the final outcome of a representation as well as the strategies employed. This is not limited to 'style', but can have a deep-seated basis in a culture's values and codes of behaviour. All these can determine the scope and limitations of representational practice, as well as the choice of options available to the artist or designer.

The photographic image was held to be an achievement of a sophisticated culture and was thought able to produce 'automatically' the type of image that artists had struggled throughout the centuries to acquire the manual, visual and conceptual skills to create. In this developmental scheme of things, every form of picture-making that had gone before, including the visual arts of 'other' cultures, amounted to more or less approximate attempts at attaining the representational heights gained by the Western world. According to some nineteenth-century theorists, just as children learned how to draw, starting with 'primitive' scribbling and developing into sophisticated adult representations, so the representations of 'others' were seen as mirrors of cultural and racial development. From this viewpoint, Western art demonstrated the development of the 'correct' ways of viewing the world. In summary, the general regard the West has had for 'other' cultures is reflected in the ways that Western scholarship has regarded the imagery of those cultures. As we shall see, such remnants continue to influence much theoretical thinking regarding the visual image. Nonetheless, on the positive side, modern scholarship has been increasingly looking to visual representation as an activity totally integrated into the fabric of culture. As Howard Morphy (1989:1) has pointed out, this 'sophisticated analytic approach coincided with changes in attitude to contemporary indigenous societies and the realization of the complexities of their conceptual systems'. From our contemporary viewpoint, upon taking a sideways glance at 'other' (non-Western) cultures, we not only find that the production of visual representations is a universal activity, but despite the proliferation of photography and other lens-based media, there also exist a vast range of ways and means of transcribing aspects of experience as two-dimensional representations. Nevertheless, despite this long history and widespread practice of visual representation, very little is known about how visual images are actually able to communicate.

Until the middle of the nineteenth century, mainstream visual communication had been concerned with the pursuit of 'realism'. Although this trend has continued through such innovations as photography, film, television, holography and contemporary initiatives in 'virtual reality', innovations in computer technology have given rise to new forms of visual representation as well as new means of delivery and new narrative forms driven by user interaction. At the very same time, the medium of television continues on a course of rapid global expansion while personal computers and mobile media devices expand the visual field, establishing the electronic camera in a central role within the 'universal' medium of communication. The digital age has led to an increased emphasis on the visual, over the traditional, written forms of communication. This dramatic renewal of interest emphasizes an urgency to obtain a greater understanding of how visual images communicate as well as their scope, limitations and potential to adapt to future technological and cultural change.

Systems of Representation

In the foregoing section, reference was made to such terms as 'visual images' and 'systems of representation' in favour of using the term 'art'. This book proposes a shift of emphasis away from the traditional studies of the visual arts to a wider theory and history of 'visual representation', which can include a broader spectrum of Western categories of architectural and engineering drawings, film and photographs, art and design, as well as a global diversity of picture-making traditions and new schemas emerging with today's digital culture. The term 'system of representation' also suggests that forms of visual image-making can be regarded as systematic – in that identifiable principles and criteria are involved in their production – and, in their cultural contexts, they serve social and cognitive functions. They can act as sites for human interaction as well as providing the means for understanding our environmental, political and social worlds. Moreover, for many traditional cultures the concept of 'art' does not exist. For example, in Australian Aboriginal culture, the activity of making pictures forms an integral part of religious ritual and other day-to-day activities. The existence of 'art' (as a specialism) and 'artists' (as its specialists) is very much a Western preoccupation, and Toni Flores (1985:35) maintains that our experience of the 'High Art' of Western culture fosters the creation of artificial divisions between the representational activities of other cultures. Many non-literate cultures recognize little distinction between art and craft, and the Western notion of the pursuit of creating an object that is beautiful, in contrast to making a functional object, has equally little relevance. Moreover, if we look to the performing arts for a comparison, we find that anthropologists have encountered great difficulty in differentiating between performance, ritual and the enactment of myth. For example, Susan Kuchler

(1987:238) describes the problem of using the Western term 'art' for broader visual representations which form part of a broader ceremonial activity: 'The art is known under the indigenous term as *malangan*. It is a collective term for sculptures and dances as well as for the mortuary ceremony and ceremonial exchange.' One solution to such dilemmas is H.R. Silver's (1978) conception of *ethnoart*, which attempts to adopt and employ those terms and concepts used by a particular culture. But even as far as Western artistic output is concerned, theorists such as George Kubler (1962) have suggested that we might turn our attention to a 'history of things', whereby all manufactured objects can be regarded as 'art'. For our present purposes, as with the term 'visual culture', this would present too broad a brush, for the purpose of this inquiry is to examine a phenomenon which essentially concerns visual representation in two dimensions.

A central preoccupation of visual representation is that the usual purpose of an image is to 're-present' something other than itself: some other 'reality' or concept. Invariably, artistic production is guided by structural principles which reflect cultural patterns. In these instances, visual images are able to reflect and promote the abstract social structures and concerns of the particular culture. Here the approach of Claude Lévi-Strauss is extremely pertinent (cf. Rohner, 1984:117). He recognizes little distinction between the *behavioural* and the *ideational*, which means that the performance of social and ritual activities (behavioural) is deeply entwined with myth and symbolism (ideational). So whether the activity is dance or painting, what we might call the *formal* aspects of behaviour – the immediate observable structures – cannot be regarded in isolation from the context of *expression* and the underlying *symbolism* – the deeper cultural or generative structures.

The problem of finding the appropriate terminology can be compounded by the lack of any universal or cross-cultural criteria for the interpretation and evaluation of artworks, whereby the Western avant-garde approach with its revisionist agenda runs in strong contrast to the relative conservatism of its ethnic counterparts. Indeed, the terms 'innovation' and 'creativity' assume very different roles in different cultures. In fact, over the past hundred and twenty years or so, the practice of making images, particularly under the heading of 'art', has made it its business deliberately to revise and challenge its own traditions of practice.

While we may live in a culture that has, for the last five hundred years at least, pursued verisimilitude – a tradition that still pervades developments in 'virtual reality' – other cultural traditions have not been so preoccupied with the representation of an 'external' reality. For example, the Abelam of New Guinea have created carvings which 'look like' animals and birds, yet there seem to be few worries over representational issues, other than how the carving operates within self-contained traditions of practice. The principles and criteria are purely *formal*, so in response to questions concerning representational meaning or significance, 'the answers … are always in the form – "It is the way to do it", or "This is the way our ancestors did it" or "This is the most powerful (supernatural) way to do it" '

(Forge, 1966:23). Questions of realism and formalism have come to play central roles in contemporary representation. Meanwhile, in the Solomon Islands, Raymond Firth (1992:27) finds in traditional Tikopean culture a contrast between the *naturalistic* and the *abstract*, where 'the bird of naturalistic form was of less ritual weight than its abstract presentation, the "sacred creature". The image of the bird in geometrical projection carried more emotional loading than the more literal presentation of it.' Other systems involve multi-referential meaning whereby any one particular element of an image can signify any number of meanings. This may be open to the misinterpretation of a developmental view of art wherein artists of other cultures and periods have striven, with only varying degrees of success, to produce the sort of image that is produced by the camera. However, as had been noted by Franz Boas (1927:221–250), the 'split representations' of animals produced by the north-west coast Indians are not failures in perspective, but operate by a very different 'system'. The artist must include the numerous symbolic features of the animal, which contain details of totemic groupings and information regarding individuals' social rank and status (see Layton 1981:153).

Not only can we find a wide range of representational systems across the world's traditional and indigenous cultures, but also in mainstream Western culture renewed emphasis has been placed on computer imagery and the increased use and proliferation of computers is demanding new and widened scope for visualization. The rapid spread of the digital image has led to a greater need to understand not only how visual imagery provides information about human culture, but also how it places renewed emphasis upon the functioning of the human mind in our perception of the environment and its visual images. Digital processing provides new models of visual perception and challenges the veracity of the visual image. As human culture has increased in its complexity, it is becoming more and more evident that a one-size-fits-all mode of representation is less and less of a viable option. Visual representation is not only inextricably linked to cultural criteria, but also abides by its own principles and internal logic. For example, in his discussion of Gozzoli's *Journey of the Magi* of 1459–61, Kenneth Clark (1949:29) points out that the fifteenth-century system of visual representation is 'not a childish or irrational way of recording visual experience, for our eye does not dwell on a single point, but moves, and we move and a procession of objects passes before it'. And while we may strive towards greater realism, aiming for exact reproductions or creations of virtual realities, our concepts and criteria for verisimilitude have always been governed by cultural requirements and aspirations.[4]

The Scope of the Book

This book intends to examine the background theoretical issues pertaining to visual images. It intends to fulfil the demand for a fresh approach to theoretical

issues that will have relevance for those working in practical aspects of the 'new digital media'. Its purpose is to introduce the theoretical ramifications arising from the practice of picture-making and that of picturing the world, and it is particularly aimed at practitioners in the fields of art and design, specifically those concerned with visual digital imagery and interactive narrativity. Its primary concern is the relation of the visual image to our conceptions of reality. Consequently the assumptions we make about the ways we perceive the world and the visual images we make of it become especially relevant. While some theorists (Goodman, 1967; Sekula, 1982) have assumed that we need to learn to 'read' pictures in order to make the connection between image and reality, I propose that the polarized positions of the conventional nature of images, on the one hand, contrasting with beliefs in the straightforward (photographic-type) realism of pictures, on the other, do not fully account either for our understanding of imagery or for the way it functions in its specific cultural setting. I argue not only that the process is much more complex, but also that neither of the hitherto influential positions is particularly helpful, or much use at all, to those whose business it is to capture or create visual images and make them understandable to a contemporary viewership. There is a demand for a new approach in our understanding of visual images that provides a fundamental starting-point for anyone who endeavours to grapple with the complexities of visual imaging and visually based interactive narratives.

The book proposes that an understanding of the ways in which visual perception operates and of the role that social and cultural factors come to play in creating 'systems of visual representation' holds the key to many of the problems encountered in image production, editing and consumption in a changing world. At the same time, image creators find themselves faced with new issues and new challenges in using pictures to communicate. The proliferation of computer-processed and -manipulated imagery has meant that the rapidly expanding fields of digital imaging and interactive narratives demand new approaches to pictures and problem-solving in design. My own experience of making interactive documentary programmes, for example *The Interactive Village* (2006), which aimed to create non-linear media genres based on moving audiovisual images, not only highlighted questions regarding how active exploratory modes of visual perception could be used to account for 'artificial' displays, but also exposed the need for new ways of recording video material as well as image gathering, organization and story-telling. The book also aims to address the most useful theories and resources that can help understand how viewers might perceive and respond to the interactive visual narrative.

While computer technology may have created the demand for new imaging systems, it can also help to make available the supply. The internet has provided the means to make reference and resort to a vast array of forms and styles of visual images. Artists and designers now have immediate access to a wide range of pictures from all the world's cultures and historical periods. Yet, if such images are

merely appropriated and assimilated into contemporary media programmes without paying regard to their specific social, cultural and historical settings, it is unlikely that they will be used to their full potential or value. In order to acquire an understanding of an image we need to be aware of the way any particular image functions within its broader system of representation. In this context, recent developments in the field of anthropology have been extremely valuable. We can find this in the broad area of visual anthropology – which we can now take to include issues of realism and representation arising from ethnographic filmmaking, but also the detailed examination and modes of analysis employed in the anthropology of art (M. Banks and Morphy, 1997). Taken together, the range of visual material referred to in this volume may have an eclectic feel about it. While it can be argued that this represents the current state within the visual arts and communication design – both fields characterized by a diversity and hybridity of visual forms – yet it also presents the opportunity to consider some specifically sensitive issues in the representation of 'others'. For example, in the case of the media representation of refugees, it is the ethical issues arising from concepts of documentary realism that become especially highlighted.

This book examines the nature of the visual image – its relation to concepts of reality – identifies the scope and limitations of a diverse range of representational systems and considers the social and cultural constraints on visual communication. It explores how these factors operate in contemporary practice, paying special regard to media images of disaster and consequential human migration. It examines the standard patterns of visual narrative employed by the mass media and proposes that they achieve little in terms of communicating the nature of humanitarian disaster. In contrast the book looks to the visual arts and experimentation with new media to achieve effective visual communication. It discusses the nature of visual imagery from three related perspectives: perception, representation and narration. The first two chapters address issues of visual perception and how these relate to the perception of pictures. Chapters 3 and 4 take a closer look at the cultural determinants on image-making. Chapters 5 and 6 review contemporary media narratives with regard to media images of refugees and forced migration, while the last two chapters aim to predict the future role of images and their narrative contexts particularly in the light of recent technological innovations in digital media.

The book begins by considering theories of visual perception and representation. Its purpose is to understand why and how visual images are able to communicate and why, within many cultures, images are seen to be life-like and useful in aiding the human ability to conceptualize. It examines the notion of 'projection' in the making of pictures and this leads to a critical examination of the cultural role of 'camera-based' imagery. The relation between human vision and the principles of the camera obscura is considered, as is the rationale for using camera-like devices to aid the making of pictures. In contemporary Western culture, despite the dramatic increase of computer-manipulated imagery, it is still generally assumed

that photographs (and images like them) provide a type of 'realism' that is relatively unproblematic: that by and large the photograph is capable of giving a good indication of what we could have seen had we been there at the time. So photography and related perspective systems offer a useful starting-point from which to consider the scope and limitations of visual representation and the social and political influences that have determined our present conceptions of pictorial reality. However, James J. Gibson's 'ecological' theory of visual perception heralded a reconsideration of the role of the picture in visual perception and a radical re-evaluation of the nature of pictures generally. According to traditional Cartesian-based theories, it is the perception of the world that requires further explanation, not the perception of pictures. If Gibson's theory of perception is adopted, many pictorial illusions that point to the fallibility of perception disappear and photographic-type images emerge as quite strange, ephemeral objects – rather than being the essential building blocks of human perception, they should be considered to be extraordinary phenomena that can astound through their sense of reality, yet can tantalize through their lack of it. This was poetically expressed by Jean-Paul Sartre (1940: 26): 'They float between the banks of perception, between sign and image, without ever bordering on either of them.' So chapter 1 examines the philosophical and psychological bases for the perception of the visual image and, in doing so, aims to establish something of its nature. Beginning with the assumed similarities between the eye and the camera, the chapter sets the scene for a more exploratory interactive theory of perception which, it is maintained, has special relevance for those involved in producing and perceiving computer-generated interactive media productions.

The second chapter, 'Perceiving Images', continues the examination of photographic images to question the relation of the viewer and image and the amount of cultural knowledge needed in order to achieve a basic perception of the image. The chapter reviews the aims and implications of research into the nature of perception of photographic images. At a basic level the research suggests that although photographic images may be easily recognizable, additional socio-cultural understanding may need to be taken into account. And this awareness should be heightened in the use of systems that do not employ linear perspective or rely more upon symbolic representational forms. The research further suggests that images do not work independently and cannot be accepted at face value. They operate within a system, and the system itself can introduce and exploit novel means of communicating through pictures. From another perspective, technological changes demand new systems of representation to record and activate them, providing the means for them to be conceptualized and realized. This not only influenced how pictures were made, but also led people to assume that vision functioned in a similar manner to the way a camera forms a picture. In this context, according to Gibson and others, it produced a type of circular argument that inhibited conceptions and understanding of both perception and representation. In the current

period, characterized by the communications revolution that has been in progress over the last ten years or so (see Cairncross, 1997; Castells, 2000; Jenkins, 2006), there is an urgent need for a re-evaluation of the systems of imagery that might reflect and, more importantly, facilitate such radical and dramatic changes. And with renewed emphasis on interactivity, the ways we respond to visual images hold the key to that endeavour.

Chapter 3, 'Cultural Representation', considers the cultural determinants of picture-making. It considers concepts of 'realism' in everyday perception and related to lens-based media. In re-addressing Gibson's theories of perception and those later developed by Harry Heft (2001), it is proposed that, fundamentally, pictures function as repositories of 'ecological knowledge'.

The chapter then considers the adaptation of lens-based media to take into account the cultural requirements of different systems of representation, and a discussion of the expressive use of space in Japanese cinema provides an example. The importance of the projection of light is considered, as is the question of how perspective-based systems of image-making have been influenced by cultural, religious and political factors.

Having established something of the nature of pictures and the ways we obtain information from them, chapter 4, 'News Media and Pictorial Tradition', looks more closely at the issue of 'visual impact' in media images of humanitarian disaster and the subsequent forced migrations that follow such events. It examines the nature of the media reporting of humanitarian disasters, but then considers the traditional images that inform contemporary image-making and that appear with predictable regularity in disaster reports. Many such images can be traced to their origins in Christian art, and a study of the 'Madonna and Child' image provides an example of how this particular image features in photographs and television news footage. It is proposed that such images are so deeply located within cultural traditions that they strike a chord with the viewer. And this may be the case with many allegorical 'biblically based' images. The chapter moves to further consideration of refugee images and the narrative contexts in which these images are placed. Often these narratives are composed as a journey, which can reflect the road movie genre of cinema, which in turn can be seen to adopt the religio-culturally determined analogy of 'the road of life' story structure, with its ethical and moral implications and subtexts.

Chapter 5 discusses further issues arising more specifically from media images of refugees. Much has been written on the subject of racism in the media and, from an anthropological perspective, the representation of 'other' cultures has been addressed. However, not only has the increase of global migrations, together with the recent relative ease of travel, highlighted refugees as a group, but also refugees are a very diffuse category of humanity to represent. As such they defy the usual media stereotypes. Until the 1980s we were unused to seeing European refugees. They were last in vast numbers during World War II. Yet the Balkan crisis brought

new images that hitherto had been the sole province of those from the so-called 'developing world'. Since World War II, Western Europeans had also forgotten that refugee status is not limited to the poor; it is a state that defies social status. Given the appropriate unfortunate circumstances, anyone can become a refugee. Indeed the unexpected conferment of refugee status fell upon the citizens of New Orleans in 2005 in the wake of Hurricane Katrina, even though they were living in the world's richest nation. In the context of forced migration, we shall consider how movie genres have become applied to television news and documentary images. In addition to narrative structure we will expand the definition of genre to include audience expectation as well as its 'institutional discourses'.

Chapter 6 acts as an extended case-study and focuses on the media coverage of refugee crisis in Afghanistan in 2001. It begins by looking at how the terrorist attacks of September 11 had the result of stimulating renewed media interest in Afghan refugees. Paying special regard to the role of visual images in the reporting of disasters, the chapter reviews the narrative strategies adopted by television news. It considers the factors that have instigated media response by examining some general issues arising from the media coverage of disasters. While the central focus of the study is on the BBC Television News special reports on the Afghan refugee crisis, selective comparisons are made with other television broadcast channels, Sky News and Euronews. The chapter concludes with a critical review of media examples that break away from conventional news formulae. The work of artists is examined as offering possible alternative strategies in representation of refugees. In this context, the representations become more empathetic, thought-provoking and innovative; however, there is a rapid deterioration in audience figures as the methods of display are no longer 'broadcasts' as such but cater for the more specialized and informed audience of the art gallery.

Chapter 7 re-addresses some of the issues already raised in the book, paying particular regard to the new technologies. It reviews the nature of the visual image, considering the scope and limitations of digital photography. Apart from the 'internal' nature of images, the new media technologies have affected the context. The chapter looks at some of the special features of narrative strategies and addresses the question of how 'visual impact' might operate when pictures are placed within the context of interactive narratives. Home viewing is currently split between a number of media-delivering modes demanding different responses and activity from viewers. The chapter concludes by looking at the scope and limitations of the 'sit-forward and interact' mode of viewing – characteristic of the user of the personal computer – in contrast to the 'sit-back and watch' mode of the television viewer. Despite current attempts to converge PC and TV technologies, the different conditions of user engagement may not be so easily reconcilable.

Finally chapter 8 aims to take the theoretical issues discussed in previous chapters and put them into practice. It examines the case-study of *The Interactive Village*, an interactive media production which takes a documentary approach to

address 'human interest' stories in the form of an experimental interactive ethnography based on life in Dolní Roveň, a village in the Czech Republic. Its purpose is not to offer a programme formula as such, but rather to test out a variety of strategies that could be easily adapted to future programming scenarios. The production delivers a new kind of formula to existing documentary genres, providing a range of unique interactive experiences on a sliding scale from 'low' to 'high' information', from news headline presentation to in-depth documentary to user-explored/supplied ethnography. Each configuration provides a personalized interactive experience, where the source sequences are configured seamlessly in real time to suit the personal wishes and needs of engagers. *The Interactive Village* not only entailed shooting original material, but also aimed to encompass the whole process: from the initial encounter with the subject to video recording to editing footage in the New Media for a New Millennium (NM2) tools to getting feedback from subjects (and subsequent revision) to the final end-user experience. The production was based upon many of the issues raised in this volume and aimed to explore the promise, potentials and possibilities of interactive documentary media in terms of their conceptual, aesthetic and technical characteristics.

–1–

Perception and Representation

Preamble

Psychologists and artists have misled one another; we have borrowed the so-called cues for depth from the painters, and they in turn have accepted the theory of perception we deduced from their techniques.

James J. Gibson, 1967:20

In the 1960s, radical changes took place in the theory of psychology of perception that led to a new re-evaluation of the nature of visual representation.[1] From today's perspective, given contemporary developments in computer-aided design (CAD), virtual reality, digital photography, interactive narratives, and so on, it can be argued that the full impact of this re-evaluation is yet to be felt. However, the 1960s perceptual 'revolution' involved a reaction to sensation-based theories in which analogies were drawn between the structure and functioning of the human eye and the photographic camera. This importance afforded to the physical similarities between the eye and the camera not only had a long history, but it has had a long-lasting influence on the visual arts for at least four centuries. Nonetheless the camera obscura and other related optical devices had been used as aids to painting for much longer: at least since the Italian Renaissance of the fifteenth century. While the 'pre-photographic' camera provided a convenient means for transcribing a three-dimensional scene on to a two-dimensional picture surface, the similarities of structure and optical function of both eye and camera had led theorists to consider the retinal image as constituting a kind of picture that is viewed by the mind of the perceiver. Consequently the problems of perceiving objects and events were identified with problems of pictorial perception. Essentially, it was believed that all visual perception is mediated by a picture in the form of the image on surface of the retina inside the eye. In the 1930s, C.S. Sherrington identified the eye with the camera – 'The eye-ball is a little camera' (1937–1938:105) – and in 1950 George Wald took an evolutionary functionalist approach to the analogy. While pointing out that the physical structure of the eye shares many common features with the camera – both use lenses, light-sensitive surfaces, adjustable iris, focusing systems, etc. – he asserts that the camera was not invented to 'copy' the eye, but maintains it was a product of 'convergent evolution, yet peculiar in that one

evolution is organic, the other technological' (Wald, 1950:33). At least, in that the phenomenon of the camera obscura had been observed for some two thousand years, yet it was not until the seventeenth century that the eye/camera analogy was first proposed, Wald might be considered to have something of a point.

Vision and the Camera Obscura

Ostensibly the first to note the basic principles of the camera obscura was the philosopher (and reputedly the founder of modern science) Aristotle (384–322 BC). He noticed that crescent-shaped images derived from a partial eclipse of the sun were projected onto the ground through the holes of a strainer. There is documentation in Aristotle's *Problemata* (Aristotle, 1927:911b 3–S, 912b 11–14) of a camera obscura device that had the purpose of making observations of the sun. It provided him with a further observation that as the distance between the aperture and the picture plane increased, so would the size of the image. Some two thousand years later this was to become a central characteristic of the photographic procedure of enlarging the image. While Aristotle made his observation explicit, we might consider his teacher Plato as having alluded to the camera obscura phenomenon. Plato explained the human relationship to reality by means of his renowned cave analogy. This picturesque example aimed to show that humankind could never have direct access to the 'real' world: we are considered to be trapped in our form of existence and unable to perceive the ideal world.[2] At most our perceptive systems could only access shadows of the world. In the context of this book the salient points are that our perceptions are at best illusory and that they are based on visual images. So although Plato did not go so far as to propose an analogy between the eye and the camera, his account of the images 'projected' onto the cave wall bears a striking resemblance to the images (or shadows) projected on the interior wall of the camera obscura. This might well have set the scene for Western thought's preoccupation with the fallibility of the senses and the consideration of pictures as being the fundamental building blocks of 'everyday' perception. Indeed, Susan Sontag opens her account *On Photography* (1977) with a chapter entitled 'In Plato's Cave'. Nowadays we might consider how much our knowledge of the contemporary world is based not upon our 'direct' perceptions, but on the relatively shadowy images that appear on our television and computer screens.[3] However, it was not until the seventeenth century that Johannes Kepler proposed a connection between the principles of the camera obscura and the mammalian eye. The French philosopher René Descartes took this principle as fundamental to his theory of dualism. His *Dioptrics* of 1637 featured a diagram which demonstrated how an image was projected via the lens of a dissected ox eye onto the retina. Thus it could be demonstrated that the eye operated on the same principles as the camera obscura, producing a projected image which could be detected

by the brain. This notion came to have a lasting influence on the arts and sciences alike.

Maurice Pirenne (1967:6) refers to the analogy between eye and camera from a physiological standpoint. Although it has been the physiological and optical similarities that have influenced much of the psychology and philosophy of perception, Pirenne acknowledges certain limitations to such an analogy. He describes the human eye as *acting* like the camera obscura insofar as the ways an image of exterior objects is formed on the retina. Consequently the principle is basically the same as that of the photographic camera. However, Pirenne expresses concern that it should not be used to identify the camera with the eye. More critical still, the new approaches to perception have rejected the importance of the eye/camera analogy that had been a central feature of perceptual theory since the early seventeenth century. In contrast to this view, more recent approaches do not rely upon the retinal image theory of perception in order to explain how we perceive the world. Instead, they stress the action and exploration of the perceiver, a process occurring over time. In this new context the differences, rather than the similarities, between perceiving objects in the world and their pictorial representations become especially pertinent.

In contemporary society the photograph occupies a central position in providing us with information about the world around us. We may not have visited the ruins of the inca city Machu Pecchu, but we can get a good idea of what they look like from their photographic representations. In addition to the contemporary record, we see how the ruins looked shortly after their discovery in 1911. As Roland Barthes (1982:93) put it, photography is the 'somehow natural witness of "what has been"'. It can also provide a type of scientific proof in that the passport photograph offers the immigration official a one-to-one matching of the photographic image to the physiognomy of the traveller. Faith in this type of representation is based upon the *iconic* (looking like) and *indexical* (that the film has been transformed by the action of light) characteristics of the photograph. Of course, we know that photographs (and physiognomies) can be manipulated, yet faith in the authenticity of the photograph remains. However competent the artist, it would be difficult to imagine a painting or drawing being an acceptable image for a passport. When we tend to think of a 'realistic' visual representation, it is usually a photograph that comes to mind. And this is supported by some natural assumptions we make of the photographic image. We readily employ it as a stand-in, a substitute or an *aide-mémoire*, for someone who is absent: perhaps a deceased person or a relative who is far away. We recognize it as an acceptable means of authentication of identity. It is generally regarded that a passport photograph presents a realistic enough likeness to the appearance of bearer as to allow him or her to travel or, in the case of identity cards or library tickets, to gain admission to areas that are usually of restricted access for the general public. So convincing is the assumed likeness that the photograph offers that we may by-pass any

acknowledgement that the thing represented is in any way mediated. At the same time there is another general acknowledgement that the photograph can often fall short of its provision of a 'true likeness': 'This is me, but it's not a very good photo – it caught me at the wrong moment' or 'I don't photograph well – I'm not particularly photogenic.' Because, under certain circumstances, we can make a direct comparison between the passport photo and the bearer to conclude that the image and the person 'are the same', because we know that the photographic camera is a machine that 'automatically' transcribes our physiognomy onto a flat two-dimensional surface, and because we know that the camera is constructed on very similar principles to the eye, we generally accept that – despite its occasional shortcomings – the photograph offers us a pretty good visual record. However, as a result of our general acceptance of this rationale and perhaps through our familiarity with photography, there may be a tendency to overlook the characteristics of the medium. It may have particular scope in its ability to provide a visual record, but at the same time we might find it has distinct limitations.

From another perspective, we may find that while we find the photograph fulfils our needs perfectly adequately, members of 'other' cultures might not find the image quite so acceptable. Not only may there be religious or cultural taboos against making a visual representation of another human being, but to members of another culture, a visual image may not be recognized as such. Rudolf Arnheim (1987:47) goes so far as to suggest that '[a] primitive tribesman, confronted with a photograph for the first time, may see only a flat object with a mottled surface. But the same tribesman may recognize simply shaped outlines of human faces, fishes, or the sun.' This is a fair enough point, but there are a number of elements that are worrying about his proposition. The 'tribesman' is non-specific. We might be tempted to ask the fundamental questions of the journalist or detective to begin to understand what really might have taken place: who, what, where, when, how and why? And we might be equally suspicious about the term 'primitive' – is this a presupposition that such people have an innate ability for a simple recognition of outline images that are in someway basic to our own understanding? Is this a remnant of late nineteenth-/early twentieth-century theories of recapitulation, whereby 'primitive' people were held to represent the childhood stages of the so-called 'higher' races? Or does it assume that such people provide a *tabula rasa*[4] free from modern influences and upon which experimental observations can be planted? Arnheim's proposal needs further investigation. It requires a broader understanding of the so-called 'primitive' cultures as well as consideration of how the practice of making visual representations functions in those cultures.

There has been a general tendency in the visual arts to produce images that 'look like' the thing they are supposed to represent. Such attempts to create a 'realistic' representation have relied heavily upon the prevailing theories of visual perception. If we are to make an image that closely resembles its referent, we might assume that the image should have the same effect on the eye as would the object

itself, so that both image and referent will stimulate our visual processes in similar ways. Naturally this places special emphasis on our ideas regarding how the visual process works. And, as theories of visual perception have changed throughout the ages, so have theories of depiction. Thus, rather than being straightforward and clear-cut, this state-of-affairs has led to complication and confusion. Hence James Gibson's claim in our opening epigraph (1967:20) that '[p]sychologists and artists have misled one another'.

Since the classical period at least, there has been a marked tendency to identify the visual with realism and the ability of the power of sight to provide the 'reality check'. This has bestowed special status on the importance of the role of imaging devices and realist systems of representation in the history of science: '[T]he reduction of the world to facts on the basis of the hypervaluation of vision requires a realist form of representation' (Slater, 1995:221). Furthermore, according to this school of thought, vision is placed firmly at the top in the 'hierarchy of the senses' (see Jenks, 1995; Ingold, 2004). This was not only in terms of whether a picture 'looks like' its referent, but there was a sense that classical authors should possess the skills to put the reader 'into the picture'. Longinus (Cassius Longinus, c.213–273, Greek rhetorician and philosopher) praised the writings of Herodotus (the fifth century BC historian) for his ability to transform 'hearing into sight'. In Longinus' account there is the sense that the writer should be able to immerse the reader in the scenes so described: '[H]e takes you in imagination through places in question, he transforms hearing into sight. All such passages, by their direct personal form of address, bring the hearer right into the middle of the action being described' (Longinus, 1953: XXVI). Similarly in the visual arts we find the painter Zeuxis, whose skill at reproducing 'reality' became legendary. His painting of a bunch of grapes was supposed to be so realistic that birds pecked at it. Whether or not Zeuxis' observations were made with the same scientific rigour as those of Bovet and Vauclair (see page 38), they became well established in the urban mythology of the visual arts. However, it was Euclid (c.300 BC) who produced the first extant work on optics, which established a connection between the functioning of human vision and the principles of geometry. Among the ancient Greeks were two contrasting theories of perception: centrifugal theories and centripetal theories. From the centrifugal point of view, it was the eye that cast its tentacle-like rays into the environment in order to 'grasp' objects. Even though Euclid subscribed to this theory, because his study of the geometrics of human vision was based on straight lines, his conclusions were nonetheless correct. The centrifugal theories were to remain influential for another sixteen centuries. According to the centripetal theories, it was the objects in the environment which cast off films that float through the air into the eye.[5] At this stage it is interesting to note that contemporary debates concerning the realism and role of visual representation have a long history and perhaps the roots of ideas about the formation of visual images created a trajectory that influenced Western thought. That Plato

condemned imitation, while Aristotle considered it to be an inherent characteristic of human nature, set the scene for extensive debates over the role of images in the Christian church, as we shall see later. For Aristotle, '[T]he instinct of imitation is implanted in man from childhood, one difference between him and other animals being that he is the most imitative of living creatures, and through imitation learns his earliest lessons; and no less universal is the pleasure felt in things imitated' (*Poetics* IV, see Aristotle, 1961).

The Ecological Approach

James Gibson's *The Ecological Approach to Visual Perception* (1979) was characterized by a new insistence on seeing things differently. It not only had a major impact upon theories concerned with the evolution and function of the visual system, but it contradicted the traditional view of the relationship between our perception of the world and its two-dimensional representations. Gibson espoused a revived scepticism towards those theories that could be demonstrated by means of visual illusions and that stressed the fallibility of perception. These classical theories, mechanistic in character and reliant on the psychophysics of vision, achieved little in explaining how organisms could perceive their natural environments and continue to survive in them. Any animal that was systematically deceived by its senses and was perpetually deluded unable to distinguish between illusion and actuality would be unlikely to stand a chance in a cruel world of natural selection. In returning to the origins of mammalian visual systems, Gibson claimed that the theory of evolution demands a biological significance to environmental features. These we should regard as the basic elements of perception. Accordingly, perceptual 'systems' evolved as part of the organism's general adaptation to its environment, whereby the creature would develop a system that could gather the information necessary for survival. From this perspective we can assert the following three points. Firstly, that because an organism has developed a perceptual system in order to engage with its 'natural environment', the issue of visual perception cannot be properly addressed with the subject removed from this environment. Secondly, it is not just the eye but the whole body that is effected by natural selection: all organs of perception acting in conjunction. However, thirdly and most significant to note at this juncture is the general relocation of the site of study away from the psychology laboratory and into the 'natural' environment.

With regard to visual representation, Gibson's ecological theory of perception is characterized by its rejection of the eye/camera analogy. The analogy's displacement from its central role in visual perception stems from a shift in emphasis from the passive registration of discrete retinal images, to an exploratory approach depending upon the whole organism's active engagement with the environment. As Gibson (1979:205) points out, we see 'the environment not with the eyes but with

the eyes-in-the-head-on-the-body-resting-on-the-ground'.[6] Despite some structural common factors shared between the eye and the camera, we find a fully integrated, dynamic and exploratory organism contrasting with a mechanical, static recording instrument. In what amounts to a radical challenge to the theories of perception that were indebted to Descartes' mind and body dichotomy, Gibson continues: 'Vision does not have a seat in the body in the way the mind has been thought to be seated in the brain.' His emphasis on activity and exploration proposes that we do not *capture* retinal pictures (like the camera, which *takes* pictures), but that we gather visual information about the world. We find this information integrated into the ambient light that is already structured by the layout and illumination of the landscape. The surfaces of objects reflect light and transmit this light in patterns, and while it is not constructed in the form of a picture,[7] it is the camera's ability to project this 'free-floating' information onto a two-dimensional image plane that enables the sampling of visual information into a discrete, passive static picture, unlike the active and dynamic processes that arise from a human being perceiving the environment.

Gibson's contribution to perceptual theory places new emphasis in distinguishing between vision and representation: our perception of the world and the pictorial images we make of it. It was inevitable that he should ask: if photographic/retinal images have been displaced from their central role in vision, how do pictures (especially those produced according to the principles of artificial perspective: similar to those of photographic representation) relate to the world as we see it? When we begin to consider how they are able to impart information, we must regard them as rather unusual phenomena. Once pictorial images have been removed from the central role in the process of visual perception, it leads to a recognition of their peculiar character and gives rise to a number of questions regarding the nature of visual representation.[8]

Gibson's theoretical shift was not entirely unheralded. He had expanded upon the Gestalt position, where the overall pattern of stimulation has more importance than the isolated stimulus. For example, our perception of 'transparency' (of a polythene bag, say) depends on our viewing a surface area that bears non-uniform patterns of translucency, opaqueness and reflectivity. These qualities depend not upon one single point of stimulation, but upon our simultaneously viewing their relative values. Indeed, Gibson acknowledges the Gestalt movement as providing the impetus for his further theoretical developments in the psychology of visual perception (Gibson, 1979:138). As part of his criticism of the retinal image regarded as a type of photograph, he takes the Gestalt point of view a stage further: 'It is a mistake to conceive each persisting pattern as a separate stimulus. ... Transformations of pattern are just as stimulating as patterns are' (Gibson, 1966:40). It is the ways in which the patterns of stimulation change over time that are most significant for perception. From this new perspective we find that most of the illusions that had aimed to demonstrate the failings of perception had been

founded on a false premise. They restricted the full active and exploratory role of the perceiver to that of a psychological subject held in a fixed position and allowed only a monocular view of abstractions or pictures. As such it has little relation to our 'natural' mode of perception. In effect the perceptual system has not only been restricted from functioning to its full capacity, but it has also been removed from the conditions in which it was 'designed' or evolved to operate.[9] The significance of Gibson's theory is that it overthrows visual perception's dependency on the retinal image; therefore the relationship between seeing and photographic images is no longer significant. Rather, we should be looking to the *affordances* of the environment to provide the basis for perception. This becomes especially relevant in our conception and production of interactive media (see, e.g., Ryan, 2001:71).

As for visual images, we might consider the example of Australian Aboriginal art, which offers a scheme of representation based not on camera-like devices, but on a direct contact with the environment. Indeed at a basic level we can see the relationship between this style of imagery and Gibson's terrain features that afford, or hinder, the organism's passage through its environment. Seen in its historical context, Gibson's theory contributed to a broader cultural reaction against reductionism. The 1950s and early 1960s were marked by a tendency to narrow academic and artistic disciplines in attempts to establish their exclusive areas. In psychology, psycho-physiological explanations had been sought to cope with the 'problem' of illusions, while in the visual arts modernism had been in ascendancy. However, in practice the focus became too narrow to justify. One of the most interesting tendencies in these disciplines in the last thirty years has been the turn away from notions of exclusion to new emphases on wider horizons and broader scope for academic and artistic endeavour. This has led to a surge of enthusiasm for the landscape and environmental concerns. So while psychologists of perception were moving from the laboratory into the environment, artists (such as Richard Long) were tempted to abandon the gallery, looking for natural materials and new sites for the production and display of work in the landscape itself – to produce *Arte Povera* and Land Art (T. Wright, 1986). Furthermore, the renewed emphasis on active, exploratory and ecological roles, in the perception of the environment and the artwork, together with a focus on lens-based media provides the basis for considering human interaction with 'artificial' displays. Consequently, such considerations provide the foundations for the new approaches of digital media and interactive narrative delivery.

The Camera Eye

[A] camera with its shutter open, quite passively recording not thinking.

Christopher Isherwood, 1939:13

Photography, the photo-chemical recording of an image produced by a camera, has a long history; cameras and related optical devices have been used by painters and

draughtsmen over many centuries (see Crary, 1992: chapter 2). As Roland Barthes (1980:31) points out, photography was the result of the coming together of two procedures, the optical and the chemical. When Nicéphore Niépce obtained the first permanently fixed image from a camera in 1827, the camera obscura had already been in use for creating perspective images of three-dimensional scenes. Since it made its first recorded appearance in 350 BC, it emerged as an aid for artists in producing realistic-looking images. For example, according to art historian Kenneth Clark (1949:57), the fifteenth-century painter Piero della Francesca was very likely to have made use of camera images: 'Piero was the greatest living master of perspective; he was also the friend of Alberti and must have known his camera obscura.' Such was Piero della Francesca's precise use of linear perspective that it has enable some theorists to illustrate by means of a map-like projection the spatial layout of his *Flagellation of Christ* of around 1460 (B.A.R. Carter, 1953; Dubrey and Willats, 1972). The simplest of these camera-like devices, described by both Leonardo da Vinci and Albrecht Dürer, consisted of a transparent sheet of glass and a sighting rod. The artist viewed the scene, through the glass, using one eye only, and traced its image onto the surface of the glass. The use of this type of technological aid led to the idea that it was the function of a picture to offer the viewer 'a window on the world'. This influential metaphor may have originated from Alberti, and is still around today.[10] In his *Della Pittura*, Alberti (1435:79) describes how he draws a rectangle, which he considers 'to be an open window through which I see what I want to paint'.

At this stage we might briefly consider the cultural specificity of the window analogy and propose that, while the perspective system may work well in some cultural settings, in others it can be seen as quite inappropriate. On the one hand, basing one's pictorial representations on the everyday experience of looking through a rectangular window may be fine for environments constructed so as to have an abundance of straight lines and uniformly sized objects. On the other, it is difficult to imagine similar systems being developed in non-urban cultures without rectilinear buildings and who use non-manufactured materials for construction: we can take Australian Aboriginal culture as an instance. We might consider that their system of representation has taken an adaptive functional approach to culture and environment. Perversely, with the invention of photography, the optimum-quality circular image produced by the camera's lens became cropped into a variety of rectangular formats. An exception to this rule was Kodak's Box Brownie (introduced in 1890), which produced one hundred images in circular format without the manufacturers feeling the need to replicate the window-like view. However, the camera obscura and other similar devices demonstrated the principles of linear perspective in terms of not only how pictures were produced, but also how pictures were perceived. In this context a perspective picture could be considered as a frozen section of the light rays projecting from the scene to the eye of the artist at the centre of perspective, as well as a kind of window, replicating the sheaf of light rays which

would have been produced by the depicted objects. However this second possibility is conditional on the spectator viewing the image with one eye only and from a fixed position, that is, from the centre of perspective. This brings us to a new position, whereby the analogy between the eye and the camera bestowed the visual arts with the scientific rationale and method for producing realistic representations, yet in theories of perception it contributed to a belief in the unreliability of the senses: that in everyday perception we can never be sure if our eyes are deceiving us. The consequence is 'the argument from illusion' – the philosophical puzzle which considers that since perception is sometimes fallible, we can never be sure whether our perception of the world is correct on any particular occasion. The 'argument', however, took its most influential form in Descartes' first *Meditation* of 1641.

Although Descartes' fundamental premise did have its peculiarities – that there might exist a mischievous supernatural being, or 'arch-deceiver', whose sole purpose of existence was to cast doubt upon all of Descartes' thinking: 'some evil demon ... who has used all his artifice to deceive me' (Descartes, 1641:100) – the effects of this line of argument on studies in perception have remained with us. Not only did these thoughts propagate the idea that our perception is essentially suspect, but it emphasized the failures of perception. For psychologists, this meant that because on occasions we might be susceptible to visual illusions, then *all* our perceptions should be regarded as suspicious. Indeed a quick survey of psychology textbooks will reveal a plethora of illustrative illusions which have the sole purpose of demonstrating how our perceptual judgements are made from fundamentally ambiguous information (see, e.g., Gregory, 1972). In many cases, such demonstrations fail to distinguish between perceiving the environment and the activity of looking at pictorial presentations. Consequently we can regard many of these visual illusions to be purely pictorial phenomena solely arising from the inherent problems of trying to represent our wider experience of the world in two dimensions. To such authors, retinal images (*qua* 'pictures') form the basis of vision. As such, they constitute simple units of 'everyday' perception. So if people experience illusions and/or difficulties in perceiving simple phenomena, then the complexity of everyday life must yield even more problems and illusions. This means that these elements of basic sensory information are not suspect in themselves, but mistakes are made from faulty inferences made from sense-data. Accordingly this involves our brains, acting somewhat against the odds, trying to make perceptual judgements from the 'data input' from our eyes.

As mentioned, the traditional term for this has been 'the argument from illusion'. In our post-modern culture we might refer to it as 'the *Matrix* phenomenon'. The character Morpheus in the film *The Matrix* (1999) poses the problem in the following manner: 'What is real? How do you define real? If you're talking about what you can feel, what you can smell, what you can taste and see, then real is

simply electrical signals interpreted by your brain.' This similarity to Descartes' point of view has not gone unnoticed by contemporary philosophers:

> [T]he Wachowski Brothers update this scenario by putting a bank of evil computers in the place of Descartes' evil genius … they plug [humans] into a huge interactive computer program known as the Matrix. What the captive humans experience very much resembles the real world of 1999, the year of the film's release, but really it is around 2200 and the world is a ruined wasteland. (Wartenberg, 2003; see also Grau, 2005)

In this hypothetical scenario, the brain is given false information through all the conventional sense channels, in which case the captive perceivers can only base our concepts of 'reality' on the information they are being fed. Fiction aside, such sentiments are still around and exerting their influence on psychological theory: 'It is amazing how hard it is to get back to the idea that we do, after all, normally perceive what is out there, not something "in here" ' (Putnam, 1990:36).

Furthermore, once the analogy between the eye and the camera was adopted, other problems arose. In comparison to the 'original' scene, the retinal image is flat, inverted and reduced in size. It might be added that we have two eyes, yet only see one image. Or perhaps if we close one eye, the illumination of the scene we see does not reduce by fifty per cent, as one would expect with photographic apparatuses such as the stereograph. Nonetheless, problems such as the inverted retinal image have been explained by theories of learning through association which suggest that as babies we have learned to see our inverted retinal images as upright.[11] Once learned, we make unconscious inferences from the information on the retina. This has led to a further identification of perception with representation, in the suggestion that we have to learn to read 'secondary' visual images, and, as we shall see later, either position is free from political ramifications centring on the nature or nurture debate. Landau (2002:35) draws the distinction thus: '[P]erception is a matter of moving about and deriving information from the constantly shifting sum of one's activities, but a visual frame in a painting or photograph cannot be shifted to make way for independent observations of the section of real space represented.' Consequently psychologists' demonstrations of the nature of visual perception, like the Müller–Lyer illusion,[12] can be considered to be purely a pictorial phenomenon bearing little relevance to how we actually see the world. In practical day-to-day life, we do not encounter such abstractions, so it does not pose a problem for the perceiver actively engaged with his/her surroundings, though it may become problematic for the artist or graphic designer (see also Livingstone, 2002).[13] Notwithstanding, some artists and designers have deliberately exploited these phenomena for their own artistic purposes. Notable examples include William Hogarth (1697–1764), M.C. Escher (1898–1972), Victor Vasarély (1908–1997) and Bridget Riley (b. 1931).

Returning to perceptual theory, the psychologist James Gibson discarded the Cartesian dualist scheme, which had regarded the perceiver and the environment as two separate entities, in favour of *reciprocity*, whereby 'the words *animal* and *environment* make an inseparable pair. Each term implies the other. No animal could exist without an environment surrounding it' (Gibson, 1979:8). Perceptual ability determines much of an organism's behaviour, and the evolution of its perceptual systems will be influenced by its requirements of its environment. Furthermore, for better or worse, some animals (particularly humans) have the capability of changing the environment for their own purposes. Perception, in the context of adaptation, must consider a number of factors: adaptation is relative to a particular environment, so the organism has to be considered in its natural habitat; although natural selection is a continuing process, it is one that is unable to predict novel changes in the environment; and it is a system of compromise in that it operates upon the whole organism and not upon its individual parts. To summarize, perception cannot be studied completely unless the subject is able to operate in its natural setting and the perceptual processes of an organism have evolved to cope with problems that are specific to that organism in its natural environment. By means of comparison, in the case of arachnids, we find a very different set of sense organs that have evolved to equip the creature for its specific ecological niche. For example, scorpions have six to twelve eyes but poor eyesight. 'However, they can readily distinguish light from dark and appear to have excellent low light sensitivity. This helps them to both avoid harsh sunlight and to navigate by starlight and moonlight. They find their way around using sensory hairs and slit organs on the legs, pedipalps and a body that picks up vibrations and scents' (Australian Museum and Ecowatch, 2004:1). This also emphasizes the range of perceptual equipment that comprises the scorpion's total perceptual system, which has evolved to provide the means for an overall engagement with its environment requirements.

Similarly, it has been suggested that humans have evolved with neural structures that are genetically programmed to interact with early visual experience to create systems that function specifically for the perception of depth. M.S. Banks, R.N. Aslin and R.D. Letson (1975) consider that the system of *binocular disparity* – the differences of information on each retina of the eye – has evolved because binocular depth information is ecologically valid. They found that if a child has a squint that makes it unable to develop binocular disparity during the 'sensitive period' of infancy, it may be impossible for the child to go on to develop the ability at a later stage in life. In evolutionary terms, during the development of the species the different combinations of retinal disparity and convergence have been associated with relative depth. However, as Pirenne (1967:196) has pointed out, this does not suggest the formation and location of a single image somewhere in the visual cortex. This is just one example of the reciprocal relationship between perceiver and environment in the evolution of perceptual systems. As a general principle,

'our eyes and brains evolved in a dynamic visual world in which objects move relative to one another and in which we ourselves are chronically moving our eyes and our heads' (Aslin *et al.,* 2002:3029) This is perfectly in keeping with James Gibson's theory of perception, based upon ecological considerations, and shifting the emphasis from the passive registration of retinal images to a perception based upon an active engagement with the environment. In fact Gibson goes so far as to completely reject the analogy between the eye and the camera from his theory of perception. We have already seen the relationship of scorpions' perceptual systems to their ecological requirements, and Gibson (1974:74) compares the structure of the vertebrate's 'chambered' eye with the 'compound' eye of the insect.

> The eye of a vertebrate may be shown to bear an image, however this is not a significant issue the optic array is more important for vision in general, which can be based on either the chambered eye or the compound eye. ... [T]he chambered eye with an image-forming lens is only one way of sampling the information in ambient light; the eye consisting of tubes each pointing in a different direction achieves the same end without a focusing lens and with no focused image.

At this point it might be worth considering why many so-called 'problems and illusions' arise out of visual perception. I might hear the sound of someone playing the piano while making occasional grunting sounds in the next room. Upon entering I find that in actual fact someone has left the surroundsound stereo playing Keith Jarrett's *Köln Concert.* For some reason this 'illusion' does not seem to hold the same perceptual problems as walking through the streets of Civray in France and seeing an open window revealing the interior of a room, I get closer to discover that two of the building's windows and the room interiors have both been painted onto the façade of the building.

Supporters of the arbitrary convention theory of picture perception would say that I found the false window convincing because I had been taught to read pictures as constituting convincing representations: a shared arbitrary code. But could the same be said of the piano-player? Do I hear Keith Jarrett because I have been taught to decode the sound waves from loudspeakers to sound like 'natural' sounds'? Or is it more plausible to suggest that both visual and auditory information produced by the painted figure at the window and CD piano recording closely approximate the same sort of information as would be produced in actuality? But whether we are considering insects or humans, the structure of the organ of perception is not so important as its ability to gather the appropriate information necessary for survival from its environment. So the type of wildlife documentaries that use visual effects to make multiple image displays in order to picture how the world might 'look' to a bee or a housefly fail to account for the organism's process of information pick-up This gives rise to some interesting visual effects for popular television programmes but conceptually confuses the representation with

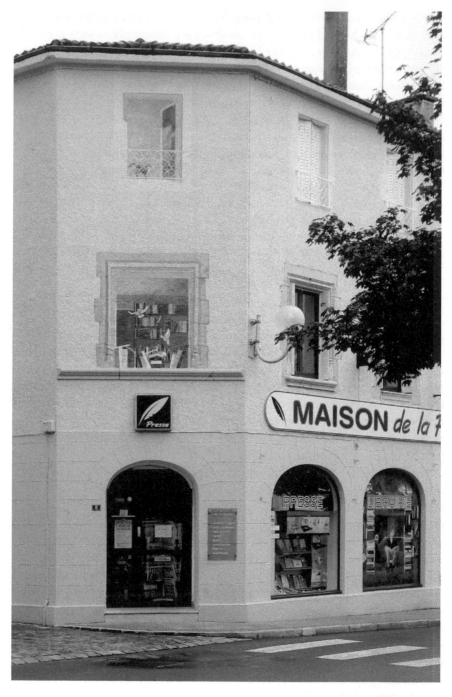

FIGURE 2 Maison de la Presse, Civray, France (2007). Photograph courtesy of the author

the perception; consequently they are subscribing to an eye/camera analogy of the insect kind.

The work of Gibson and his followers has extended earlier criticisms of the Cartesian tradition (e.g. the already mentioned Gestalt theorists of the 1920s). Ernst Mach, for instance, suggests that perceptual problems can arise when categories are muddled. He does not deny the presence of the physical aspects of perception, yet believes that whatever the physiological and optical theories may assert, the subject's act of seeing remains. So inverted retinal images are not significantly involved. According to Mach (1981), 'The question why we see the inverted retinal image as upright has no meaning as a psychological problem. ... For the experiencing subject, such a question just cannot arise' (quoted by Lübbe, 1960:105). He uses an example of 'self-reflexive drawing' (which includes the artist's own nose and moustache) to criticize the dichotomy of subjective and objective. The drawing was made to demonstrate that there is no phenomenal world in which the subject is not already present, nor is there a subject which is not already in the world. It is Gibson who takes these views a stage further by suggesting that it is the subject's determination and experience of changing stimulation that indicates an objective world. For those familiar with continental philosophy one will notice strong correspondences between Gibson's theoretical position and phenomenology.[14] For example, Edmund Husserl (1915) argues that the theorizing of the act of seeing must be of a different nature to the theorizing of physics and traditional psychology. He makes his point very simply: 'I do not see colour sensations, but coloured things, I do not hear sensations of sound, but the song of a woman singing' (quoted by Lübbe, 1960:108).

The TVSS: Tactile-Visual Substitution System

An experiment performed at the Pacific Medical Center in San Francisco, where a system was evolved to provide artificial sight to blind persons, has strong links with Gibson's theory, the eye/camera analogy and any attempts to update the old analogy by one involving the eye and a video camera. The Tactile-Visual Substitution System (TVSS) involves the 'translation' of the visual pattern, received by a video camera, into a pattern of vibrations on the skin of the subject's back. As long as the camera remained in a fixed position, the subjects experienced a tingling pattern of sensation on the surface of the skin. When the camera was moved, thus creating (Gibsonian) transformations in the pattern of stimulation, the effects of 'external' perception were experienced, in some cases quite dramatically. The experimenters reported that their subjects 'have given startled ducks of the head when the tactile image was suddenly magnified by a turn of the zoom lever on the camera' (B.W. White *et al.*, 1970:25). Moreover, when the subjects themselves were given control over the camera movements, they achieved perception of external space:

> With fixed camera, [subjects] report experiences in terms of feelings on their backs, but when they move the camera over the displays, they give reports in terms of externally localized objects in front of them. The camera motion here is analogous to eye movements in vision and this finding raises the interesting possibility that external localization of percepts may depend critically upon such movements. (p.25)

It seems that earlier attempts at aiding people with impaired vision had been restricted by theoretical blinkers in the form of Cartesian approaches to visual perception. The TVSS experimenters point out some of the difficulties raised by the traditional theories of perception: such attempts at 'providing information to the blind have been based upon hopelessly old-fashioned ideas about the way the perceptual system works' (p.26). They attribute this to the distinction made between sensation and perception, and the attitudes that have consequently evolved in perceptual research, and further acknowledge that their conclusions concur with Gibson's theory of perception. In particular (referring to his *The Senses Considered as Perceptual Systems*, 1966): 'Gibson would expect performance with the system to improve markedly when the observer was free to probe the environment to pick up information. Gibson has repeatedly stressed the importance of such exploratory activity in perception' (p.26). And this expectation is supported by Loomis and Lederman (1986:31.3):

> [Gibson] believed that the process of touch undergoes a fundamental change when the observer is given control over the 'pickup' of information. When permitted to examine an object actively, the observer does not attend to the particular momentary sensations but rather seeks over time and space the invariances in the stimulation that characterize the object being explored.

Naturally since the TVSS experiments started in 1963, there have been dramatic changes in the technological capabilities within this field. The digital era, together with the introduction of mini-cameras, has made the TVSS systems more compact and to some degree more portable. Now the environmental information provided by the camera is no longer transferred to stimulations on the back but onto the tongue, which is not only 'very sensitive and highly mobile' but, owing to the presence of 'saliva, assures good electrical contact' (Bach-y-Rita *et al.*, 2003:288).

> It now appears possible to develop tactile human–machine interface systems that are practical and cosmetically acceptable. For blind persons, a miniature TV camera, the microelectronic package for signal treatment, the optical and zoom systems, the battery power system, and an FM-type radio signal system to transmit the modified image wirelessly could be included in a glasses frame. For the mouth, an electrotactile display, a microelectronics package, a battery compartment, and the FM receiver will be built into a dental retainer. (p.291)

Paul Bach-y-Rita[15] *et al.* list other possible applications of the system to aid the perception of astronauts to robotics to undersea exploration, and (with depressing predictability) the military potential of such a device has not gone unnoticed. However, they (p.285) maintain that seeing takes place in the brain: '[I]mages that pass through our pupils go no further than the retina. From there image information travels to the rest of the brain by means of coded pulse trains, and the brain, being highly plastic, can learn to interpret them in visual terms.' It seems that appropriately structured signals from other sources – such as the tongue – have the potential to be understood by the brain as providing visual and spatial information. This is an area where the speculations of today's science fiction writers become tomorrow's actuality. At the risk of confusing the reader, I am tempted to introduce a third Gibson into the proceedings. Apart from Walker Gibson and James Gibson, science fiction writer William Gibson, in his novel *Neuromancer* (1984), anticipates implanted glasses that include microchannel image-amps for night-vision: 'He realized that the glasses were surgically inset, sealing her sockets. The silver lenses seemed to grow from smooth pale skin above her cheekbones, framed by dark hair cut in a rough shag' (p.36).

Summary

The chapter has aimed to examine some of the initial thinking on the nature of pictorial images. It has considered some of the ideas that contributed to (and were derived from) the assumed similarities between the eye and the camera. Some of the arguments cited and their historical precedents begin to take on new relevance in the context of contemporary virtual reality systems and interactive media. Alongside an emphasis on the passive nature of the perceiver, there has been a general undercurrent of the illusory nature of perception. The Cartesian theories, with their basis in 'the argument from illusion', had anticipated that ambiguities were inherent in our processes of visual perception. The perceiver would passively infer information from a static pattern of sensations. In this context, two-dimensional images (pictures) were considered to be the building blocks of everyday perception from which we construct our world. According to this view, it is the perception of the world that requires further explanation, not the perception of pictures. James Gibson's theory of perception can be seen as having greater relevance to everyday life. If his approach is adopted, many of the illusions that point to the fallibility of perception disappear. In the psychology laboratory the success of the most convincing demonstrations of perceptual unreliability depend upon the perceiver being forced into the role of a passive spectator, viewing the display from a distance, and/or through a peephole. In such instances 'the subject's perception is limited to one viewpoint and the ground of the perception has been made indeterminate. Both limitation is sufficient to destroy natural perception as such and

hence my grasp of the situation is subject to error because my capabilities as a perceiver are severely cramped' (Fahrmeier, 1973:268). On the one hand, this can be seen as part of a general trend, symptomatic of the academicizing of the discipline of psychology, which favoured the laboratory setting over the natural environment:

> The emergence of modern psychology in the university was fateful in that it placed the psychologist in a setting that was, phenomenologically speaking, walled off from larger society. Imagery of the laboratory – encapsulated physically, replete with instrumentation, restricted and substantive in focus, producing data capable of quantitative analysis – was dominant and widespread. (Sarason, 1990:13)

On the other hand, it can leave us questioning the nature of visual representation. If pictures no longer form the basis of our everyday visual perception, it is *they* that become the strange, ambiguous and fascinating phenomena.

–2–

Perceiving Images

Universal Language

In chapter 1 we saw that James Gibson's theory of perception, in rejecting the eye/camera analogy, casts doubts upon the assumed similarity between perceiving the world and obtaining information from photographic images. However, we may still tend to assume that photographs are readily understood by those who view them and that they bear a close correspondence to the things and events they depict. In mainstream culture it is generally regarded that the photograph sets the standard for realistic visual representation; the standard to which 'naturalistic' art aspires. Such a sentiment led the photographer August Sander (1933:674) to describe photography as a 'Universal Language', whereby '[e]ven the most isolated Bushman could understand a photograph of the heavens – whether it showed the sun and moon or the constellations.' As in Rudolf Arnheim's example in the previous chapter, tribespeople are cited and brought into the discussion to establish a cultural base-line for picture perception, though here to support a different perspective. It is this 'objectivity' of the photograph that has always been considered an important feature. Photography has a 'mechanical' nature, therefore we may think of a machine-made image as a type of imprint that relies little upon human agency. 'Originality in photography as distinct from originality in painting lies in the essentially objective character of photography ... between the originating object and its reproduction there intervenes only the instrumentality of a nonliving agent' (Bazin, 1967:13). Bazin's play on words gets a little lost in translation: the French word *objectif* can be translated as 'objective' or as 'lens'.[1] In this manner the photograph may be subject to the same sort of fascination as the Turin Shroud, whose fabric some believe bears the unmediated image of Christ's body. The fascination with the automated image is not just the preoccupation of photographic theorists, and later on we shall consider the special religious status reserved for the image 'not made of human hands' (see chapter 4). However, it may be suggested that it is only the viewer's knowledge of photography's mechanical nature (Bazin's 'instrumentality of a nonliving agent'), that the creation of the image does not necessarily require human involvement, that accounts for its high status for providing accurate representations in present culture. In this context it suggests an automatic transcription of the three-dimensional world onto a

two-dimensional flat surface. Following on from the previous chapter, the question that can now be considered is: if photographic images do not form the basis of visual perception, may they appear as secondary, derived phenomena with characteristics very different from the way we perceive the world?

So thus far, the rejection of the eye/camera analogy, and the status of illusions in psychological experiments, the consideration of the organism in its environment and criticisms of 'the argument from illusion' have pointed to a new theory of perception. In this ecological approach to perception, the emphasis moves towards the investigation of the kinds of information available to the moving, actively engaged perceiver. Perception is not based upon a fixed punctate image. The perception of photographs and other such representational pictures must therefore be regarded as rather special. The perspective system of visual representation, evolved from camera-like devices, has been considered the natural way of representing the environment in the Western world for the last five centuries. It is generally believed that images based upon this system have a strong resemblance or correspondence to the depicted object or event. Constructivist theories, based upon the eye/camera analogy, held that the images of the world focused onto the retina in a similar way that the camera focuses an image onto the surface of the film, providing the basis of visual perception theory, in which the perceiver makes unconscious inferences. This regarded a type of photographic pictorial image as the simple unit of a retinal-based theory of visual perception, equating the perception of the world with the perception of pictures. As photography operates on the basic principles of linear perspective, it is this projection system that is often adopted as providing a 'ready-made' system for the truthful rendition of objects and events. As Marshall McLuhan (1970:11) put it: '[P]hotography is the mechanization of the perspective painting and of the arrested eye.'[2]

According to Gibson, although images may appear on the retina, they are not central to an explanation of the perceptual process. This stresses the differences between our 'normal' perception of the environment and the manner in which the photograph records it. In this context, Gibson (1979:70) points out that many theorists fail to remember the origins of the system and term *perspective*: 'The Renaissance painters who discovered the laws of the projection of a street scene (say) on a transparent picture plane to a fixed station point called it artificial perspective to distinguish it from the natural perspective of ordinary perception.' The term *perspectiva artificialis* (artificial perspective) was coined by Alberti in 1435 in his *Della pittura (On Painting).*[3] It could be taken that this implied, in the early days of linear perspective, that it was considered to be a derivative of everyday perception, not the basis for it.

In more recent times, this notion has been taken to new extremes. For instance, Nelson Goodman (1967:19) has further suggested that photographs, and other pictorial images based upon linear perspective systems, are so unlike 'ordinary' perception that they are entirely conventional: '[T]he behavior of light sanctions

neither our usual nor any other way of rendering space; and perspective provides no absolute or independent standard of fidelity.' In Goodman's scheme of things, pictures are closely akin to language, and these 'arbitrary' systems of representation only appear *realistic* because we have learned to see them as such. Thus pictorial realism is relative to the culture and society in which the images serve: '[A] picture, to represent an object, must be a symbol for it, stand for it, refer to it … . almost anything can stand for anything else' (p.5). So, according to Goodman, there is a general free play between objects and their images, though education and habit fix the connection between reality and representation. As such the process 'depends not upon imitation or illusion or information, but inculcation. Almost any picture may represent almost anything; that is, given a picture and object there is usually a system of representation' (p.38): a set of symbols reproduced to a set of conventions. Goodman suggests that representation is a matter of choice on behalf of the artist and habit on the part of the observer. In this state of affairs, systems used in representation, such as perspective, may have no more relation to what they represent than alphabetic writing does to its referents, and, in relation to perception, pictures are so unlike 'normal seeing' they are analogous to language. This approach suggesting there is no intrinsic relation between the picture and its referent had already been put forward by Leo Steinberg (1953), who declared there is no technical skill involved in imitating nature; the skill lies in the ability to reproduce graphic symbols to a set of conventions. In essence this premise was not particularly innovative and, in retrospect, we can find a number of variations on the same theme. The suggestion that perspective may be symbolic had previously appeared in Erwin Panofsky (1924–1925), and had been developed further by John White (1957).

Meanwhile, Arnheim (1956) takes a less extreme view to that of Goodman, maintaining a belief that it may be only a matter of time before modern 'unrealistic' depictions will appear 'realistic'. This depends more upon the attitude of the spectator than the picture itself '[T]his "artistic reality level" may shift quite rapidly. Today we can hardly imagine that only a few decades ago the Cézannes and Renoirs looked offensively unreal' (p.117). We might question here whether *realistic* is the issue. In line with Arnheim's account (and returning to the example of my passport photograph), could I possibly imagine myself explaining to the Immigration Officer that the picture in my passport that replaces the usual photographic ID is my portrait painted by Chris Ofili? That it is in fact a realistic representation, only at this moment in time she can't see it as such. However, quite soon, her 'artistic reality level' will shift and, once she has learned to read the image as a true likeness, I shall be allowed to enter the country. A much exaggerated rendition of this absurdity features in a plot from the BBC Television comedy series *Blackadder* (1986).[4] In the episode 'Money', set in the sixteenth century (and, needless to say, some two centuries before the invention of photography), the finest portrait painter in England, Mr Leonardo Acropolis, is commissioned by

Blackadder to paint a picture of the baby-eating Bishop of Bath and Wells, who has been drugged and placed in a compromising position. It is presumed that a painting, despite the likelihood of its distortion of the facts through inaccuracy, artistic interpretation and/or embellishment, will provide the necessary evidence that our hero can use to blackmail the Bishop. And, as far as the plot is concerned, the blackmail attempt proves a success.

The 'arbitrary convention' theory of pictorial representation and its variations have been challenged by Maurice Pirenne (1952), Decio Gioseffi (1957) and Gibson (1979: 285), who employs his theory of perception as the basis for his argument:

> [T]he essence of a picture is just that its information is not explicit. The invariants cannot be put into words or symbols. The depiction captures an awareness without describing it. The record has not been forced into predications and propositions. There is no way of describing the awareness of being in the environment at a certain place. Novelists attempt it, of course, but they cannot put you in the picture in anything like the way the painter can.

However, Goodman's idea that pictures are successful as representations because they are 'read' to an arbitrary, yet shared, code, relying on cultural convention not resemblance to their referents, is based on similar principles to the traditional theories of perception (outlined in chapter 1 of this volume). Here retinal images in the form of 'pictures' were held to form the basis of vision, constituting the simple units of 'everyday' perception. This process, highly susceptible to illusions, involves our brains making perceptual judgements from the 'data input' from our eyes. One of the problems with subscribing to the eye/camera analogy is that the eye, just like the camera, would produce an upside-down image of the world. Accordingly, it was held that we had to learn to see our inverted retinal images as the correct way up. In consequence, there are strong similarities between this sensation-based theory of perception (and 'the argument from illusion') and Goodman's symbol-based theory of representation, in the sense that in visual perception the 'same data can always "mean" any of several alternative objects the number of possibilities is infinite' (Gregory, 1972:26), while in visual representation 'almost anything can stand for anything else' (Goodman, 1967:5). In addition, there are more minor variations on Goodman's theme. Ernst Gombrich (1960) proposes that pictures look 'lifelike' when they conform to the prevailing artistic schemata: they are successful in the context of their culture. And Richard Gregory (1972) would maintain that a successful picture is impossible as we cannot confirm the 'object hypothesis' that the image sets up. The opposing view of Gibson's limited correspondence of the picture to the world set against Goodman's belief that any correspondence can only be acquired by learning automatically raises the nativist-empiricist question. If we have an innate ability to perceive the

information in pictures, it would lend support to the theory that we make sense of the images because they are similar to how we see the world. On the other hand, if the ability could be shown to be learned, it would lend support to the 'arbitrary convention' theory – the understanding of pictures being similar to the acquisition of language.

Experimental Approaches

Three main areas of study in the psychology of perception – comparative, developmental and cross-cultural – have aimed to resolve the issue of whether the perception of pictures is an innate or learned ability. Comparative studies have aimed to find out if animals can be sufficiently 'fooled' by pictures so as to respond to them as if presented with the 'real' situation. Developmental studies have aimed to establish whether very young children, without previous tuition, can recognize and respond to depicted objects. Cross-cultural studies have aimed to discover whether members of those cultures who have little or no pictorial tradition have difficulty in interpreting pictures, as supposed by Sander and Arnheim. For our present purposes some of these experiments might be briefly summarized. Some may only serve as passing interest, others will strike the reader as plainly bizarre, yet none of them are really able to account for how visual images operate as dynamic phenomena woven into our socio-cultural fabric. Notwithstanding, some experimental residues have crept into to the 'urban mythology' of the visual arts. For instance, according to Allan Sekula (1982:85–86), 'The anthropologist Melville Herskovits shows a Bush woman a snap-shot of her son. She is unable to recognize the image until the details of the photograph are pointed out.' This leads Sekula to conclude emphatically that '[t]he Bush woman "learns to read" after learning first that a "reading" is an appropriate outcome of contemplating a piece of glossy paper. Photographic "literacy" is learned.'

Animals and Children

Notwithstanding, R.J. Herrnstein and D.H. Loveland (1964) must have been inspired by the much older myth: that of Zeuxis, a Greek painter who in the fifth century BC produced a still-life of grapes so realistic that it was pecked by birds. They trained pigeons to peck when seeing a photograph containing humans, and to stop pecking when seeing a photograph from which humans were absent:

> Many slides contained human beings partly obscured by intervening objects – trees, automobiles, window frames, and so on. The people were distributed throughout the pictures – in the center, or to one side or the other, near the top or to the bottom, close up or distant. Some slides contained a single person, others contained groups of various sizes. The people themselves varied in appearance – they were clothed,

semi-nude, or nude; adults or children; sitting, standing or lying; black, white or yellow. (p.550)

Although some training was required to teach the animals the testing technique, the experiment indicated that training in pictorial conventions was not necessary in this case. Indeed many of the comparative experiments suggest that picture perception is an innate ability found across a variety of species. Keith and Catherine Hayes (1953) found that monkeys would try to pick up and/or respond to drawn objects, and chimpanzees learned to imitate actions illustrated in pictures. They also displayed an ability to match objects and pictures. Robert E. Miller *et al.* (1967) and R.J. Miller (1973) found that monkeys would observe and respond to each other through television pictures. Richard Davenport and Charles Rogers (1971), meanwhile, emphatically concluded that apes can receive information from pictures at first sight. There are many other comparative experiments involving the perception of pictorial images that are less conclusive than those mentioned above. Although they may appear to support an innate ability to recognize objects in pictures, this may not be exactly what is going on. For example, sticklebacks and robins will attack red objects without any more subtle discrimination, that is, whether stickleback-shaped or robin-shaped or not. However, the experiments mentioned above have been directed to more specific issues: for example, a chimpanzee putting his ear towards a picture of a watch, but not to a set of numbers arranged in a circle, or a picture of a ball. Many of these experiments have employed both photographs and line-drawings as visual material. The experiments have involved an extraordinarily wide variety of creatures, from lizards and domestic hens responding to life-size video images, to jumping spiders responding to black-and-white video images. When it came to sheep it was found they could discriminate between photographs of human faces and sheep faces, and Clun ewes displayed amorous behaviour in the form of licking the pictures presented to them (Bovet and Vauclair, 2000:148).

There may be some difficulties with the comparative animal studies that are shared with the studies in developmental psychology. Tom Bower (1977) suggests that it is unlikely for young babies to see pictures as representations. He presented babies with life-sized colour photographs of toys to see if they attempted to grasp at the images. Some reached for the edge of the photograph, but not for the represented object itself. His conclusions differ to those of Hayes and Hayes (1953), in which monkeys tried to pick up depicted objects. 'I have never seen a baby try to pick up a pictured toy, or eat a pictured cookie, or do anything else with the picture of an object that he might be expected to do with a real object. Pictures seem forever to be consigned to the limbo of the unreal' (Bower, 1977:66). In Bower's experiment it is possible that the cues delineating the edge of the photograph may have been so strong as to detract from and override the 'realism' of the picture. In contrast to this conclusion, John Kennedy

devised a task that resulted in an adult subject attempting to pick up a line-drawn pencil.

> For curiosity I once presented a subject with a line drawing that invited trompe l'oeil. It was of a scene with children playing. On the same page but to one side of the central scene was a line drawing of a pencil, drawn complete with an eraser and a sharp point. The subject was required to add a drawing of a figure in the midst of the children. To his embarrassment, on two occasions the subject, gazing thoughtfully at the space where he was to draw, reached out his hand to pick up the line-drawn pencil! (Kennedy, 1974:51)

The experiment performed by Julian Hochberg and Virginia Brooks (1962) involved 'starving' their child of pictorial images for the first nineteen months of his life. The investigation 'was designed to determine whether a child who had been taught his vocabulary solely by the use of objects, and who received no instruction or training whatsoever concerning pictorial meaning or content, could recognize objects portrayed by two-dimensional line-drawings and by photographs' (p.624). One of the factors that made the parents decide to begin the tests was the child accidentally seeing the television for the first time. The child 'became aware of events on the TV set in the next room, managed to obtain a glimpse of the screen on which a horse was being depicted, and excitedly cried "dog"' (p.626). As far as the tests were concerned, the child named almost all the pictures correctly, whether they were photographs, complex line drawings with interior detail, or simple outline drawings with minimal interior detail. Whatever the test results might have shown, it is interesting that the child's first indication of recognizing depicted objects was in his 'natural' environment': seeing the television in the next room and not in the confines of the psychology lab.

Whilst recognizing the vagueness and testing difficulties of any general theory of developmental picture perception, Kennedy (1974:64) proposes a three-step sequence. Firstly, young infants become aware of objects in motion, but cannot associate this with the same object when stationary. Then the child recognizes static objects, but not their depictions. And, finally, he or she develops the capacity to recognize the same object 'in many guises': static, in motion and pictorially. Kennedy concludes: 'The best spirit in which to take the theory, at this point, is that it is fascinating speculation, a conceivable and imaginative interpretation of the facts, a theory that contrasts with the alternative theory that children have to be taught piecemeal, a set of pictorial conventions' (p.64).

Cross-Cultural Experiments

The third area of psychological research, cross-cultural, has been the main experimental source of support for the 'arbitrary convention theory' of picture

perception. While some of the animal experiments might strike the reader as rather unusual in their methods and the developmental studies as lacking in concrete conclusions, dealing with adult humans has had its attractions. Nonetheless, this area is perhaps the most quoted, misquoted and generally the most problematic in terms of its scientific worth. This, combined with its ethical ramifications, can result in a type of 'scientific imperialism' producing curious results. Early reports of missionaries and anthropologists suggest that members of 'other' cultures cannot understand the photographic images presented to them: 'The natives are frequently quite incapable of seeing pictures at first, and wonder what the smudge is here for' (Kidd, 1904:87). Statements such as this have been taken to imply the realism we naturally assume for photography is highly questionable. Yet Goodman (1967) finds support for his 'arbitrary convention' theory in cross-cultural research in picture perception.

The basic idea behind this type of research would appear to produce fairly conclusive evidence to solve the innate/learned ability problem in pictorial perception. The attraction in this research has been to find a 'primitive' culture with little or no pictorial tradition. If the members of the culture, when shown a photograph for the first time, experience difficulty in making any sense of the marks on the piece of paper, yet can later be taught to perceive the image, it follows that photography, like language, has no immediate relation to perceiving the environment and it is the 'reading' of photographs that is an acquired skill. The appeal of a simple, straightforward approach with the potential for yielding easily drawn conclusions may have led some researchers to overlook the significance of some important cultural differences in an area of research that has certain political and racial implications regarding the intelligence of the subjects. However, much of the early cross-cultural work took the form of casual observations, often by anthropologists but also by missionaries and explorers. Some reports relate to the 'magic' of a new technology: 'To show them photographs, and try to explain what I wanted only made them worse. They imagined I was a magician trying to take possession of their souls' (Thomson, 1885:19). Yet while some stories bear witness to reactions of total incomprehension as related by Kidd, others express surprise at the startling reality of photographs: for instance, A.B. Lloyd (1904) observed people fleeing from the room in terror having encountered a slide projection of an elephant. Marshall Segall *et al.* (1966) relate many anecdotes in which members of 'primitive' cultures can see photographs only as flat surfaces of various shades of grey. While Goodman (1967) quotes this work in support of his 'Languages of Art' theory, Sekula (1982:85) resorts to the same source in order to prove conclusively that '[p]hotographic "literacy" is learned.' These observations conclude that in a first encounter with a photograph, subjects are not able to perceive them as depictions of objects or scenes. In Melville Herskovits' own words, '[A] Bush Negro woman turned a photograph this way and that, in attempting to make sense of the shadings of greys on the piece of paper she held. It was only when the details of

the photograph were pointed out to her that she was able to perceive the subject' (Herskovits, 1948:581). Another difficulty mentioned by Segall *et al.* (1966) is that some subjects found that the most interesting aspects of the photograph were the white edges and rectangular format. This is interpreted as the subjects being more concerned with the photograph as an object, because they are unaware of its representational character. The conclusion is drawn that 'one can regard the photograph as we use it as an arbitrary linguistic convention not shared by all peoples' (Segall *et al.* 1966:55). It is a strange feature of these reports that the researchers interpret puzzlement as an inability to see photographs as depictions. Perhaps it is the technology of photography that creates puzzlement. New modes of representation produce, in people of contemporary Western culture, similar behaviour to that reported of Herskovits' Bush woman. When viewing a hologram for the first time, turning the plate 'this way and that' helps to solve the puzzle of how the picture may have come into being, the technology behind it, and helps to explain how any illusion might have been achieved. It is quite possible that a surface that bore a strange tension between the 'real' and 'non-real', object and image, would cause more interest, investigation and perhaps puzzlement than a surface that was merely daubed in shades of grey.

> Photographs are clearly special objects. Would not anyone meeting a photograph for the first time be puzzled, not know quite what to say, but certainly deny that it was, physically, the represented object? How easy it would be for an experimenter to interpret inquisitive puzzlement as an inability to take information from pictures ... not because the subjects find them totally incomprehensible, but because they have a pointed, well-controlled, systematic curiosity. (Kennedy, 1974:67)

This may also account for attention being directed to the format and white edges, noted by Segall *et al.*, Bower (1977) and Judy Deloache *et al.*, who found that 'physically grasping at a picture helps infants begin to mentally gasp the true nature of pictures' (1998:210). This also raises the question of the quality of the photographs and other visual material used in the experiments. For example, while some images may be sharp and clear, neatly fitting Susan Sontag's description of photographs that appear as pieces of the world, as 'miniatures of reality' (1979:4), others may be more suited to C. Jabez Hughes' 'uncomfortable idea that "the artist" had spilled a cup of *café noire* over sundry sheets of paper, and pinned them to dry' (1861:260). There do not appear to be any extant photographs from the early experiments. While this does not dispel the possibility that it may be purely a matter of print quality determining whether a photograph is seen as a clear depiction of a subject or as shadings of grey on a flat surface, it does suggest that if members of other cultures do have difficulty in perceiving the information contained in photographs, it may be because they immediately recognize them as representations, yet of a kind that do not conform to their own systems of representation. This in itself

does not necessarily refute the theory that supports innate ability. Having grown accustomed to their own, perhaps more symbolic, styles of representation, they may experience a clash with Western systems, which, no matter how realistic, may give rise to confusion. However, even giving the benefit of doubt and assuming that Herskovits' 'snap-shot' (Sekula, 1982:85) was of reasonable quality, the matter is by no means clear-cut. Sekula claims that Herskovits' Bush woman is unable to recognize a snap-shot of her own son, yet in 1894 Professor W.H. Flower, reviewing Bertillon's method of photographing criminals for purposes of classification (described in one of Sekula's later papers, 1986), noted that '[p]hotographic portraits of even one's best friends' were not always recognizable.[5]

So much for photographs. With other forms of representation, William Hudson had pointed out a number of difficulties with a line-drawing showing a hunter at one side of the picture, an antelope on the other, but between them a tiny elephant standing on a hill. In order to test whether the subject is 'interpreting' certain depth cues (relative size, partial overlap, etc.), the subject is asked whether the hunter was hunting the antelope or the elephant. 'Responses to the questions whether the hunter was aiming at elephant or antelope or whether elephant or antelope was nearer the hunter were taken as self-evident indications of two-dimensional or three-dimensional pictorial perception' (Hudson, 1967:94). It was assumed that if the subject was using depth cues, the elephant would be seen in the distance; if not, it would be seen directly in front of the hunter's spear. This type of visual material has been criticized on a number of points (e.g. Kennedy, 1974). The picture of the hunter had been designed to present a limited amount of information to ensure that only the required points might be studied, yet the very lack of information renders the image ambiguous. For instance, the ages and types of animals depicted are not clear. Both factors could alter the spatial relationships of the picture. Antelopes, when fully adult, vary in size from sixteen inches to ten feet in height. Indeed the question 'Which animal is being hunted?' depends upon which animal is perceived by the viewer as being closest to the hunter. The experimenters are thus presupposing a lack of sophistication on the part of the subject. It is possible that the subject may not be sure if the question is conceived in terms of the scene in depth or the spatial relationships of the picture plane. It is also possible that there may be differing local customs, laws, and so on, governing the hunting of different species. At least it appears questionable whether a single man armed with a spear would go elephant-hunting. For instance, reputedly the Ituri pygmies traditionally hunted in teams and probably would do their best to avoid deliberately engaging an elephant in a face-to-face confrontation. On the matter of cultural conventions, Hudson (1967) shows a picture of five men leaping around with spears in their hands that is open to cultural ambiguity. The question might be asked 'Are the men fighting or dancing?' in an attempt to elicit a response that might indicate whether the depiction is perceived or not. In some tribes it is forbidden for men to dance together – thus interpretations of the scene may vary subject to the cultural setting;

the question itself could leave some subjects feeling extremely awkward or showing the, by now familiar, signs of incomprehension and puzzlement.

In redirecting the focus of their research from sheep to humans, Dalila Bovet and Jacques Vauclair find that the overall picture is far from simple. They find that adults who have never experienced two-dimensional pictures often have difficulty in recognition, yet 'motion pictures are more easily recognized than still pictures, slides are better recognized than colour photographs, the latter leading to better performance compared to black-and-white photographs and line drawings' (2000:159). Ironically this is close to the conclusion of Segal *et al.*, who state that 'motion pictures are almost universally perceived without trouble and that colour prints are also' (1966:33). Yet Bovet and Vauclair (2000:146) found that 'the ability to recognize significant information in pictures, such as photographs is evident even in very young infancy (demonstrated at 3 months or younger).' They hypothesize that picture perception is 'innate but that this ability diminishes if the person has grown up without the opportunity to see 2-D representations' (p.159). This could be worrying for Hochberg and Brookes, depriving their child of visual images at an early age. It led me to ask Professor Hochberg (forty-four years after his experiment) if the child had suffered any psychological ill-effects as a result. I was interested to know if this early deprivation had created an aversion for pictures, or if the child 'may have become an artist, filmmaker or the like!' He replied:

In fact, the child drew well, was enormously interested in comics (like virtually all kids at that time), studied film-making for a while in college, but finally opted for computer systems work. On the other hand, I had a great-uncle who (like many of my relatives) was raised in a family and community that barred representational pictures (thou shalt make no graven images) and he, after migrating to the US, became a moderately successful cartoonist-graphic artist (which is how I pretty much knew the outcome of the more disciplined experiment in advance, despite ... the ... argument that pictorial recognition had to be learned as a language is learned).[6]

Quite conveniently, this introduces a cultural dimension, and religious attitudes to visual images will be discussed later. Nevertheless, upon further examination, the entire issue of cross-cultural experimentation is a contentious area and the motivations for performing such experiments are dubious to say the least. Much of the research gives little indication that the experimenters have a sufficient understanding of, or sympathy for, the culture of their subjects; nor do they seem to consider how the notion of the 'psychological experiment' might be experienced from the subjects' point of view. Indeed the antics of some experimenters might understandably leave subjects extremely puzzled: by their displays of insensitivity compounded by racist attempts to prove the low intelligence of the African:

Dr. Fick has rushed about South Africa giving Intelligence Tests and drawing conclusions from them, without having any idea of what Intelligence Tests actually measure

... and with a control group of incomparable material. ... His offence is made worse by the fact that many of the faults that mar The Educability of the South African Native (1939) were pointed out to its author ... in 1934. His own educability would therefore appear to be nil, which seems to be a serious disqualification for assessing that of others. (Winterbottom, 1948:55–59)[7]

Although there is little evidence to directly implicate experiments in visual perception in these activities, it is essential to consider the traditions and background against which research may have been conducted. As Paul Landau (2002:11) puts it: '[T]he experiments undertaken by Herskovits and his colleagues prefigured colonized people as people who lacked, and therefore could highlight, something called "naturalistic conventions".' Indeed some experimenters drew the conclusion that 'the South African native has not the learning ability to be able to compete on equal terms with the average European, except in tasks of an extremely simple nature ... the difference in ability is partly innate' (Van Rensberg,1938:45). Such a concept of 'competing on equal terms' is extremely suspect. Within the subject's culture there is probably little necessity to understand the social role of the psychologist, let alone the function of the experiment. Thus the very procedure of a psychological experiment would be alien to the subject and produce strange results. Leonard Doob (1961:561) appears to straddle the position of experimental insensitivity, while at the same time recognizing a cultural divide between experimenter and subject: 'One of the greatest difficulties in interviewing Africans is the inability of many of them to report their own impressions, feeling and even actions. They may be willing to provide information but simply be unable to express themselves through lack of practice in situations resembling interviews.'

It might be interesting to consider the above in the context of the conclusions drawn with reference to perception influenced by evolutionary theory, mentioned earlier. Perception cannot be studied completely unless the organism is able to operate in its natural setting. This might equally refer to the cultural setting of the subject. Here we are reminded of Seymour Sarason's (1990) criticism of the academizing of psychology (see page 32) and Joan Miller (1999), who calls for psychologists to pay more attention to developing sensitivity to cultural factors. A pure inability to 'report their own impressions, feelings and ... actions' would present any group with extreme difficulty to function socially, or even or organize themselves for survival. Their inability could only be due to the extraordinary circumstances in which they found themselves. It may be that in order to give clear responses in such conditions, the subjects have to first learn how to behave in an experiment. This would preclude the supposition of naïvety and innocence of Western culture upon which the psychologist had been depending. It might be added that if the subjects think a test may be a measure of intelligence or job suitability, for example, they may be more concerned to give the answer that they anticipate to be 'right' (see also Dubow, 1995, and Aumont, 1997).

Often enough, when scholars have questioned the transcultural 'transparency' of photography, and even the idea that photographs signify through resemblance, they have looked for evidence in colonial contexts – such as Africa. ... Wherever we come down on the question of whether Africans could or could not read 'naturalistic' visual signs before being habituated to them, however, the debates themselves naturalize a host of imbalances in colonial and postcolonial relationships. (Landau, 2002:11)

What is more disturbing is that during the 1950s the Experimental Ethno-Psychology Department of South Africa's National Institute for Personnel Research (NIPR) had addressed itself to the 'problem' of depth perception among 'illiterate, relatively primitive Africans' (NIPR, 1958:26). Using specially designed visual images, the study found they were unable to interpret perspective correctly, though in 1961 another 'confidential' report suggested that this was culturally determined. This survey compared 'Indian, Bantu, Coloured and European primary school leavers', which in itself suggests a sense of recapitulation theory. Another 1950s experiment conducted by Mundy-Castle suggested that 'blacks might be more emotional but less visually perceptive that whites' (Dubow, 1995:242). He had studied pictorial depth perception in Ghanaian children in the belief that they would find linear perspective problematic because it is a 'highly abstract' concept (Mundy-Castle, 1966:122). While Saul Dubow (1995:242) concludes that the work of the NIPR cannot be considered racist 'in the simple sense' – as it pointed more to environmental factors than hereditary differences between whites and blacks – yet its 'status and objectives ... remain highly problematic'.[8] Steven Pinker (1997:57) points to the 'confusion of scientific psychology with moral and political goals' and the 'pressure to believe in a structureless mind'. He concludes that 'the dichotomy between "in nature" and "socially constructed" shows a poverty of the imagination, because it omits a third alternative: that some categories are products of a complex mind designed to mesh with what is in nature.' This brings us to a standpoint that is not dissimilar to that of Gibson's *ecological* approach to visual perception.

Curiously, in visual arts criticism, there has been the tendency to subscribe to the idea that picture perception is a learned ability, in order to support a theory of the social construction of reality. Unfortunately, in order to do so, support for this argument has been derived from Cartesian theories of perception, relying on evidence gleaned from what Landau (2002:11) aptly describes as 'imbalanced colonial relationships'. Hidden agendas aside, cross-cultural studies seem to suggest that confusion in perceiving pictures can depend upon the researcher's inability to separate certain issues. If identifying the content of a picture is muddled with whether the picture is being perceived in the first place, unusual results may occur. The cross-cultural research on the perception of photographs is by no means conclusive. However, the more recent psychological research, reviewing and criticizing the early reports and research, is pointing towards an innate understanding

of pictorial images (R.J. Miller, 1975; Bovet and Vauclair, 2000). Even if pictorial perception is a learned ability, it is acquired extremely quickly, so much so as to set it apart from learning to read written language. First stating that 'knowing how to look at pictures does not come naturally to man', an article in *Life* magazine proceeds with the following anecdote:

> Some years ago a missionary who wanted to make contact with a primitive South American tribe flew over the area first and dropped, along with gifts, several pictures of himself. He hoped the photographs would help the tribe recognize him as a generous and friendly visitor when he came in person later. Unfortunately the natives could make no sense of the shadowy language of the pictures, and when the missionary arrived they ate him. (author not named, *Life* magazine 1966:6–7)

This non-attributed anecdote probably says less about the perception of photographs than it does about the fondness of South American tribes for missionaries. It is quite easy to put the converse interpretation on such scant and vague details. For instance, with similar authority and conviction, I could plausibly suggest it is 'well known' that the kinds of gifts that missionaries usually distribute to tribes are cooking utensils and foodstuffs. Under such circumstances, the 'natives' immediately understood the photograph of the missionary as the accurate and unequivocal representation of the final missing ingredient. So when he arrived in person it was quite natural that they should eat him – the recipe was complete![9]

The attraction of a 'good story' is another factor, and myths are usually characterized by their rhetorical impact. It is often the case that 'urban mythology' and what people wish to be true are more enticing than actuality (Reed *et al.*, 1987, find the social sciences are particularly susceptible to such conflation[10]). Even if 'primitive' tribes do have difficulty in perceiving photographs, it may be because the photographs do not conform to their own systems of representation. Here the contradiction between the culture's own style of representation and the Western style may account for misleading interpretations of results. This may well be the case with Anthony Forge's study of the Abelam of New Guinea. Citing Segall *et al.* (1966), he accepts uncritically the urban myth: 'The inability of people in cultures not used to them to see photographs is of course well-known' (Forge, 1970:286). Nonetheless, Forge does recognize the inherent difficulties in making comparisons of inabilities for which he has 'no systematic material' (p.287). However, he does suggest that photographs are so unlike Abelam art, where he finds 'that in two-dimensional painting there is no desire or attempt of any sort to establish visual correspondence with either nature or three-dimensional art' (p.281), that Abelam vision 'has been socialized in a way that makes photographs especially incomprehensible' (p.287). We might conclude that in this instance it makes no difference whether or not humans possess an innate ability to perceive photographs; the Abelam had been socialized out of perceiving them. Yet again,

however, the situation does not appear to be irreversible: 'I trained a few boys to see photographs; they learnt to do this after a few hours of concentrated looking and discussion on both sides' (p.288).

So it is possible that one reason why Herskovits' Bush woman was experiencing difficulty in recognizing a photograph of her own son is that the photograph operates in representational system that is significantly different from that of Bushman paintings, which in themselves may involve high degrees of socialization to understand a complexity of significances and meanings (for example, as described by Lewis-Williams, 2003). By means of contrast, Bedouin tribes have no form of representational art, and Wayne Dennis showed that they had few problems when asked to produce representational drawings. In fact they 'spontaneously' used a variety of 'conventions' when depicting human forms (cited in Kennedy, 1974:74). If we give the conventionalist position the benefit of the doubt, from the anecdotal accounts of both Herskovits and Forge it does appear that if 'learning to read' photographs is an acquired skill, it can be learned quite rapidly and easily, so much so that it sets it apart from the processes required to learn a new language. And, oddly, Segall *et al.* and Forge found that their subjects experienced much less difficulty with colour photographs.

Summary

In our contemporary world of electronic mass-communications, the perception of visual images by animals and obscure tribal cultures may seem rather out of place. However, the implications of this research have particular relevance if we are in the position of designing computer programs or building narratives that involve the participation and interaction of the viewer/user. At a basic level the research suggests that although photographic images, as such, may be easily recognizable, additional socio-cultural understanding may need to be taken into account. And this awareness should be heightened in the use of systems that do not employ linear perspective or rely more upon symbolic representational forms. It further suggests that images do not work independently and cannot be accepted at face value. They operate within a system, and the system itself can introduce and exploit novel means of communicating through pictures.

From another perspective, technological change demands new systems of representation for those changes to be conceptualized and realized. This might lead us to reflect further upon the epigraph quoting James Gibson that introduced chapter 1: that '[p]sychologists and artists have misled one another' and that 'painters … have accepted the theory of perception [psychologists] deduced from their techniques'. In the years preceding he invention of photography the increased use by artists of camera-like devices stemmed from, and at the same time reinforced, the analogy between the eye and the camera. This not only influenced how pictures

were made, but also led people to assume that vision functioned in a similar manner to the way a camera forms a picture. In this context, according to Gibson and others, it had produced a type of circular argument that inhibited conceptions and understanding of both perception and representation. In the current period, characterized by the communications revolution that has been in progress over the last ten years or so (see Cairncross, 1997; Castells, 2000; Jenkins, 2006) there is an urgent need for a re-evaluation of the systems of imagery that might reflect and more importantly facilitate such radical and dramatic changes. And with renewed emphasis on interactivity, the ways we respond to visual images hold the key to that endeavour.

–3–

Cultural Representation

Reality is that which, when you stop believing in it, doesn't go away.
 Philip K. Dick, VALIS (1981:77)

In relation to Gibson's theory of perception it may be assumed that visual images display a number of 'natural correspondences' to the perceived environment. The appearance of texture gradients in a photograph, for example, are of very similar appearance to those perceived by the stationary observer in the environment. The division of the image or environment by means of a horizon into light/dark, sky/land, provides another example: 'For the terrestrial environment, the earth–sky contrast divides the unbounded spherical field into two hemispheres, the upper being brighter than the lower' (J.J. Gibson, 1979:66). One could supplement Gibson's statement – 'For the photograph, the earth–sky contrast divides the framed flat surface into two parts, the upper being lighter than the lower.' Given the differences between viewing the photograph and perceiving the environment, the presence of the horizon forms an important point of reference in both cases. The placing of the horizon within the frame has been a great concern of both painters and photographers; Gibson believes it is an essential and basic orientating factor in perceiving the environment: 'The horizon never moves, even when every other structure in the light is changing. This stationary great circle is, in fact, that to which all optical motions have reference.' Returning briefly to pictorial phenomena, the placing of a figure (or figures) on the horizon by filmmakers is often used to create dramatic effect.

 An example of a subtle use of this effect occurs in Charles Laughton's film *Night of the Hunter* (1955), where the image of a horseman travelling across the horizon enhances the menacing disposition of preacher Harry Powell (played by Robert Mitchum). It also achieves a sense of desperation and loneliness in the closing sequences of Akira Kurosawa's *Ran* (1985); by contrast, a ploughman silhouetted on the horizon becomes a potent symbol of traditional Turkish cultural values in Xavier Koller's *Journey of Hope* (*Reise der Hoffnung*) (1990) (see Figures 3 and 13).

 I have already mentioned how under *unusual* viewing conditions the photograph has a physical capability of deceiving the viewer by its realistic appearance. This may account for the 'realism' with which the photograph is normally accredited.

FIGURE 3 Jaipur, India (2006). Photograph courtesy of the author

In experimental psychology comparative and developmental studies support this view, suggesting that animals and young children, when subjected to certain photographic displays, can be fooled by the images they perceive. However, cross-cultural work presents a number of difficulties. At the risk of generalizing, it could be said that whereas cultural differences are essential to cross-cultural experiments, many of the difficulties with developmental studies arise because the children are in the process of acquiring culture, and the question of culture (at least in the accepted sense) does not arise in studies involving animals. However, it should be remembered that photography is a cultural product, despite its 'realistic' nature. The conditions under which the children were shown photographs were such to divorce the images from their cultural context and thus established what might be described as a 'natural realism' of photography – this might be contrasted with 'cultural realism'. Most of the problems seemed to arise in the cross-cultural research because the photographs were introduced into a cultural setting, perhaps into a culture, which, whether or not possessing qualities of 'natural realism', did not find compatibility with, or require, that particular system of realistic representation. Our usual encounters with photographs are accompanied by our subsidiary awareness that they are products of photography. The subjects in the cross-cultural studies might have had every reason to be puzzled if they were handed a piece of reality in a neat container itself displaying the properties of being an object in its own right. If the subjects of the cross-cultural experiments were as innocent of Western culture as suggested, they would not have the knowledge necessary to

obtain a realistic impression from the photograph. This is not to simply say that they had not learned the 'language' of photography, but the experiments would set the 'natural realism' of the photograph in direct opposition to the subjects' 'cultural realism'.

The Nature of Realism

It now becomes apparent that referring to the term 'realism' as an absolute standard, against which representations can be set, is not appropriate to this discussion. So far I have contrasted the photograph with the 'perceived environment', yet it may be argued that this may not account for the different requirements that different organisms or cultures may have of their environments. It could be suggested that snails, dogs, stock-brokers and Ituri pygmies have different conceptions of reality – this certainly appears to be the case among artists.

It might be speculated that one could consider the 'physical world' as providing a basis for reality. Physics could be cited as a basic structure from which different organisms extract information relevant to their survival. A similar theory could help to explain the wide range of artistic styles that vary from culture to culture – artists extracting selected information from a basic conception of 'reality'. In this case, with different cultures adopting and developing the style that suits their cultural purposes, it could be assumed that the members of these cultures have different experiences of 'reality'. Photography, however, a physical process based upon optics and chemistry, might act as a mode of expressing aspects of this 'physical reality'. This is the point taken up by Slater in his essay 'Photography and Modern Vision' (1995). He considers the photograph's realist qualities in terms of its superiority to pre-existing representational systems, e.g. draughtsmanship; its existential relationship with the photographed object or event ('something must have passed before the lens', p.222); and its industrial origins purporting to produce a mechanical impersonal objective vision. In accounting for what he calls its 'trivial realism', photography 'appears to have an intimate relationship with the positive, to be a machine for the production of positivist vision' (p.222).

Furthermore, it has been suggested that as organisms have different 'patterns of reality' or 'webs of significance', so too do different cultures. According to this view, it is language that determines how we see the world. And language is one such, perhaps the dominant, arbitrary framework that humans impose onto reality. In support of this position, it is often cited that the Inuit peoples (traditionally referred to as Eskimos) have four hundred different words for snow. This suggests two important possibilities: that in order to cope with their environment, the Inuit have developed a vast spectrum of appropriate words; or that the language reflects the unique ways in which they perceive their environment, and strangers to such surroundings are unable to detect the subtleties of the environmental conditions. In

fact over the decades this idea has 'snowballed' from an initial misreading of the anthropologist Franz Boas's writings on the subject. 'Anyone who insists on simply checking their primary sources will find that they are quite unable to document the alleged facts about snow vocabulary (but nobody ever checks, because the truth might not be what the reading public wants to hear)' (Pullum 1991:160). At the same time, the unfortunate term 'Eskimo' has been used as a type of ragbag categorization for a widely disparate group of tribal peoples. Geoffrey Pullum declares: '[T]he truth is that the Eskimos do *not* have lots of different words for snow, and no one who knows anything about Eskimo (or more accurately, about the Inuit and Yupik families of related languages spoken by Eskimos from Siberia to Greenland) has ever said they do' (p.160). He points out that in most cultures specialized trades (such as horse-breeders and botanists) have many different names for things: '[P]rinters have many different names for different fonts (Caslon, Garamond, Helvetica, Times Roman, and so on). ... Would anyone think of writing about printers the same kind of slop we find written about Eskimos in bad linguistics textbooks?' (p.165). Pullum puts this down to a buried racist tendency to believe anything about unfamiliar groups: a belief in 'how primitive minds categorize the world differently to us' (p.162). No doubt we could add the perception of photographs to this. In the process of popularizing Laura Martin's paper (1986), Pullum continues: '[T]he alleged lexical extravagance of the Eskimos comports so well with the many other facts of their polysynthetic perversity: rubbing noses; lending their wives to strangers; eating raw seal blubber; throwing Grandma out to be eaten by polar bears' (p.162).

Gibson's *ecological* approach to visual perception is not without its complications. For instance, he suggests that the environment is 'meaningful'. This standpoint flies in the face of the Western Cartesian philosophical/scientific tradition that suggests that the environment has no *meaning* in itself; rather *meaning* is a particular quality imposed on the environment by human beings. From this point of view, *meaning* is subjective and psychological. Of course, this leads to the philosophical conundrum – if, as humans, we are all constructing our individual meanings and experiences of the environment, is interpersonal communication achieved more through luck than judgement? But this question may arise from a false dichotomy:

> [I]t is justifiable to say that the environment is comprised of meaningful objects, meaningful events, meaningful places, meaningful social actions, meaningful social institutions, among other things, ... because in large measure, collectively and historically, these features of the shared environment have been created by us. This is not to say that meanings have been imposed on an otherwise meaningless environment. Rather we engage a meaningful environment of affordances and refashion some aspects of them. (Heft, 2001:329–330)

As for visual images, these amount to constructed embodiments of 'ecological knowledge'. Their production is ongoing, cumulative and they are 'woven into the fabric of our sociocultural world' (p.330). This point of view takes us part-way in Clifford Geertz's direction. As Geertz (1973:5) puts it, culture is 'not an experimental science in search of law but an interpretive one in search of meaning'. Elsewhere in the same essay he suggests: 'Culture … is not just an ornament of human existence but – the principal basis of its specificity – an essential condition of it' (p.46). Indeed Joan Miller (1999:87) takes Geertz's perspective a stage further by describing culture 'not merely as a product of evolution but as itself a selective factor in the evolutionary process'.

Space in Japanese Cinema

In chapter 1 it was suggested that a system of visual representation like linear perspective, with its influential metaphor of 'a window on the world', was unlikely to have been coined by a culture that had no windows, straight lines or uniform/manufactured objects. Yet despite the presence of such features in Far Eastern cultures, paintings employing parallel perspective systems 'did not use the pictorial space in the Western manner, one framed window for one event or scene' (Hagen, 1986:142). This is most noticeable in the silk scrolls produced in eighteenth-century China (Rawski and Rawson, 2006:114–115). Here the artist (or artists) adopted a series of viewpoints that appear to avoid the single station-point of Western perspective as well as the single moment/instant *tableau vivant* of classical painting/photography. It is possible that the use of parallel lines and the adoption of a high viewpoint (the characteristic 'bird's-eye view') in the Chinese system indicates an indeterminacy of the artist's viewpoint. In the case of the Chinese scroll 'Ice Game on the Palace Lake' (c. 1760), it is the product of least three artists, Jin Kun, Cheng Zhidao and Fu Longa'an, which tends to defeat the notion of the 'window on the world' as seen by the individual viewer (perhaps most evident in the cinema as the 'point-of-view' or 'POV' shot). But the dimensions of the scroll itself are 35 cm x 578.8 cm and some scrolls from this period, not even 1 metre in height, can be as long as 26 metres. This means that the viewer is presented with a single image in the 1:26 format! This extreme 'letter-box' format is similar to the grand narrative representation of the Bayeux Tapestry (of the late eleventh century), but in the tapestry the images are relatively schematic and follow a distinct timeline. What distinguishes the Chinese scrolls is that they present a single landscape/cityscape scene that runs the entire length of the depiction. This not only runs in contradiction to the idea of the single station-point of Western art, but defies any notion of an image derived from camera-like devices. While the depicted scene appears as a spatial continuum, it also facilitates the viewer's 'reading' of an episodic narrative over time. Without wishing to make too

much of the language analogy, if the photograph displays the 'simple past' tense brought into the present (as Roland Barthes expressed it, the 'there-then' becomes the 'here-now', 1977:44), the Chinese scroll displays a type of 'present perfect continuous' which shows that something that had started in the past has continued up until the moment the image was made – and then becomes the 'here-now'.

In addition to traditional Chinese picture making, the parallel perspective system is a characteristic feature of Japanese art. Consequently, some Japanese film directors have aimed to use the lens in such a way as to emulate these traditional methods of image-making. However, these should not be seen as distortions or deviations from the 'correct' use of the lens; rather, using long-focus lenses and high viewpoints more closely approximates Japanese perspective systems than the converging lines more frequently used in Western art. In one of Akira Kurosawa's later films, the aforementioned *Ran* (1985), not only has he produced shots that bear close resemblance to paintings of the fourteenth-century Muromachi period (in the opening hunting scene, for example), but the use of a long lens from a high viewpoint results in the parallel perspective effect characteristic of the Japanese art tradition. As a further example, in Yasujiro Ozu's *Tokyo Story* (1953) viewers used to European and American film genres are confronted by a movie that appears very different to their expectations. The individual shots have been most carefully composed and appear to be extremely static. In contrast to Kurosawa's high camera angles, Ozu's camera is consistently placed at a very low angle: the fact that the camera never moves, appearing to be fixed at about three feet above the ground, has led to the suggestion that it is in the position of a hypothetical participant observer in Japanese sitting posture. At the same time, there is a 360° use of space (which frequently involves breaking the standard cinema 'rule' of 'crossing the line')[1] and there are sudden cutaways to landscape and cityscapes – the so-called 'pillow' shots.[2] Although Ozu's approach is very different to that of Kurosawa, the end result is the same in their achievement of a sense of flatness. In *Tokyo Story*, the action takes place within stage sets that could have been inspired by the paintings of Mondrian. In one sense this reduces the sense of 3D space, but it also enables the viewers to perceive different levels of depth: for example, as the partition screens in the Japanese houses are pulled back to introduce new elements into the drama. At the same time, the series of stage flats determine the actors' movements on horizontal and vertical planes, allowing little movement from the back to the front of stage, thus further reducing increases and decreases in the actors' sizes and consequently the sense of perspective recession in depth. As far as the screenplay is concerned, this way of shooting could be read as enhancing the notion of the characters' entrapment in their socially determined roles. A similar technique is used in the jail sequence in Jim Jarmusch's *Down by Law* (1986), where not only are the characters confined by the physical constraints of the prison cell, but Jarmusch does not allow the actors to move out of the frame, thus heightening our sense of and feeling for their plight and state of incarceration.

However, if we consider *Tokyo Story* from an anthropological perspective, it is intriguing that the inclusion of incidental elements (which are not exactly essential to the plot) are reminiscent of Bronislaw Malinowski's *imponderablia of everyday life*: the paradox of the apparently non-essential yet all-important detail. Linda Ehrlich (1997:70) has written of *Tokyo Story*: '[L]ike the seemingly solitary shots of vases, hillsides, and laundry hung out to dry, the human figures in Ozu's films are both essential and transitory, eventually passing from the frame.' Similarly in the script, if we as viewers adhere to our expectations of a straightforward linear narrative, pieces of dialogue can lead us nowhere. Here we need to be especially careful. For example, a casual reference is made to the Atami beach resort, and before we know it, the narrative has leapt forward and our protagonists are already there. As well as the narrative device of *dramatic ellipsis*, in which events essential to the plot take place off-screen, in *Tokyo Story*, many shots are characterized by their emptiness. 'Empty rooms are not really empty – they are full of the presence of people who were there before. ... Ozu holds the shot just a few seconds longer than we might expect in order to remind us of this' (Ehrlich, 1997: 70–71). This play on the viewer's retrospections and anticipations extends John Berger's simple, yet extremely effective, demonstration of how our perception of a painting is influenced by the knowledge we bring to it. In his *Ways of Seeing* (1972:27) a painting is reproduced and described as 'a landscape of a cornfield with birds flying out of it'. We are instructed to 'Look at it for a moment. Then turn the page.' Over the page the painting is reproduced a second time but accompanied by a statement which reads 'This is the last picture that Van Gogh painted before he killed himself.' In more recent film, Ozu's empty scene device is employed to great effect by Víctor Erice in his film *El Sur* (1983). After the suicide of her father, the young girl Estrella confronts a series of vistas which, earlier in the film, we have been led to associate with the images of her father. The vistas, all characterized by a dramatic (Western) perspective recession, leave the viewer with a strong perception of emptiness and absence as we recall what we have seen, and, as a result, this is contrasted with what we have been led to expect to see in these same locations. It serves to demonstrate how a picture can have significant 'visual impact' due to its narrative context even though the image itself may have been reduced to minimal content: '[L]ike the traditional Zen artist, Ozu directs silences and voids' (Schrader, 1972:28).

Writing about Ozu's *Tokyo Story*, Lindsay Anderson expressed dissatisfaction with the title, preferring the American title *Their First Trip to Tokyo* (in Desser, 1997:148). This emphasis on the journey taken by the two old people places the film more firmly in the Japanese tradition of painting and writing about journeys. And here the emphasis is not so much on the Hollywood preoccupation with the frontiersmanship of the road movie, but on the human relations of parting, greeting, separating and meeting together again. In its relation to reality the film is of a different order to the one we are used to. Finally, 'Ozu's strategies are deeply

rooted in elements of the Japanese aesthetic tradition – the deemphasis of drama and the elision of plot elements in theatrical works, the emphasis on mood and tone instead of story in literature' (Desser, 1997:7). At the same time, we should be cautious not to become too prescriptive in this regard. As we saw with Ozu's and Erice's representations of emptiness and absence, the viewer has as much to gain much from the image's context as he or she does from the perception of the contents of the image itself. On this point, Panofsky distinguishes between 'motives' and 'stories'. While 'motives' account for the immediate recognition of objects in the picture, 'stories' depend upon the viewer's understanding of a broader contextual/literary discourse. However, we speculate that in some contexts (e.g. Clark's perception of medieval imagery in chapter 1), these are types of knowledge that are not so easily separable. Indeed the whole 'story' might be taken to include the broader cultural setting of the image, and this would apply to a variety of systems of visual representation. In addition, the close relationship between a visual representation and its social message may enable the identification and recognition more general patterns of visual culture.

Casting Light

> The entire west face of the house was black, save for five places. Here the silhouette in paint of a man mowing a lawn. Here, as in a photograph, a woman bent to pick flowers. Still further over, their images burned on wood in one titanic instant, a small boy, hands flung into the air; higher up, the image of a thrown ball, and opposite him a girl, hands raised to catch a ball which never came down.
>
> The five spots of paint – the man, the woman, the children, the ball – remained. The rest was a thin charcoaled layer.
>
> Ray Bradbury, 1952:203–204

Ray Bradbury, in his short story 'There Will Come Soft Rains', provides a vivid and haunting description of the formation of a visual image, though in his case it is formed not by the action of light projected onto a photosensitive surface, but from the heat of a thermo-nuclear explosion. The bomb's impact has annihilated the 'nuclear family', yet their former presence had sheltered parts of the painted wall from the blast, leaving only patches of paint surviving as a rudimentary form of visual representation: the only remaining evidence of their once existence. In some senses this picture is reminiscent of the photograph's ability to 'capture the moment' and to preserve it for posterity (if in Bradbury's story there will be future generations left surviving the nuclear holocaust). Although the production of Bradbury's image has not involved a lens, the general principle of its creation not only conforms to the *indexical* mode of representation, but also accurately describes the rationale behind *orthographic* projection. In C.S. Peirce's system of semiotics, the *index* (in contrast to the *icon* and the *symbol*) is a sign that results

from some kind of causal relationship with its referent: '[I]t is a direct physical imprint, like a fingerprint left at the scene of a crime or lipstick traces on your collar' (Mitchell, 1992:24). Considered in this way, the photograph provides us with a 'trace' of the scene recorded. It is similar to a fingerprint or a footprint, whereby the camera acts as the agent that enables the subject or scene to become imprinted on the film surface. Later in this volume, we shall see how this, too, becomes an important factor in religious iconography.

Much of Western art is based on a projection system, whereby the light rays emitted by an object and scene pass through a small aperture, which causes the inversion of the image, and are cast onto a two-dimensional surface. The casting of light has played important roles in human history. It was not only central to some of the principles that governed the construction of ancient earthworks such as Stonehenge, but the casting of shadows by objects onto a flat surface – the origin of the *orthographic* projection – has been a basic source of picture-making since the Old Stone Age and might again remind us of Plato's cave metaphor. This relatively simple form of image-making, which does not rely upon the camera, has the advantage of not being subject to some of the problems that arise from photographic hardware: for example, lens distortions and foreshortening. Images produced by this means are not restricted by the notion of a frame, but are bounded only by the expanse of an irregular picture surface: a cave wall, for instance. In addition, the camera obscura is 'architecturally dependent' in that the phenomenon is most likely to be observed only by people who dwell in geometrically consistent, flat-surfaced buildings.[3] Nevertheless, it is one thing to observe a 'natural optical phenomenon', it is quite another for a culture to decide to incorporate it into a system of visual representation, let alone give it a central role. 'Other' cultures have adopted systems of representation that employ quite different criteria. Japanese painting, for example, has employed multi-viewpoints as well as an *oblique* projection system. Other representational strategies, such as cave art, emphasize other pictorial criteria, for instance that the image has neither definable boundaries, nor anything resembling a frame. So we can consider the tradition of representing the world through the boundary of a rectangle as being a peculiarly Western urban phenomenon: 'Chinese painters like Chou Ch'en never considered that they should portray nature as if it were seen through a window, and they never felt bound to the consistency of the fixed viewpoint demanded of their Western counterparts' (Edgerton, 1980:187).

However, although orthographic projection involves a one-to-one mapping producing an image that does not vary in size or shape from the object it represents, the system does pose a number of restrictions upon the artist: for example, it is only through recording the sitter's profile that a recognizable portrait can be obtained; it is usual for the 'Egyptian style' to be adopted for a clear depiction of the full figure. We can consider the art of the ancient Egyptians as the embodiment of a particular method of picture-making abiding with its own 'rules' and optical

principles. It is distinctive in its flattened-out appearance, which places no reliance whatsoever upon foreshortening. One of the dangers of using foreshortening is that it can render part of the picture, at least, as ambiguous. With the Egyptian method, as with some contemporary technical and architectural drawings, there is little possibility of confusing the actual shape of represented objects. If an object is circular, then it is drawn as circular on the picture-plane. From a social perspective it is interesting to note that the rules of Egyptian painting were most strictly adhered to in the representation of people of high social status. The artists felt they could be more lax in their endeavours with regard to slaves, servants, animals and objects that had no special significance. While there is also an absence of linear perspective, the suggestion of distance (depth cue) through the *relative size* of objects is in evidence. In common with some (ethnic) arts, it is probable that the role of the artist was not recognized: 'In the Egyptian language, characteristically enough, there is no word for "art" or "artist"' (Woldering, 1963:72–73). This has led Monroe Beardsley (1966:23) to conclude that the Egyptians had not 'distinguished their response to art as such from their religious and political attitudes'.

For the sake of argument, in the orthographic system of representation, the sun's rays, upon striking an object on the Earth, can be considered as parallel. This means that, irrespective of the distance of the object from the picture surface, the depicted object will always be projected as the same size as the original. This seems to be the same principle involved in the projection of the image of the family onto the house wall in Bradbury's example with which we opened the chapter. Although the basic principle and idea behind this formation of the image is quite sound, it may reveal a technical error on Bradbury's part. If the source of emission of the intense light was a thermo-nuclear explosion, we would expect the rays to radiate from the source, rather than adopting the 'sun-like' parallel projection. Therefore the images in Bradbury's story – determined by their distance from the wall – would be of very different sizes, unless all those represented were pursuing their different activities equidistant from the wall. However, for the moment, there are two points of central importance to this system: only to an extremely limited degree is it possible to place objects in pictorial space, and the representation itself has no central viewing point and exists without having any integral concern for the viewer. This contrasts with the role of linear perspective systems in creating dramatic illusions, such as Andrea Pozzo's painted ceiling *The Apotheosis of St Ignatius* in Sant' Ignazio in Rome, discussed at length by Maurice Pirenne (1974).

The fact that Pozzo's ceiling is in the church dedicated to St Ignatius, depicting the saint in such a spectacular all-embracing manner, is quite in keeping with the saint's own philosophy and may account for Pozzo's concern to produce such a spectacle. In describing St Ignatius of Loyola's *Spiritual Exercises*, Ryan (2001:116) suggests that 'since the body cannot be physically transported to the

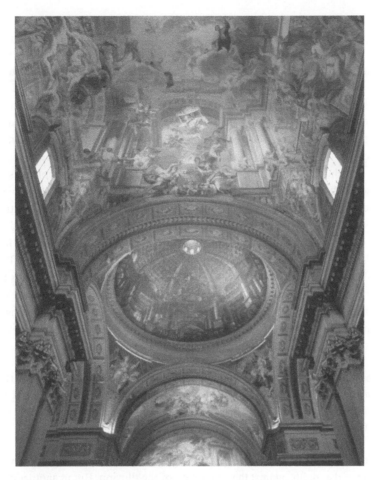

FIGURE 4 *The Apotheosis of St Ignatius*, Sant' Ignazio, Rome (1691–1694). Photograph courtesy of the author

scenes described in the Gospels, its participation in the sacred events must be mediated by the imagination.' The visual was key here, as 'at the time of Ignatius, and even more in the Baroque, sight began to emerge as the primary sense, the one that leads all perception' (p.362fn).

The conditions for viewing the painted ceiling from the correct position create an illusion of the scene that the viewer would have seen had s/he actually witnessed the saint's entry into heaven. We could anachronistically describe the painting as a sixteenth-century attempt at 'virtual reality': 'As was the case in VR technology, the condition for immersion in the sacred events is a relative transparency of the medium' (Ryan, 2001:118). And Pozzo had used a number of techniques to help achieve the transparency of the medium and such a strong illusory

effect. For example, the ceiling of the church is not flat, so the information that the viewer picks up from the depicted image overrides their detection of the picture surface. This has meant that the image 'projected' onto the ceiling is anamorphic, and if inspected from close-up, the painted figures are in actuality quite distorted. This illusion of St Ignatius is enhanced by the fact that the image is situated some thirty metres off the ground. Consequently, *binocular disparity* is not so significant: the picture is at such a distance that we cannot perceive depth by the differences in information pick-up by each eye. An additional 'reality-enhancing' characteristic is that the painted image appears to be part of the viewer's space in that the real church architecture is made to appear to continue into depicted space. To further enhance the painting's illusory power, the image needs to be viewed from the centre of perspective (or station-point), so the correct viewing position is indicated by a yellow marble disc on the floor of the church. Of course the illusion is quite convincing if we remain rooted to this spot; however, if we adopt James Gibson's mode of exploratory perception and move freely around, the illusion breaks down. In the words of Pozzo (1707:73) himself: 'Since Perspective is but a Counterfeiting of the truth the Painter is not oblig'd to make it appear real when seen from Any part, but from One determinate Point only.' Alberti (1435) was also aware that once an observer had moved from the station-point of a picture, it does not appear so 'realistic', as commented upon by Pirenne (1967:Plate 5 fn):

> In the church itself a spectator in this position still sees the painted ceiling in 3D, like the building itself, but the painted architecture is no longer in line with the actual architecture of the church. When the spectator moves about, the painted architecture seems to change its shape continually – and to be about to collapse.

It should be added that the subject matter – suspended-animation figures hovering in mid-air – also fights against the conviction of the illusion. But in another part of the church, and perhaps most interesting, is an illusory cupola that has been painted onto a flat ceiling. This provides a very strong effect of a concave dome shape until one stands right below it, at which point the degree of anamorphosis is quite clear.

Any account of Pozzo's ceiling would be incomplete if we did not consider the reason why he went to such lengths to produce such a dramatic *trompe-l'oeil* painting. Not only was it Pozzo's intention to produce a painting that aided the 'imaginative projection of the body into represented space' (Ryan, 2001:119), but the image was politically motivated and can be seen as symptomatic of the Counter-Reformation. This emerged from Council of Trent under Pope Paul III, which was convened intermittently from 1545 to 1563 as a response to the rise of Protestantism. It attempted to make artists conform to the production of religious art and (as far as European art was concerned) it resulted in something of a North/South divide. While Protestant religious painting often featured ordinary

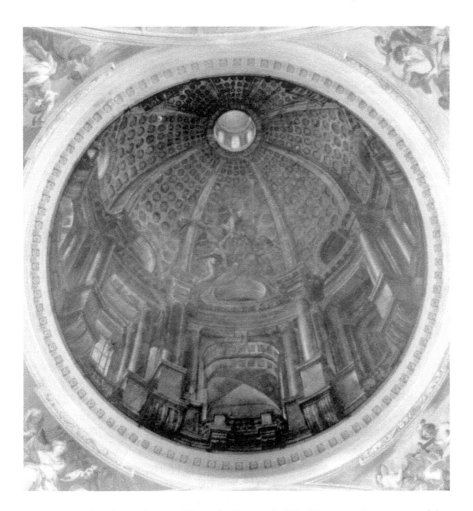

FIGURE 5 Painted cupola, Sant' Ignazio, Rome (1685). Photograph courtesy of the author

people and displayed a distinctly secular attitude, basing its imagery on everyday events, the art of the Catholic South presented idealized images of Christ, the Virgin Mary and the saints.[4] Just as relics were venerated in the Catholic Church, so, too, were paintings and other religious imagery. Vehemently opposed to believing in the sacred nature of images, iconoclastic movements grew out of Protestantism. By contrast, in its attempt to win back the converts to Protestantism, the Roman Catholic Church went completely in the opposite direction, intending to involve worshippers through emotional response by means of overwhelming the viewer through theatricality and passion in art displayed in increasingly ornate churches.[5] The result aimed for an overwhelming of the Gibsonian 'perceptual systems'.

In Pozzo's painting of St Ignatius, founder of the Jesuit order famous for its over-seas missionary work, a line of descent is depicted from Christ to Ignatius to the Jesuits to the converted to the non-converted. In some respects this type of hierar-chical narrative echoes the structure of medieval painting. As expressed by Pozzo in his *Perspectiva pictorum et architectorum* (1693: text for fig. 101), from the wounds of Christ 'issue forth rays of light that wound the heart of St Ignatius, and from him they issue, as a reflection spread to the four parts of the world' (see Levy, 2004:151).

Such was the impact of Pozzo's designs that they set a trend and spawned a number of imitators during the following decades (Levy, 2004:213–237). However, for present purposes, not only do Baroque ideas concerning representa-tion provide a dramatic illustration of the boundaries between 'everyday' percep-tion and that of visual images, but also they have wide implications for those engaged in devising a rationale for contemporary computer-based imagery. As Ryan (2001:15) puts it, the theories of St Ignatius of Loyola (and others) 'show that, far from promoting passivity ... immersion requires an active engagement with the text and a demanding act of imagination'.

Conclusion

At face value, it would seem that a type of 'technological determinism' is respon-sible for the formation of pictures, whereby it is a culture's theory of vision that determines its modes of visual representation. And we can see there is indeed a close analogy between Plato's ideas regarding the nature of the world and the pre-vailing canons of visual representation. In his case, he was expounding his philo-sophical analogy of shadows cast on the wall of the cave at a point of transition in visual imagery from systems based on *orthographic* projection to those of *oblique* projection. Two thousand years later, Kepler's theory of vision, as well as theories used in support of the visual arts of the sixteenth and seventeenth centuries, were closely associated with Descartes' philosophical standpoint. Furthermore, much of our contemporary computer technology, by means of virtual reality head-sets, for instance, is devoted to simulating our current understanding of perceptual input.

The photographic image was considered to be a very close approximation to that which we actually see. The chemical fixing of the image enabled the capture of what might be considered a natural phenomenon: the camera obscura's image. The important point for photography is that a theory of pictorial representation evolved which had a firm basis in the current understanding of the optical and physical mechanisms of vision. In our present age of computer technology we have inherited this tradition of developing representational systems that aim to replicate our current understanding of visual processes. As we saw, a significant change in perceptual theory occurred in the 1960s and 1970s in the work of the psychologist James J. Gibson, the development of whose theory is most clearly described in his

Ecological Approach to Visual Perception (1979). Existing theories of perception, as we saw, did not provide an adequate account of how organisms could find their way around their environments. Not only did Gibson's theory provide this, but his approach to perception, originally derived from problems arising from flight simulation for trainee pilots (Gibson, 1979:124), has taken on additional contemporary relevance in the creation of virtual environments (Reingold, 1991:143–144). In particular it is Gibson's concept of the active exploratory perceiver that is most relevant to notions of computer interactivity, a subject to which we shall return later in the volume.

—4—

News Media and Pictorial Tradition

In the previous three chapters we have considered the nature of pictures and the ways we obtain information from them. We shall now look more closely at the issue of 'visual impact' with regard to media images: particularly those of disaster and the human migrations that follow. Despite the visual record of such events being ascribed to the categories of 'documentary' or 'news footage' purporting to offer the viewer transparent records of 'reality', the images themselves and the descriptive narratives that accompany them usually conform to traditional patterns. For example, narratives composed as journeys can reflect the twentieth-century road movie genre of Hollywood feature films. However, these more contemporary narratives themselves have adopted 'the road of life' story structure, with its biblical origins and accompanying ethical and moral implications.

The mass media representation and reporting of death and humanitarian disasters, along with war and conflict, produce some of the most striking media images to reach our television screens. When it comes to news coverage, dramatic images are those that make the story. In this context, not only do people seem to want pictures, but pictures are what they are given. When the terrorist attacks on New York's World Trade Center took place in 2001, Steve Anderson, controller of News and Current Affairs for the ITV network, stated: 'We went for the footage, rather than analysis ... we wanted people to see what was happening ... let the BBC do the discussions' (Brown, 2001). This tendency is most clear in the media representation of disasters. In the year 2000 Mozambique was engulfed by floods. ITN reporter Mark Austin (2000) called it 'a telegenic catastrophe' as the disaster rescue efforts included helicopters snatching victims from the waters, dramatic shots of floods, and sensational stories such as a baby born in a tree. In addition the availability of helicopters for news crews produced spectacular aerial shots that clearly displayed the scale of the disaster. Austin declares that 'it had an immediate impact. Finally, the world took notice With no dramatic rescues, no riveting footage, would the world have noticed?' Apparently not: a year before the Mozambique disaster, cyclone 05B struck coastal areas along the north-eastern state of Orissa. There the population suffered more than ten times (c. 10,000) the fatalities of Mozambique (c. 700), and over seven times as many people were affected (c. 15 million and c. 2 million, respectively), yet the disaster raised only £7 million in aid in comparison to Mozambique's £31 million, according to Isobel

Eaton (2001), a former BBC *Newsnight* producer. One major reason for the difference seems to have been that the Orissa tragedy was not particularly photogenic. In the words of another ITN reporter, Mike Nicholson (1999): 'Pictures are everything, and its well nigh impossible to convince the viewer of the scale of the disaster when the only pictures we can show are unsteady shots of people casually wading knee-deep through a flooded rice field.'

Although it seems fairly clear that the Orissa images were lacking in visual impact, there may be other factors that determine the type of coverage and the extent of public response. But even when the images might be thought to have 'impact', they can result in a type of standardization that results in *visual wallpaper*. This type of material conforms to Dave Marash's 'TV Codes'. According to Marash (1995), an ABC News reporter, the code for 'hurricane' comprises images of '[p]alm trees bending to the gale, surf splashing over the humbled shore, missing roofs, homeless people showing up in local gyms. You see it once or twice most years.' He continues by citing 'storm of the century', Hurricane 'Andrew', which hit Florida in 1992.[1] The news reporting of 'Andrew' conformed so closely to the stereotypical television coverage that nobody realized the seriousness of the disaster: '[T]he pictures are the same, and so is the response. Even in a well-wired White House, with independent additional sources of information, it was days before it dawned that people in Florida were afraid and angry because they knew what had hit them but no one in authority seemed aware. Even though they could see it on television.' This type of lack of response was repeated in 2005 when Hurricane 'Katrina' hit New Orleans. However, of the many conclusions reached, the US House of Representatives inquiry blamed the media who 'greatly exaggerated reports of crime and lawlessness' (2006:169) on the part of disaster victims. In addition the 'official' lines of communication proved unreliable which meant that 'public officials lacked the facts to address what the media reported' (p.163). Ironically, reports of victims shooting at rescue helicopters 'were later understood to be actually coming from individuals trapped and trying to attract the attention of rescuers in helicopters' (p.169).

In many cultures there exists a strong desire to express visually and directly the human experience of disasters. After the tragic events are over, this can provide a way of coping: a therapeutic response to the catastrophe. Susanna Hoffman (2002:118) observes this reaction in the aftermath of the 1991 Oakland firestorm: 'Like disaster victims everywhere, they faced the enormous task of reconstituting their lives ... ritual arose among them immediately. They built shrines, invented ceremonies, and told sagas. ... A book of disaster writings and photographs appeared. Shows of firestorm art and videos surfaced in galleries' (Hoffman, 2002:118). In his novel *A History of The World in 10½ Chapters*, Julian Barnes (1989:125) poses the question: 'How do you turn catastrophe into art?' He describes the process as 'automatic' and suggests a number of instances: 'A nuclear plant explodes? We'll have a play on the London stage within a year. A president is assassinated? You can have the book or the film or the filmed book or

the booked film. War? Send in the novelists. A series of gruesome murders? Listen for the tramp of poets.' He goes on to propose that the representation of catastrophe is fuelled by the human desire not only to understand what took place, but also to satisfy our 'need to justify it and forgive it':

> We have to understand it, of course this, catastrophe; to understand it, we have to imagine it, so we need the imaginative arts. But we also need to justify it and forgive it, this catastrophe, however minimally. Why did it happen, this mad act of Nature, this crazed human moment? Well, at least it produced art. Perhaps in the end, that's what catastrophe is *for*.

The particular representation that Barnes has in mind is Géricault's *Raft of the Medusa*. Painted in 1821–1824, this depicts the survivors of the French ship *Medusa*, which had hit rocks on its way to Senegal on the west coast of Africa in 1816. When disaster struck, the wealthy took to the lifeboats and the others were furnished with a raft. Later the raft was cut adrift. After many days afloat the survivors on the raft resorted to cannibalism.[2]

'Mad act[s] of nature' may be one thing, and are often faced with a sense of resignation, but suggestions of human responsibility (often due to failures to act or inabilities to foresee the unfolding tragedy) are quite another. They give rise to anger and calls for retribution. Public attitudes change rapidly when a seemingly natural disaster can be put down to human error or bureaucratic inefficiency.[3] The

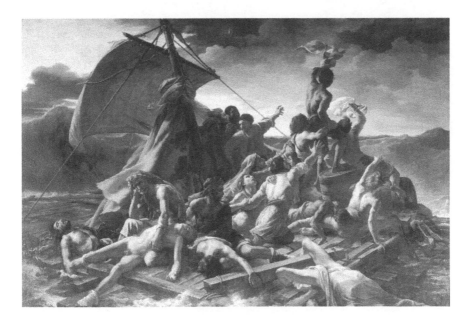

FIGURE 6 *The Raft of the Medusa*. Théodore Géricault (1821–1824). With permission of the Musée de Louvre, Paris. © Photo RMN/© Daniel Arnaudet

nature/human responsibility debate is an old one. Eighteenth-century philosophers argued over the causes of the Lisbon earthquake of 1755. The dispute centred on the distinction between *Moral Evil* (human agency) and *Natural Evil* (brought about by forces of nature). Voltaire (1759), in his criticism of Leibniz, maintained that a benevolent God would not allow such a disaster to occur. Rousseau, meanwhile, pointed out that the city of Lisbon was a human construction. As a consequence most of the deaths were caused by falling buildings and fires, a death-toll exacerbated by a tightly packed population. '[I]t was hardly nature that there brought together twenty-thousand houses of six or seven stories. If the residents of this large city had been more evenly dispersed and less densely housed, the losses would have been fewer or perhaps none at all' (Rousseau's letter to Voltaire concerning the 'Poem on the Lisbon Disaster', 18 August 1756, R. Goldberg, 1989:12). The earthquake had been followed by a tsunami and a fire. About a third of Lisbon's 270,000 population perished (Braun and Radner, 2005).

Even when death proves to be caused by natural forces, however, there is a tendency to personify death in the form of a malevolent spirit or 'angel of death'. This phenomenon typically occurs in nineteenth-century art found on tombs and gravestones.

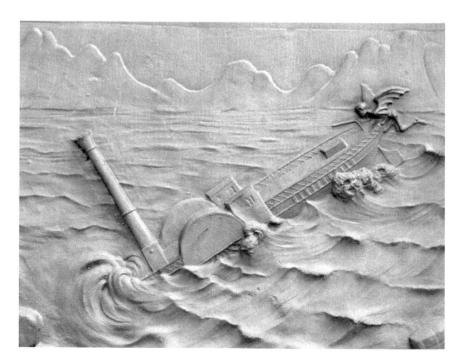

FIGURE 7 Tomb of 'Familles Cavé et Lemaitre', Montmartre cemetery, Paris (2007). Photograph courtesy of the author

When it comes to the 'crazed human moment', motivation and justification are more difficult to rationalize. In trying to understand seemingly irrational human behaviour, the anthropologist Michelle Rosaldo (1980) attempted to explain why and how violent bursts of anger manifested in bouts of headhunting among the Ilongot of the Philippines. Why did this occur among an apparently sociable and peaceful group of people? It seemed that when men were overcome with anger, when they had a 'heavy heart', headhunting provided the means to placate that anger. Rosaldo's concentration on the indigenous terms *liget* (anger or passion) and *beva* (the knowledge that controls that passion) suggested that as young men matured, through headhunting, they experienced a shift from *liget* to *beva*: from outbursts of passion to developing the type of knowledge that enabled them to gain control of their emotions. It is the 'rage, born of grief, [that] impels [the headhunter] to kill his fellow human beings' (R. Rosaldo, 1989:1). Contrary to popular expectations, the heads were not kept as trophies, but the 'act of severing and tossing away the head enables him … to vent and … throw away the anger of bereavement'. Michelle's husband Renato had found it impossible to accept the Ilongot's 'too simple' explanation for headhunting, dismissing it as 'thin, opaque, implausible, stereotypical, or otherwise unsatisfying'. He admits that 'no personal experience allowed me to imagine the powerful rage Ilongots claimed to find in bereavement' (p.3). Yet it wasn't until Michelle's accidental death that he came to understand the intensity of such grief: 'I experienced the deep cutting pain of sorrow almost beyond endurance, the cadaverous cold of realizing the finality of death, the trembling beginning in my abdomen and spreading through my body, the mournful keening that started without my willing, and frequent tearful sobbing' (p.9). He concludes: '[N]othing in my own experience equipped me even to imagine the anger possible in bereavement until after Michelle Rosaldo's death in 1981. Only then was I in a position to grasp the force of what the Ilongots had repeatedly told me about grief, rage, and headhunting' (p.19). In this present context the Rosaldos' experience is doubly pertinent. Firstly, it aims to achieve a degree of objectivity that helps to explain the cultural force of emotions and how they become manifest in violent forms of human conduct. For Barnes it is this 'crazed human moment' that may eventually result in art. Secondly, it accentuates the need for subjective empathy that repositions the ethnographer to open up to that which seemed inexplicable thus far. Arguably, this is also the role of artists such as Géricault: 'the portrayer of madness, corpses and severed heads' (Barnes, 1989:136).

Alfredo Jaar's Rwanda Project

For a more contemporary problematic response to disaster, the artist Alfredo Jaar's 'Rwanda Project: 1994–1998' addresses the issue of genocide (Jaar, 1998). Here it is not necessarily the subject of death and killing that creates the problem for the

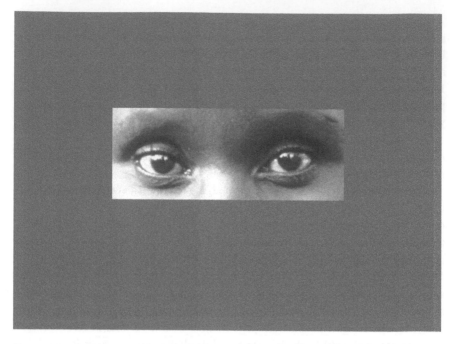

Figure 8 *The Eyes of Guetete Emerita*. Alfredo Jaar (1998). Photograph courtesy of Alfredo Jaar

artist. As Susan Sontag (2003:66–67) reminds us, Leonardo da Vinci laid down precise instructions for portraying 'war in all its ghastliness'. It is more how to represent the sheer scale of the massacre that had taken place. Jaar sets the context by providing large colour photos of location: landscapes showing where mass murders had occurred, together with hand-drawn maps indicating the location of each photograph and camera angle. The piece of central concern is based on an interview with Guetete Emerita, a woman who, despite witnessing the murder of her husband and sons, managed with her daughter to escape the genocide. A backlit text offers factual details of the events that had taken place: 'Over a five month period in 1994, more than one million Rwandans, mostly members of the Tutsi minority, were systematically slaughtered as the world closed its eyes to genocide', yet by the time we appear to be approaching a conclusion, the perspective has shifted to the subjective viewpoint: the impression that 'the eyes of Guetete Emerita' had left upon the artist. Then we see an enormous light table covered by a mountain of approximately one million 35mm slides all bearing the same image, 'the eyes of Guetete Emerita'.

In remembrance of the first systemized mass killing of the modern world, Jaar's art-work is reminiscent of chilling documentary evidence from Auschwitz. At the Nazi concentration camp on display, piled high, is a collection of spectacles that had once belonged to the victims of the holocaust.[4] These aids to seeing draw attention

to what we can't see. Having been uniquely prescribed, the spectacles 'stand in' for the victim, they draw attention to their owners' enforced absence. The effect may be similar to the device of *dramatic ellipsis*, in which events essential to the plot take place off-screen, as in the films of Ozu and Erice. In contrast to the figures and statistics that might be broadcast by newsreaders or government agencies we can get an immediate impression of the vast numbers, just in one look. A more appropriate term is the French *coup d'oeil*, which means *a glance*, but *coup* can also signify a *blow* or a *shock*. We might imagine not only the character of the spectacles' owners, but also the dreadful sights the owners went on to see unaided after their glasses had been taken away. In a similar manner, Guetete Emerita's eyes represent the experience simultaneously of the individual and of the many. Although Jaar's work shares some common features with photojournalism and documentary film in its sense of distance and objectivity, he avoids the direct representation of death and suffering, aiming for a more subtle approach. Again the idea of *dramatic ellipsis* is especially pertinent as emphasis is shifted to the location of the tragedy, so the absence of those events becomes highlighted: 'This grave political event of incomprehensible dimensions has been humanized by Jaar, whose work insists upon it as one million instances of the kind of personal grief he encountered. He does this by combining quantity and sameness in a single miniaturized image. One million deaths, one million absences, one million survivors' memories' (Moore, 1998).

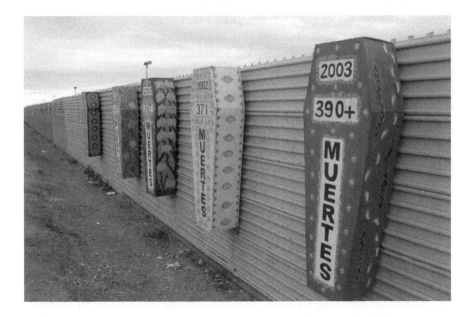

FIGURE 9 Memorial coffins, Tijuana, Mexico (2007). Photograph courtesy of the author

Thoughtful approaches to bringing public attention to disaster not limited to the lofty confines of the art gallery. In Tijuana, on the border fence between the US and Mexico, there is a vernacular example of visual representation relating to an on-going catastrophe. Local people have attached painted coffins as a protest against the number of lives lost of those who had attempted to cross into the US each year.

Each coffin displays the annual death toll and is painted with traditional Mexican motifs. For example, one of the coffins bears images of footprints winding between painted skulls and serpents. On one level, this symbolizes the inherent dangers in attempting to cross the border. This reading of the coffin could lead one to assume that its purpose is part memorial, part warning. However, in the pre-Hispanic era, skulls were displayed as symbols of death and rebirth. They popularly feature today in the Mexican *Día de los Muertos* (Day of the Dead) festivities. Similarly, serpents were considered to operate on a less easily defined border: between the human world and the spirit world. In this context the footprints are not simply facing the dangers of crossing the political divide between Mexico and the United States of America, but they exist and move in the divide between life and death. Yet if in these ways the images conform to tradition, in other ways they depart from it. Traditional Aztec burial is in the 'crouch' position, representing another dimension of the death and rebirth cycle whereby 'the Aztecs arranged a dead person's body in a foetal position, with legs drawn up and sprinkled water on the corpse. In this way an individual might return to the same position and environment as in the womb' (Moctezuma, 1988:130; see also Lukowski, 1988). In contrast, the 'upright' burial has very different connotations and, perhaps as the body is placed in the position of sentry, has a worldwide association with the burial of warriors. From a very different culture, that of tenth-century Iceland, Viga Hrapp, 'Killer-Hrapp', the anti-hero of the *Laxdœla Saga*, made a specific request to be buried in this way:

> [W]hen I am dead I want my grave to be dug under the living-room door, and I am to be placed upright in it under the threshold, so that I can keep an even better watch over my house. … Hrapp soon died and all his instructions were carried out. … And difficult as he had been to deal with during his life, he was now very much worse after death, for his corpse would not rest in its grave; people say he murdered most of his servants in his hauntings after death, and caused grievous harm to most of his neighbours. (Magnusson and Pálsson 1969:77–78)[5]

This deeper reading implies a significant move away from the memorial-role of the Mexican coffins standing for the passive victims of a disastrous situation. They can now be read as expressing a sense of defiance, refusing to lie down. So the individuals who had attempted to cross a physical border are represented as stranded on a spiritual border. Despite the annual death toll, the political issue remains very

much alive. As long as the physical border exist, the victims will not rest or be forgotten.

The Madonna and Child Icon

Having looked at photographs of refugees over several years, one becomes aware of the perennial resonance of the woman with her child. This is not just any woman; she is composed as an almost madonnalike figure.

Liisa Malkki, 1995:11

The prevalence of Christian iconography in culture seems to be so ingrained in the Western psyche that its images recur over and over again. We find that the Madonna and Child icon, in its various forms, appears regularly in photojournalists' coverage of poverty and disasters. For instance, Don McCullin's photograph of a mother and child from the Biafran famine (1968) appears as a variation on the Madonna and child theme. In this photograph the emaciated figures of the mother and child assume the familiar pose of the religious icon. We can compare it with a detail from a fifteenth-century forerunner: Rogier van der Weyden's painting *St Luke Drawing a Portrait of the Virgin*.

In this context, it is apparent that the photograph both conforms to and perpetuates a longstanding pictorial tradition. This, in itself, might demonstrate the power of the visual image to invoke the viewer's response – that we are culturally conditioned to responding sympathetically to the image. Through McCullin's referencing the past, his photograph transgresses its immediate denotative function – recording the plight of one particular mother and child in the 1970s – and takes up a connotative role – acting as a general symbol for the Biafran famine (or indeed for Third World poverty in general).

Nonetheless, although McCullin's photograph can be shown to conform to tradition, it also deviates from it, appearing almost as a 'negative' of van der Weyden's painting. It is the contrast of sameness and yet difference that makes the photograph so fascinating. On the one hand we can mentally flip the photograph over onto the painting to find both images compositionally identical (save the position of the mothers' arms). Nevertheless we find that a comparison of the images conforms neatly to a structuralist scheme of things whereby the key elements of the images can be paired into sets of *binary oppositions*. This type of analysis stems from the work of the anthropologist Claude Lévi-Strauss, who aimed to establish a system of universal characteristics that reflected the 'rules' of any given culture: a scheme that would specify what could be eaten and who could be married. Lévi-Strauss considered these to be universal elements in the cultural vocabulary. Rather than being founded in primitive superstition, this system was held to be a basic example of logical thinking. Of course, as universal characteristics, binary oppositions are not limited to tribal societies. In the two images,

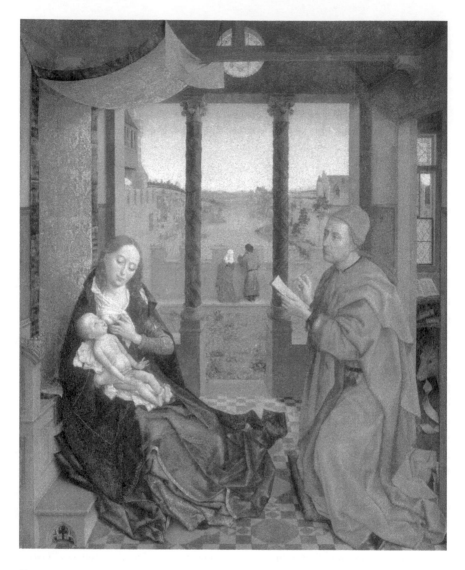

FIGURE 10 *St Luke Drawing a Portrait of the Virgin.* Rogier van der Weyden (1435–1440). Photograph © 2008 Museum of Fine Arts, Boston

despite their compositional similarities, we can list the *binary oppositions* as: black/white; poverty/opulence (of surroundings,[6] clothing, etc.); naked/clothed; emaciated/well fed; actively helping/passively supporting; eye contact/deferred gaze; secular/spiritual; realism/idealism (mythic); and so on.

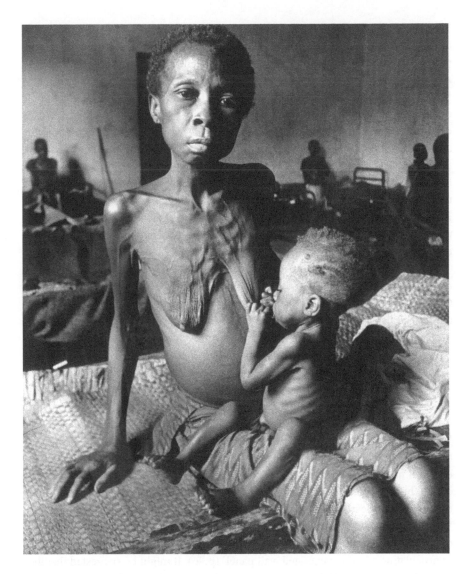

FIGURE 11 *Biafra, a Twenty-Four Year Old Mother and Child Awaiting Death*. Don McCullin (1968). Reproduced with permission

St Luke, the artist

Of course, there are numerous Madonna images that could have been chosen for the comparison, but what is particularly intriguing about van der Weyden's painting is its 'self-reflexive' nature: it is a painting that is also about the activity of painting (see Maniura, 2003). If we widen the image from the detail of the

Madonna to the full frame of the painting, there is the figure of St Luke in the act of drawing her portrait. '[I]n representing St Luke portraying the Virgin, the art of painting renders an account of its own aims and methods' (Panofsky, 1953:253). According to a sixth-century Christian legend of Greek origin, St Luke was the first 'artist' to create an image of the Virgin, so the painting depicts the genesis of one of the most influential iconographic traditions.[7] The multi-talented Luke – evangelist, writer, physician and the first Christian artist – inspired a number of artists (including El Greco in the 1560s) who portrayed him in the act of painting the Virgin. And the subject was a very popular choice: 'Painters, it is argued, would have had a clear interest in making and using an image of their patron engaged in the very act that rationalized his patronage' (Maniura, 2003:88). All the same, Robert Maniura states: 'The legend of St Luke as a painter, far from being a minority interest, was deeply embedded in a mass devotional practice with a heavy emotional investment: pilgrimage' (p.89).

However, there is much more to icon painting. Legend maintained that St Luke's original portrait was to be found in the monastery of the Panaghia Hodegetria in Constantinople. Although this icon was lost during the Turkish invasion of 1453, copies had been made and these were held to maintain some of the inherent religious qualities of the original. Although this might not be in accord with contemporary notions of 'authenticity', it does suggest a persistent fascination with the idea of the 'unbroken line'. The rationale behind this is described by Marina Warner (1976:292); she asserts that 'the all-important lifeline, the direct chain of descent from God to man, is not broken if the images appeared miraculously or were painted by Luke in the presence of the Virgin.' As put by Maniura (2003:90): 'St Luke is said to have painted the Virgin Mary's portrait from life: the "truth" of the image lies in a verisimilitude derived from direct observation.' And if that observer happens to be one of the Evangelists, the 'truth' of the image is considered to be on a par with the Testament itself. 'The idea of St Luke as the guarantor of images was clearly very deeply engrained' (p.95). Later Maniura mentions that '[t]he story of an image "not made of human hands" was as much the standard way of articulating a highly venerated wall painting as the legend of St Luke was a way of articulating a highly venerated wall panel' (p.96). It might be suggested that the belief in the authenticity of the image created not from human agency was a precursor to the invention of photography more than three hundred years later.

In the field of photography Dorothea Lange's *Migrant Mother* (1937),[8] taken as part of the Farm Security Administration (FSA) project during the American Depression, might also be cited as one of the progenitors of McCullin's Biafra photograph (discussed earlier). Lange's image constitutes such a landmark in the documentary tradition that many would consider that no history of photography would be complete without its inclusion. In relation to its own social/historical context (as in the case of McCullin's Biafra photograph), 'it could be said to stand in iconically *for* the Depression' (Roberts, 1998:85–86). Nonetheless this image,

in turn, continues upon the longer trajectory of visual representation: 'Dorothea Lange's famous "Migrant Mother" is a timeless madonna. The "holy mother" theme captions the image, placing it so that we apprehend the universal in the guise of the immediate, the sacred incarnate as the humble' (A. Trachtenberg, 1988:70). According to Lange's own account of the photo-shoot:

> I saw and approached the hungry and desperate mother, as if drawn by a magnet. I do not remember how I explained my presence or my camera to her, but I do remember she asked me no questions. I made five exposures, working closer and closer from the same direction. I did not ask her name or history. ... I knew I had recorded the essence of my assignment. (D. Lange, 1960:42–43)

It appears that she had recognized, in the woman's situation, the potential for a cultural/religious icon and had instinctively captured it on film: 'Lange knew she had found precisely the ideal image she was searching for' (Levine, 1988:26). Images such as these have become longstanding cultural icons which can automatically elicit the appropriate emotional response. Some constitute a variation on a theme and some images evoke other images. Subsequently Lange's *Migrant Mother* has been transformed by graphic artists: two years later Diane Thorne adapted Lange's *Mother* into the lithograph *Spanish Mother: The Terror of 1938* (1939); in the 1960s the image appeared in Venezuela as *Bohemia Venezolana* (1964); and in the following decade she changed race for the Black Panthers' newspaper (1973) (see V. Goldberg 1991:140–141). Thus Lange's subject, named Florence Thomson, loses her identity, becoming '*the* migrant mother' of the 1930s, later to be transfigured alongside the Virgin Mary as 'the universal mother' of the twentieth century.[9]

At this point we might question the appeal of such imagery. Is it the simple fact that a Christian icon is so deeply embedded in our culture that it immediately elicits an emotional response? In a society that propagates traditional sex roles, does it place the viewer in a paternal role that recognizes the vulnerability of an unprotected mother and child? Here the state of innocence might be reinforced by Mary's supposed virginity. Does the Madonna represent 'every woman' or 'every mother'? St Mary had humble origins yet was elevated to spiritual heights. However, from another perspective, we can place the Madonna and Child in opposition to the Cartesian perspective. It will be remembered that Descartes' position of potential deception by the evil deceiver reduced him to being sure only of his own existence. This characterizes human the separateness of human existence: uneasy and alienated, in stark contrast to the unified dyadic image of mother and child. In some images, the image of unification is reinforced by breast-feeding (suckling). Perhaps the earliest depiction, *Maria Lactans* (AD c. 250) is the one to be found in the Priscilla Catacombs in Rome, though Warner (1977:193) suggests that the image had Egyptian origins 'where the goddess Isis had been portrayed

sucking the infant Horus for over a thousand years before Christ'. Furthermore, it appears to be something of a universal theme:

> Goddesses have suckled their divine offspring as far back as discovered civilization. Two thousand years before Christ, the goddess of Ur offered her son her breast; in Mexico in statues carved around 1000 b.c., in Liberia, the Lower Congo, the Ivory Coast, and the Gold Coast, female deities nurse their babies. In India later sculptures show the infant Krishna with his mother Dewaki. (Warner, 1977:193)[10]

So much for the history behind the universal mother and child image. In the case of contemporary disaster and refugee images, it might seem strange to question 'where do pictures come from?' It seems fairly obvious that they are 'taken' of a particular person in a situation of migration in a specific location. However, as Liisa Malkki (1995:9) has indicated, there exists a 'tendency to universalize the "the refugee" as a special "kind" of person not only in the textual representation, but also in their photographic representation'. In the 1930s, when Lange photographed her *Migrant Mother*, the situation was not quite so straightforward. It seems that Lange was driving through the countryside, looking for an image that would satisfy a preconceived idea. This will be discussed in greater detail later. However, with most news images we see, there is a sense of the picture-makers not offering an unbiased impression by photographing what is there, but looking for images that conform to the camera operators' preconceptions. Indeed sometimes it is difficult for the 'reality' to get through the editorial 'obstacle course'. Although photographers might shoot pictures that are 'non-stereotypical', it is more likely that the more predictable images will be chosen by those who occupy positions further along the editorial chain.

In taking a 'snap-shot' overview of media images of refugees – and in recognition of the biblical origins in forming the prototypes of some of these images – I would make a tentative proposal that media images of refugees can be classified in the following categories of 'image types'. There is a possible distinction in the representation of refugees between 'Old Testament' and 'New Testament'. In the former case they are depicted in a state of degradation (rags and ruin) derived from Adam and Eve's expulsion from the Garden of Eden. However, the image of the expulsion from the Garden of Eden symbolizes the struggle to gain salvation and, in this context, artists have created visual icons to emphasize the predicament of humanity. It would appear that an 'iconography of predicament' has emerged. It provides an essential visual resource that can be drawn upon when human catastrophe is to be represented. This 'Fall of Man' stereotype usually features a couple or small group in states of degradation, isolation, nakedness, etc. In contrast there are the 'New Testament' images of those who are depicted in the style of Joseph and Mary's 'Flight into Egypt': people who are displaced but not necessarily starving nor destitute. They may be portrayed with a few possessions, sometimes

accompanied by a means of transport. In one illustration, *Dva begstva* (*Two flights*) by I. Gur'ev, that appeared in the First World War Russian publication *Rodina: illiustrirovanji zhurnal die semeingo chteniia* (*Motherland: Illustrated Journal for Family Reading*) No. 1, 3 January 1916, the connection between the Holy Family's flight and that of the refugee family has been made quite explicit (Wright, 2002:57).[11] In modern times the donkey usually depicted in the 'flight into Egypt' type of image has been replaced by the car laden with possessions, and this image was featured many times during the so-called 'Third Balkan War' that commenced in 1991. Ten years later with the US invasion of Afghanistan the donkey returned as a central feature of this image, once again provoking its biblical connotations: for example a contemporary 'Flight into Egypt' style of image, complete with donkey, appeared on the front page of the Swedish newspaper *Svenska Dagbladet* (7 October 2001). In a quest to find the origins of such associations, Thomas Mathews (1993:23–53) in his chapter titled 'The Chariot and the Donkey', appears to remain a little puzzled regarding the significance of the donkey in Christian iconography. Aside from providing transport to Egypt, the ass witnessed the birth of Christ, and not only is Christ depicted entering into Jerusalem on a donkey, but also he is shown riding side-saddle: 'a motif that had become standard in Byzantine Art' (p.41). Side-saddle is certainly not the pose of the conquering hero; rather the riding position usually assumed by women.[12] 'In all these manifold appearances of the ass one detects something of the special pleasure that Christians took in believing that Christ had led them into a kind of looking-glass world in which all the traditional values were turned inside-out and upside-down' (p.48). Elsewhere Mathews considers earlier classical art associating the donkey with Dionysiac processions.[13] Wherever the source of such imagery lies, or whatever its precise meaning may be, its special significance is still recognized by contemporary newspaper picture editors. There is a third category: 'Exodus', the mass movement of people which may suggest the out-of-frame presence of a pursuer. In addition we find the 'Madonna and Child' image a regular occurrence, which may be incorporated with any of the other categories. While there are always inherent problems with classificatory systems, they can have the virtue of providing a working model for analysing the problem. In the long run they may be abandoned, adapted or adopted as their appropriateness only becomes apparent during the course of the research. In this context, they are used to form the basis for discussion of wider media issues.

Expulsion from the Garden

The process of coming to see other human beings as 'one of us' rather than as 'them' is a matter for detailed description of what unfamiliar people are like and a redescription of what we ourselves are like. This is a task not for theory but for genres such as ethnography, the journalist's report, the comic book, the docudrama, and … the novel.

Richard Rorty, 1989:xvi

Although the media images of refugees that appear in the newspapers and on our television and cinema screens are relatively recent phenomena, the subject of forced migration has a long pictorial tradition. For example, in Masaccio's painting *The Expulsion from Paradise* (c. 1425–1428),[14] the image of Adam and Eve's expulsion from the Garden of Eden by an angel contains many of the same constituent elements as some of today's press photographs.

When comparing Masaccio's painting with the photograph by Darren Whiteside, taken in East Timor that appeared in *The Guardian* (21 September 1999), both images show a couple in distress escorted by an armed guard(ian). The background of each image is fairly sparse save for a piece of architecture – in the former: the gates of paradise; in the latter: a ruined/abandoned building. Besides its connection with the Masaccio painting, Whiteside's photograph has stylistic similarities to the Christian icon of the Madonna and Child. As we have already seen, this is an image that reoccurs with predicable regularity. One difference in Whiteside's photograph is that the child (though breast-feeding) is holding an empty cup – this, too, may have biblical connotations, where the cup operates as a symbol of human destiny, signifying the way in which an individual's fate is allotted by God. It may be likened to receiving a cup which may overflow with blessings,[15] or to having a cup that may contain 'fire and brimstone'.[16] This might

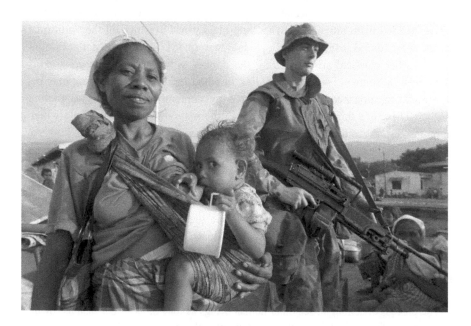

FIGURE 12 *An Australian Soldier Walks Past an East Timorese Woman in Dili*, 20 September 1999. Photography: REUTERS/Darren Whiteside. *The Guardian* (21 September 1999). Reproduced with permission

lead us to question if this kind of sourcing and interpretation is indeed appropriate for a front-page newspaper photograph. Arguably, one of the functions of this type of photograph (like the newspaper headline) is to grab the attention of the casual observer in the hope that the image may 'hook' them into buying the paper. So we might ask if we are pursuing a mere academic exercise, or is it possible that we register the symbol of the cup subconsciously, and is it at this level that it contributes to our overall recognition and understanding of the image's message?[17]

In returning to the book of Genesis and with regard to Adam and Eve's expulsion, Stephanie Moser (1998) demonstrates how biblical stories provided the model for images of pre-history. While this is not my precise concern, she does examine the extensive influence of the Bible in establishing a narrative framework. Pictures which focused on Adam and Eve inspired illustrators in making their depictions of early human life: Adam and Eve next to the tree of knowledge in the Garden of Eden; their expulsion from Paradise (their original 'homeland'); and their labours in the wilderness. According to Moser, stories from both biblical and classical origins have proved to have a great visual potential. The Bible itself has provided inexhaustible inspiration for visual representation, and Moser suggests that biblical illustrations were significantly responsible for the spread of Christianity. The Venerable Bede, for example, in his *De Templo* (AD c. 729–731), supports the use of religious images in their portrayal of accounts from the Bible so they can be 'recalled to minds of faithful pictorially ... the sight of these things often tends to elicit great compunction in the beholders and also to make available to those who are literate a living narrative' (Connolly, 1995:91). In this context he refers to the Greek word for a painting as 'living writing'. But for our purposes the notion of compunction (*compunctio*) is particularly interesting: the feeling of guilt or moral scruple. This implies that the depiction of tragic events may have a role in stirring our consciences to acts of compassion.

As with Mathews and the origins of the donkey image, Moser points out that although the early Christian images go back as far as the fourth century, they drew upon the (even older) classical tradition. She makes reference to *The Golden Race* and the five ages of Hesiod – similarities between the classical and biblical schemes seen in the story of the expulsion from Eden; both led to a state of degradation. In Hesiod's case the concept was one of regression from an earlier idyllic state.

Artists highlighted key iconographic themes which enabled people to make sense of their past and their own place in the world. Some biblical iconographic features were to become closely associated with secular imagery. At the same time, despite Christianity's origins in Judaism, which has always taken a strong line against visual imagery,[18] its iconography took quite a different approach. Indeed Beth Williamson (2004:3) suggests that the Christian religion's approach to visual representation is one of its essential and distinctive features:

In adapting Graeco-Romano pagan imagery to form images of Christ … the emergent Christian church went against Judaism's prohibition regarding images and idols, and this helped to mark out the developing church as distinct from the religious and theological culture of Judaism. The very existence of Christian art is therefore one of the things that makes up the specific and fundamental character of Christianity.

This mixture of the religious, secular and pagan iconography, together with the point that contemporary icons can be endowed with the same power and status as religious icons, was acutely observed by Carlo Levi in his novel *Christ Stopped at Eboli* (*Cristo si è fermato a Eboli*). Levi lived among peasants of Lucania after he was banished from Rome by Mussolini's regime in 1935 for his anti-Fascist writings.

[W]hat never failed to strike me most of all – and by now I had been in almost every house – were the eyes of the two inseparable guardian angels that looked at me from the wall over the bed. On one side was the black, scowling face, with its large, inhuman eyes, of the Madonna of Viggiano; on the other a coloured print of the sparkling eyes, behind gleaming glasses, and the hearty grin of President Roosevelt. I never saw other pictures or images than these … they seemed the two faces of power that has divided the universe between them. But here their roles were … reversed. The Madonna appeared to be a fierce, pitiless, mysterious, ancient earth goddess, the Saturnian mistress of this world; the President a sort of all-powerful Zeus, the benevolent and smiling master of a higher sphere. Sometimes a third image formed, along with these two, a trinity: a dollar bill, the last of those brought back from across the sea, or one that had come in a letter of a husband or relative, was tacked up under the Madonna or the President, or else between them, like the Holy Ghost or an ambassador from heaven to the world of the dead. (Levi, 1947:120–121)

It is interesting to note the connection between the Madonna icon and Roman paganism, as well as the reference to the 'ancient earth mother', as Levi's 'casual' observations are in accord with the more scholarly investigations of Mathews (1993), Moser (1998) and Warner (1977). As Williamson (2004:14) puts it:

Christian imagery has become part of the fabric of western culture, and has become part of the wider artistic and cultural vocabulary of modern image-makers, not only fine artists, but also film-makers, illustrators, graphic designers, commercial product designers, and those who design and create advertisements, the visual form that accounts for perhaps the greatest percentage of image-making that we see in the modern world.

Biblical Appeal

Biblical imagery is not limited to the visual. In the context of humanitarian emergencies the notion of 'biblical' is adopted as a pictorial metaphor used to describe

the nature of the disaster. As we saw in the preface, Michael Buerk used it to describe the Ethiopian famine of the 1980s in the television report that launched the Band Aid appeal. Of course Buerk's commentary accompanied the broadcast of harrowing images of the famine victims: a strong reminder of the 'third meaning' achieved through word and image juxtapositioning. Although Buerk's use of the term 'biblical' was probably innovatory and audience grabbing in its time, by now it has become a stock phrase. Two decades later, reporting on the Afghan refugee crisis, BBC Television News reporter Matt Frei used the term in two separate news reports as if 'biblical' has now become a quantifiable measure of the scale of the disaster: 'This is a famine of *almost* biblical proportions' (my emphasis).[19]

Not only do biblical themes provide a repertoire, but the contemporary artist can also resort to a wider visual tradition. This can involve deliberate 'staging' by filmmakers, whereby a director such as Stanley Kubrick uses the paintings of Gainsborough and eighteenth-century military prints to provide the period look of the film *Barry Lyndon* (1975). Furthermore, much later in the film, to emphasize the degree of Lyndon's decline and fall, Kubrick adopts a number of Hogarthian images from his series *The Rake's Progress* (Hogarth, 1973): for instance, an initial cutaway shot to an overturned chair. However, perhaps operating on a less intentional level, contemporary photographers may find themselves referring to a subconsciously acquired cultural repertoire of imagery. In these instances we can find images that display similarities in style and content to predecessors from the history of art. Much has been made of this in regard to the photographs of Sebastião Salgado depicting thousands of Brazilian mineworkers: 'Looking at these images, I know what happened several thousand years ago when the Egyptians built the pyramids. I understand what it must have looked like when the Mayas constructed their extraordinary cities. He's brought something biblical to it, he didn't just do a reportage' (Robert Pledge, Contact Press Images/Europe).[20] Pledge's account of Salgado's imagery reveals the repertoire of imagery to which the photographer has resorted. Salgado's photos have been likened to paintings, particularly those of the classical tradition. And this has become a point of controversy. As Susan Sontag (2003:70) puts it, 'their focus is on the powerless, reduced to their powerlessness.' As in the comparison between McCullin's *Mother* and the van der Weyden *Madonna*, there are differences as well as similarities.

In the movies, images of historical scenes do not rely so much on accurate records or representations of the past, but on pictures of the past from relatively contemporary Western culture. For example, in D.W. Griffith's films *Intolerance* (1916) and Cecil B. DeMille's *The Ten Commandments* (1956) and *Cleopatra* (1934), scenes of were often based upon the orientalist paintings of Sir Lawrence Alma-Tadema (1836–1912) (see Ash, 1990). There is a strong tendency within visual representation to first refer to other images than the wider 'world out there'.

This point of view is reminiscent of the Russian Formalist critic Viktor Shklovsky, although the matter of discussion is poetry. He states:

> Many still believe ... that thinking in images ... is the chief characteristic of poetry. ... But we find that images change little; from century to century, from nation to nation, from poet to poet, they flow on without changing.
> [P]oets are much more concerned with arranging images than with creating them. Images are given to poets; the ability to remember them is far more important than the ability to create them. (Shklovsky, 1917:7)

With the benefit of hindsight this may be considered something of an exaggerated viewpoint. But if we apply Shklovsky's view to the feature film and the concept of 'genre', we find that indeed there are repeating and recurring themes in today's cinema (the 'road movie', for example) that, despite changes in technology, have been around since the earliest days of story-telling (Homer's *Odyssey*, for example).

Ofili's Madonna

Despite the Madonna and Child image appearing (perhaps) subconsciously in the minds and aspirations of documentary photographers and picture editors, it remains an image that is consciously produced. For example, we might consider the Turner Prize-winner Chris Ofili's painting *The Holy Virgin Mary* (1996): 'a black Madonna with a clump of elephant dung on one breast and cutouts of genitalia from pornographic magazines in the background' (Vogel, 1999). And, of course, there is the singer Madonna who plays on her pseudonym by making mischievous religious allusions – e.g. the song 'Like a Virgin' – and adapting the medieval mandorla[21] of the Virgin Mary into her personal insignia. While Staallbrass (1999:109) declares Ofili's painting to be 'clearly blasphemous', he finds 'the figure is quite dignified and the elaborate decorative surface of the painting could serve as a homage to its subject.' Whether these images – Ofili's painting and Madonna's adopted persona – are adaptations or transmutations of the existing tradition is difficult to tell. It is possible that they are extending its meaning in a similar manner to Warner's suggestion that the no-longer-popular icon of the breast-feeding Virgin *Maria Lactans* (who has 'become too exalted to suckle her child') yet survives in its contemporary manifestation on the German wine label Liebfraumilch (1977:204). Ofili, of Nigerian descent and who describes himself as a 'churchgoing Catholic', says of his paintings: 'I wanted to bring their beauty and decorativeness together with the ugliness of shit and make them exist in a twilight zone' (quoted in Stallabrass, 1999:109) and Akure Wall (1996:n.p.) likened them to a decadent 1970s Nigerian front room populated by the 'glamorously dressed in every colour and fabric you've ever seen. ... Drinking gin and

laughing at jokes you don't understand.' In this context Ofili's painting might give a contemporary multicultural 'spin' to the religious iconography: a mixture of the scared and profane. We might be reminded that Carlo Levi's 1944 interpretation of the Madonna of Viggiano with her 'black, scowling face, with its large, inhuman eyes' as 'a fierce, pitiless, mysterious, ancient earth goddess, the Saturnian mistress of this world', was not exactly in keeping with religious doctrine.

Ofili's *Virgin* had the power to shock.[22] When it appeared in the show 'Sensation: Young British Artists from the Saatchi Collection' at the Brooklyn Museum, Mayor Rudolph W. Giuliani threatened to cut off the museum's city subsidy 'if the show was not cancelled'. He singled out *The Holy Virgin Mary*, along with several other works, as 'sick stuff' (Vogel, 1999). The matter was settled in court and Giuliani had to back down. While on exhibition, Dennis Heiner, a 72-year-old Christian, threw white paint across Ofili's painting and smeared the paint over the canvas. Ironically this act of iconoclasm brings us full circle to the legend of St Luke's painting the Virgin and Child. As noted above, Cormack suggests that the St Luke legend emerged during a period of iconoclasm. Perhaps the saint's artistic talents were formidable enough to subdue this storm. Ofili's were not! Whether it resulted from shock tactics and/or a desire for commercial exploitation, a similar controversy had arisen from Madonna's 'Like a Prayer' video. The video caused outrage amongst religious groups because Madonna used signs of stigmata (displaying her bleeding hands), she kissed a black statue/saint that came to life, and appeared to have an orgasm on the altar. The cover for the CD on the song prominently displayed the aforementioned mandorla. The video was released just before a Pepsi commercial that featured Madonna and played the music of 'Like a Prayer'. The Vatican condemned it, and the Church urged people to stop buying Pepsi as a protest, after which Pepsi cancelled a sponsorship deal as well as any future broadcasts of the commercial after it had had only two airings.[23]

Upon reflection both Ofili and Madonna may be subscribing to a different, though more recent, tradition: that of popular culture confronting religious sensibilities. In 1966 John Lennon had remarked that the Beatles were 'bigger than Jesus Christ'. This comment also led to outrage from religious groups and in the Southern Bible Belt of the USA, and Beatles records were burned as a result. Less violent protestations took place in 1968 (coincidentally the year of Ofili's birth) when the Beatles released the song 'Lady Madonna', which was clearly about prostitution. However, as we have seen, such icons as the Madonna become transformed and modified to suit different locations and historical periods. For example, the present-day Mexican Day of the Dead has Aztec origins extending back over some three thousand years. It was dedicated to the goddess Mictecacihuatl ('The Lady of the Dead'), though with the dominance of the Roman Catholic Church and through a process of syncretism, the Aztec festival was moved to coincide with the Christian All Saints' Day and All Souls' Day and

Mictecacihuatl became transformed into Saint Death, but remained a female figure. However, much against the wishes of the Church, who saw her as a pagan phenomenon, she also became identified as an aspect of the Virgin Mary.

This chapter has aimed to demonstrate religious origins and influences on contemporary images of refugees. As such they resort to the same iconography which may result in eliciting a similar emotional response in the viewer. However, this relationship is not limited to the contents of refugee images. The next chapter will examine the broader context of images and the narrative patterns in which they function.

–5–

The Representation of Refugees

The journalists have set up at the Polana Hotel, the plushest in town. It has a swimming pool and beautiful views of the sea. They have set up satellite links and all have their cameras. It's ironic, and I feel very uncomfortable, talking about such a huge disaster when we're in the middle of such luxury. The relative comfort we all have in Maputo contrasts with what we see daily in the flood areas. I think about this dilemma – journalists taking up space in helicopters that could be used to save a few more people, yet their cameras are so important in showing the world, to get support for a crisis that needs so much support. But in just a couple of days it has become a real circus.

Kate Horne, Oxfam, 2000

In the preface to this volume, I mentioned Walker Gibson's conception of the 'fictitious reader', described as 'an artifact, controlled, simplified, abstracted out of the chaos of day-to-day sensation' (1950:2). Similarly, Georges Poulet (1972:48) finds: 'I often have the impression, while reading, of simply witnessing an action which at the same time concerns and yet does not concern me.' Although there are very strong links with literature, it seems that this type of experience is not limited to fiction alone. Much of this can be ascribed to technological changes that have helped shape the modern era. For example, Bronson examines the changing relationship between author and audience determined by the printing process. During the Enlightenment, heavily influenced by the philosophical tradition that could be traced to Descartes, a distancing had developed between authors and readers, 'who accept this separation as a primary condition of their creative activity and address their public invisibly through the curtain, opaque and impersonal, of print' (Bronson, 1968:302). In more recent times the emergence of computer technology has resulted in a distancing from warfare, turning it, according to Paul Virilio (1989:70), into a 'detached spectacle' (see also Telotte 1999–2000). The contemporary distancing of the viewer from the action facilitated by optical technologies and the new media appears in stark contrast to battle-watching historically, a 'spectator sport' that was not without its dangers. For example, on the US side of the border during the Mexican Revolution of 1910 'a good many Americans died … most were hurt while gawking at battle scenes from a dangerous perch' (Vanderwood and Samponaro, 1988:130). Although the US Army erected barriers to keep the crowds away from danger, stray bullets still claimed their casualties.[2]

There were suggestions that some spectators may have been targeted deliberately. Notwithstanding, battle-watching was big business. Hotels offered roof-top seating (Martínez, 1983:97) and a thriving postcard industry developed displaying photographs of atrocities as well as pictures of the refugees from the conflict, captioned 'Uncle Sam's Guests' (Vanderwood and Samponaro, 1988:85, 113). Nowadays, thanks to electronic media, our curiosity and desire for entertainment can still be satisfied at someone else's expense, but in safety and armchair comfort. 'War affords the pleasures of the spectacle, with the added thrill that it is real for someone, but not, happily, for the spectator. ... When war becomes a spectator sport, the media becomes the decisive theater of operations' (Ignatieff, 2001:191). One of the problems with 'spectator sports', however, whether this is football, war or humanitarian disaster more generally, is that spectators can easily get bored or feel saturated. In the words of the protagonist in David Lodge's novel *Therapy* (1996:5):

> [I]t's what they call 'compassion fatigue', the idea that we get so much human suffering thrust in our faces every day from the media that we've become sort of numbed, we've used up all our reserves of pity, anger, outrage. ... [S]mudgy b/w pictures of starving black babies with limbs like twigs and heads like old men. ... How is one supposed to stem this tide of human misery?

The main responsibility for bringing these images into our homes lies almost entirely with the focus of media attention. Owing to the increased speed and accessibility of media technology, a 'visual culture' is emerging that relies more and more upon information provided by pictures. The images we see on our television screen play a crucial role in determining how we construct our reality. One of the consequences of our 'digital era' is a considerable reduction in communication through language, in favour of relying on the visual image to tell the story. As Michael Ignatieff (1998:26) puts it: 'The entire script content of the CBS nightly half-hour news would fit on three-quarters of the front page of the *New York Times.*' For journalism, the outcome is a more simplistic treatment of current affairs. Yet when we stop to think about how much of our knowledge of the world is derived from pictures (Heft's *indirect* knowledge, 2001:350–2), we find that there is also very little general understanding about how visual images communicate this information. It is becoming increasingly important not only to analyse the ability of visual images to create new discourses, but also to examine the social and institutional constraints on their function. The power of the visual image has received little attention in research on the media representation of catastrophe, despite the fact that, as Liisa Malkki (1995:9) points out with regard to photographs, 'photographic portrayals of refugees are, in our day, extremely abundant. Most readers have probably seen such photographs, and most of us have a strong visual sense of what "a refugee" looks like.' The visual representation of refugees plays an essential, yet neglected, role in forming the stereotype of 'the refugee', by

focusing on the poor who walk or remain and suffer when war or disaster strikes, rather than the rich who fly out, or the less well-off who drive away. Yet all peoples are potential subjects for the state of forced migration, and refugees remain shadowy figures, transcending the existing sex, race and class stereotypes adopted in visual representation.

However, as we saw in the previous chapter when discussing the Madonna and Child icon, many of the pictures that we see of disasters, and the refugees who flee them, conform to pre-established patterns. And, here again, Christian iconography re-emerges with predictable regularity. For example, in Christian religious painting we find a long tradition in portraying forced migration which can be traced from 'The Expulsion from the Garden of Eden' to 'The Flight into Egypt'; such images have played a central role in the development of Western visual representation. When compared to contemporary images of refugees, there are striking similarities in content and style. Our understanding of humanitarian crises in part may be influenced by these broader cultural traditions. Nonetheless fashions and media have changed. During the last decade or so, a generation that had grown up unused to seeing images of European refugees (other than as historical documents) came to see pictures of starving Africans displaced by the victims of 'ethnic cleansing' in Eastern Europe, and more recently the Western tourists who became victims of the Sumatran Tsunami in 2004.

In an attempt to understand the images of humanitarian disaster and its consequential human migrations, we shall consider some contemporary images of refugees in the press and look for patterns and common elements in their construction and usage. This chapter identifies some historical archetypes that are used to portray the subject of forced migration and elaborates on the suggestion that many 'standard' images of refugees conform to patterns already established in Christian iconography. It suggests that viewers find accord with the images (with which they are already familiar) and that they may evoke a familiar storyline. Having considered the images, we address the narratives into which the images are placed and consider the ways that the refugee story has been structured in fiction film and propose that feature film portrayals can conform to the 'road movie' film genre. The definition of 'genre' is expanded to include 'institutional discourses'. Existing media research on the issue of forced migration has paid scant regard for the visual image. At this point the image's wider context is introduced, followed by outlining some issues arising from recent technological and institutional changes in media practice.

In the series of screenings 'Refugees on Screen' that I convened at University of Oxford's Refugee Studies Centre (2000–2002), I aimed to present to the students a broad spectrum of visual representations of *refugees* spanning news reports, television documentaries and feature films. One of the striking characteristics of the series was that the most harrowing reports of genocide, accompanied by eye-witness interviews (e.g. Steve Bradshaw's *When Good Men Do Nothing*,[2]

which reports on the UN failure to react to the Rwanda genocide of 1994), could have the effect of shocking the students. Nonetheless they would remain relatively detached while contributing rational arguments and insightful observations. However, when fictitious accounts of the refugee experience were screened (e.g. Xavier Koller's *Journey of Hope*) there was hardly a dry eye in the house. The students seemed to become directly and deeply involved in the story, amounting to an intense empathy with the protagonists, their plight and the tragedy as it unfolded. Consequently I felt it important to look at some of the narrative strategies behind such films and at how the visual images of refugees contributed to the effectiveness of the storyline.

'On the Road': Migrants in Fiction Film

the East of my youth and the West of my future.

Jack Kerouac, 1957:20

Kerouac associated his proposed journey across the United States of America with the wild frontier: the early American pioneers and an indulgence in 'dreams of what I'd do in Chicago, in Denver, and then finally in San Fran' (1957:15). His semi-auto-biographical novel *On the Road*, in which Kerouac's 'heroes' travel around the USA in the quest for new and exciting experiences accompanied by a sense of chaos and despair, can be seen as a forerunner to the 'road movie' genre of feature film which gained its ascendancy in the 1960s, for example Dennis Hopper's *Easy Rider* (1969). Although 'on the road' movies are not essentially about refugees, they possess striking similarities in structure to those narratives that have attempted to highlight the issues of migration through the medium of fiction film (examples include Gregory Nava's *El Norte*, 1983; and Stephen Frears' *Dirty Pretty Things*, 2002). In contrast to the documentary film, which (arguably) has an ability to promote social change through highlighting (and raising questions about) a specific problem, the fiction film has some distinct disadvantages. The most obvious is that (by nature) it does not offer the viewer an 'actual' portrayal of 'reality'. No matter how well scenes have been re-created, or how closely based upon a 'true story', we know them to be 'acted out'. In this context, the feature film can afford to draw heavily on symbolism. An example here is Xavier Koller's 1990 film *Journey of Hope* (*Reise der Hoffnung*) in which a family of Turkish farmers sell their possessions with the intention of taking up a new life in Switzerland. On the journey they are exploited by traffickers, they have to negotiate the dangers of crossing the Alps and are finally apprehended by the Swiss police. An early stage of film features a seemingly casual shot of the protagonists heading down the road (to an uncertain future) while a ploughman with horse-drawn plough, placed on the skyline, fulfils a compositional role of enclosing the shot and, at the same time, symbolizing the traditional life of toil and hardship that is to be left behind.

FIGURE 13 Still from *Journey of Hope* (*Reise der Hoffnung*). Xavier Koller (1990).
© Catpics Ltd.

The husband, as the prime motivator for the couple's migration, leads the way
and his wife (somewhat reluctantly) follows. This thematic shot, early on in the
movie, encapsulates the plot acting as a visual summary of 'the story so far'. Of
course the image of the ploughman has its own symbolism and connotations. It can
be seen as representing man's basic relationship with the land, the annual seasonal
cycle that continues throughout time regardless of the rise and fall of empires; as
the honest provision of human necessities, and so on. Not only is the ploughman
a recurring theme in art, featuring in Brueghel's *Landscape with the Fall of Icarus*
(c. 1558); Samuel Palmer's etching *The Early Ploughman* (1861/1868), P.H.
Emerson's photograph *A Stiff Pull* (1888) – but the image of the ploughman in
Journey of Hope, though fleeting, occurs at a key point in the narrative. It is similar
to the appearance of a Madonna and Child in Richard Attenborough's film *Gandhi*
(1982), which also appears on the screen for just a few seconds, but at the pivotal
point between a scene almost totally de-saturated of colour, suggestive of Gandhi's
impressions of the 'real' India, in stark contrast to the next scene of the luxurious
and colourful world of politics and India's upper classes.[3] In both films, therefore,
despite being based upon 'true' episodes from life, filmic conventions depart from
actuality. For example, in *Journey of Hope* there is a scene in which the would-be

migrants meet with a trafficker to hand over the payment for their passage. This is shot convincingly in 'documentary style', but this element of verisimilitude becomes interrupted by music which accompanies his counting the money after the couple have left the room.

The general narrative of *Journey of Hope* is a familiar one. It is reminiscent of the 'road movie' genre. Together with other migrant films – *El Norte*, for example – the plots fit conveniently into this genre. In *El Norte* the journey begins for two young Guatemalan Indians following the politically motivated murder of their parents. They aim to migrate to the USA. On the other side of the border, the brother and sister find that their new reality contrasts strongly with their vision of a promised land. As illegal aliens they are hounded by the immigration authorities and the film results in the tragic consequences of their embarking on the journey. Thus the storylines of *Journey of Hope* and *El Norte* are similar to such cinema classics as *Midnight Cowboy* (1969), *Easy Rider* (1969), *Badlands* (1973) and *Thelma & Louise* (1991). For example, at the beginning of this genre of film we usually witness a dispensing of objects that symbolize the life to be left behind. In *Journey of Hope* the protagonists take the irreversible step of selling their farm animals; in *Badlands* the childhood home is set on fire; and in *Easy Rider* Wyatt and Billy throw away their wrist-watches. Usually two characters set out on an adventure – they meet various good, bad and ugly characters *en route* – a major set-back is resolved and, although their final goal (the end of the journey) is reached (or may be in sight), it is likely all to end in disaster. The end of the journey can be a physical, spiritual or psychological destination or may involve aspects of all three. Without making too much of it, a case could be made for finding biblical precedents in the narrative structure of the 'road movie': the character(s) who contest(s) the authorities is set against accumulating odds, and is finally sacrificed for the cause (of freedom or justice, etc.). The road itself has a special meaning of a physical and metaphorical nature, representing freedom or discovery. The 'road movie' perpetuates the allegorical tradition derived from the 'Journey of Life' that occurs frequently in Christian literature. Looking further back in literature it can feature the theme of 'the quest', for example similar to the narrative of Homer's *Odyssey*. The film structure is that of an episodic journey through which characters can be involved in the process of self-discovery or learning about each other and/or themselves along the way; this can be in the form of a life-changing experience. The 'road movie' has its own rules, iconography and conventions; thus the 'movie migrant' is set on a predestined course from point A to point B. The implications for the narrative are that the end of the journey is finite (and often stated in the early stages of the film) and the drama is acted out sequentially in chronological time. In terms of human psychology, there is usually an underlying theme of self-discovery. Yet, at the same time, the protagonist (usually male) is caught between the two worlds of his past and future. Contrasts are established between home and 'life on the move' – for example in *Journey of Hope*

these are characterised in terms of the growing tensions between the heroine and hero, respectively. The migrant is also cast as the outlaw – wanting to become part of the new culture, yet having to resort to elicit means to attain this goal. The individual (outlaw – as in the Robin Hood legend) set against the power of the state can come to represent freedom. In addition the elements of frontiersmanship in the protagonist's pursuit of a new and better life suggest that the migrant movie has much in common with the genre of the 'Western'. In *Journey of Hope* the protagonists are portrayed possessing both dignity and courage. They engage the viewer's sympathy and understanding.

Nonetheless, there is a central problem in classifying films in 'genres' in that many do not fit quite so neatly into such categories. So one characteristic of the 'road movie', the element of disaster, is (needless to say) shared with the 'disaster movie'. This film sub-genre usually involves a natural or human-made catastrophe against which a cast of (often quite predictable) human 'types' is confronted by their personal weaknesses. Earthquakes, fires or plane crashes have become popular subjects for this kind of movie, which flourished during the 1970s. Indeed, in the post 9-11 era, we are experiencing another flurry of movies and television programmes devoted to mass destruction and human disaster. To an extent *Journey of Hope* conforms to Maurice Yacowar's 'disaster movie' basic type, 'The Ship of Fools': '[T]he dangers of an isolated journey provide the most obviously allegorical disaster films, given the tradition of The Road of Life' (1977:91). Similarly we find that the migrant feature film *The Boy Who Stopped Talking* (*De Jongen Die Niet Meer Praatte*) (1997) shares much with Yacomar's basic 'disaster' type, 'survival': 'A respectable variety of disaster films detail the problems of survival after a disastrous journey' (p.91). This film, set in Holland and eastern Turkey (with Dutch and Kurdish dialogue), follows a boy, Memo, on a journey from his Turkish village to join his father, a dock-worker living in Holland. Seriously disturbed by his up-rooting to an unfamiliar setting, Memo decides to become silent. With the help of a sympathetic teacher and by making friends with a local boy, Memo gradually adapts to his new situation.

Thus far, the essential point about feature film genres is that they restrict the subject to 'types' of narrative, yet each new narrative has the potential to revise the tradition. For example Ridley Scott's film *Thelma & Louise* revised the genres 'road movie', gangster film and 'buddy movie'. The characters Thelma and Louise – in replacing the two male 'buddy' outlaw protagonists (or female/male Bonnie and Clyde) with two women journeying through a male-dominated American West – retained aspects of the anti-heroes' alienation and 'frontiersmanship', yet the film introduced a feminist dimension to a traditionally macho genre through its portrayal of sisterly unity and strength. So genres themselves exist in a state of flux: 'Each new genre film constitutes an addition to an existing generic corpus and involves a selection form the repertoire of generic elements available ... each new genre film tends to extend this repertoire, either by adding a new element or

by transgressing one of the old ones' (Neale, 1990:56). One issue to be addressed concerns the nature of genre – whether that of the feature film, the photograph, the documentary or the television news broadcast. In particular the use of the generic structure together with the ability to expand and change the structure will be examined.

In All the Gin Joints

[W]ithin each period the structure of the myth corresponds to the conceptual needs and self understanding required by the dominant social institutions of that period … .

Will Wright, 1975:14

In general, refugees have been well served by the feature film. Taking as additional examples, two of the most popular films ever made, we find that the well-to-do von Trapp family become refugees at the end of *The Sound of Music* (1965) and almost every central character in *Casablanca* (1942) is (or, during the course of the screenplay, becomes) a refugee. In *Casablanca* the message is very positive. In the prologue the city of Casablanca is introduced as a type of transit camp on 'the torturous, roundabout refugee trail'. Early on in the film as the 'unhappy refugees' (along with other 'usual suspects') are rounded up by the police, a pick-pocket associates them with 'the scum of Europe [that] has gravitated to Casablanca'. But as the plot unfolds, such sentiments are soon left behind. Alongside the Bogart, Bergman, Henreid 'love–triangle', the plot follows a re-kindling of Rick Blaine's (Humphrey Bogart) concern for human rights. From his initial cynical standpoint – 'I stick my neck out for nobody' and 'the problems of the world are not in my department' – we watch him wrestle with his conscience, emotions and moral obligations to take extreme personal risk and loss in aiding the refugees (his rival and former lover: Henreid and Bergman, respectively) to escape to freedom: '[T]hrough-out the picture we see evidence of his humanity, which he does his best to cover up' (Harmetz, 1992:56).

From today's standpoint the *Casablanca* story appears as one of romantic escapism (a characteristic it shares with *The Sound of Music*). Although *The Sound of Music* is based on a 'true story', there is little in *Casablanca* that has a basis in reality. Nonetheless, *Casablanca* is a curious reflection of real life in that many of those involved in the making of the film were European refugees who had escaped from Nazi persecution. Perhaps two of the most relevant examples are, firstly, Robert Aisner, the film's technical adviser, who had actually taken the route described in the film's prologue – 'Paris to Marseilles. Across the Mediterranean to Oran. Then by train or auto or on foot across the rim of Africa to Casablanca in French Morocco', then to Lisbon and America (the intended route of the Bergman and Henreid characters in *Casablanca*) – and, secondly, the 19-year-old actor Helmut Dantine, who plays the part of the young Bulgarian refugee hoping to earn

passage (for himself and his wife) at the roulette wheel. Dantine had served time in a concentration camp for his anti-Nazi activities in Vienna before escaping to the United States.

In conclusion, for the refugee cause, we can put forward three key advantages that the fiction film has over the documentary. First, the A to B structure of the physical journey undertaken by the protagonist(s) means that the viewer gets the whole picture in understanding the cause and effect of migration: the situation left behind; how and why decisions are made to migrate; hardships encountered; coming to terms with a new location; and so on. In contrast, the documentary, and more so the news item, tends to deal with either foreign stories or home stories, often failing to point out the connection between the two. Second, the familiar narrative of the road movie is one that we are used to seeing being played out by people of our own culture, so the viewer is more easily able to identify with the plight of the refugee through their previous knowledge of the story's structure. And thirdly, it is the business of a fiction film to persuade the audience to identify with the protagonist(s). Whether this involves our 'seeing' the points of view of the central character or of a number of characters, our 'sticking with' the plot demands a certain degree of spectator identification. After all, this power to engage the viewer is the movie-maker's business and that of 'story-tellers' in general. The literary critic Walker Gibson (1950:1) takes this to something of a melodramatic extreme: 'We assume, for the sake of experience, that set of attitudes and qualities which the language asks us to assume ... and, if we cannot assume then, we throw the book away.' Insofar as this might involve the viewer in sharing the decision-making and understanding the world from the refugee's perspective, it is likely to generate a degree of empathy that is seldom present in attempts to provide a factual rendition.

Television Images

[T]elevision has become the privileged medium through which moral relations between strangers are mediated in the modern world. Yet the effects of televisual images and the rules and conventions of electronic news-gathering on such moral relations are rarely examined.

Michael Ignatieff, 1998:10

In his essay 'Is Nothing Sacred? The Ethics of Television', Michael Ignatieff addresses two polarized views of television images. On the one hand he considers them as voyeuristic; on the other, they are seen as promoting the 'internationalization of conscience'. He proposes that images cannot assert, they can only instantiate something if the viewer is already predisposed in the form of a moral obligation – this obligation has Christian roots. If we return to the notion that refugee images have their roots in Christian iconography, this might suggest that

our moral obligation is something of a triggered response. In contrast, members of 'other' cultures that are not based upon Christian principles may also feel themselves to be under moral obligations. At least we may consider the iconography of the visual image in the West as belonging to a wider set of moral codes and conventions. This is a matter to be addressed.

Another point made by Ignatieff is that he regards television news as a genre, the over-dominance of genre of which in 'the flow of television news reduces all the world's horror to identical commodities'. In contrast, he recognizes the virtues of television documentaries which 'sometimes achieve the prerequisite of moral vision itself; they force the spectator to see, to shed the carapace of cliché and to encounter alien worlds in all their mystery and complexity' (p.32). As we saw in the discussion of the feature film migration 'road movie', the standardization of plot and narrative makes it relatively easy to see the story conforming to a prescribed narrative or pattern. But news, which is primarily concerned with presenting facts with little recourse to a storyline, at first sight may appear to sit uncomfortably under the description of a 'genre'. It is no accident, however, that we often refer to news 'stories': 'News is a genre as much as fiction or drama: it is a regime of visual authority, a coercive organization of images according to a stopwatch' (Ignatieff, 1998:26). Ignatieff suggests that the genre of television news is determined by the structure and contents of the news. However, a closer look at the use of the term may offer a different insight, proposing that it is not a simple matter of form and contents but also one of audience expectation. Steve Neale (1990:46) differs somewhat here, arguing that genre does not simply refer to film 'type', nor is it limited to spectator expectation and hypothesis, but is the product of *institutional discourses*: production, marketing and consumption. While the news is subject to types of story – home, foreign, human interest, etc. – it is strictly controlled by time constraints. Primarily a visual medium (e.g. captured in the saying 'no pictures, no story', which has been attributed to the Labour Party key spin-doctor Alastair Campbell), it is packed into 15-, 30- or 60-minute time-slots with fierce competition among stories not only to get into, but also to stay in and move up, the running order. At the same time, without being exactly xenophobic, a type of myopia abounds – characterized by an emphasis on the immediate local significance of stories. It seems that we, as readers and viewers, are prepared to accept such reporting even though it runs contrary to our 'instincts': '[W]e may feel there is something morally dubious about a greater concern for a fellow *New Yorker* than for someone facing an equally hopeless and barren life in the slums of Manila or Dakar' (Rorty, 1989:191).

Some analysis of the television news 'genre' with regard to the subject of migration has been conducted by Greg Philo and Liza Beattie of the Glasgow Media Group. The approach they use in their study of 'Race, Migration and Media' (1999), that of *thematic analysis*, aims to provide a 'detailed examination of the language and visuals of a series of news reports' (p.180) of the major TV channels

'and a study of other textual and visual images in press reports'. The news is divided into its constituent elements: 'headlines, interview questions, reported statements and key visual moments'. However, despite the promise of a 'detailed examination of the language and *visuals*', 'a study of other textual and *visual images* in press reports', as well as 'key *visual moments*' (my emphases), there is minimal reference to visual images. The study remains very thorough, but extremely logo-centric. For instance, pictures are cited only twice. The first occasion is when 'the BBC had a report including images of labourers on a farm in Spain, growing courgettes and presumably contributing to the local economy' (p.191); the second: 'The news ... included visuals of Asians entering the UK' (p.195). Granted Philo and Beattie do analyse the dialogue that accompanies the images, but the nature, structure, exact content and appearance of the visuals are left to the reader's imagination. We may assume that they are referring to Marash's 'TV Codes' (see chapter 4). The use of such footage, often 'stock-shots' (also known as 'library pictures'), has its precedents in the history of art (see Gombrich, 1960:121). However, for Philo and Beattie the issue becomes rather confused by their use of the term 'image' to describe the spoken or written 'metaphor'. For example, their analysis of the use of the metaphor 'flood' to describe the potential arrival of immigrants in news reports: 'The frequent repetition of images such as this constructs a very specific view of the migration process. It is presented in the terminology of a natural disaster, in persistent reported statements which go unchallenged by journalists' (p.183).

Moeller (1999) also indicates the inherent problems of generalization and formulaic language that accompanies images and metaphors. By contrast, she refers to the economy of the visual images and metaphorical expressions (which 'can more succinctly describe a face or a moment in time than can paragraphs of narrative', p.47). Moreover, she makes a clear distinction between 'image' and 'metaphor': 'Words may give meaning, but in our visual era, images are essential to effective communication – especially in the telling of the news. Images have authority over the imagination' (p.47)

In another paper by members of the Glasgow Media Group, 'The Media and Africa: Images of Disaster and Rebellion' (Beattie *et al.*, 1999), which examines the press and television coverage of the Rwanda/Zaïre crisis of 1996/1997, the term 'dominant image of Africa' is loosely referred to (p.233). Although the claim is made that the 'language and visuals of these news reports create a vivid and pervasive image of Africa' (p.233), at best, visual sequences are described but not analysed. For example, a television report is accompanied by 'an image of the emaciated frame of a young child, lying on the ground where he has collapsed from exhaustion or disease with his aid biscuits lying on the ground beside him, just beyond his outstretched hand. An older child stops, looks down and walks past' (p.238). Here there is no attempt to consider how the visual image and the narration work together to contribute to the report, or how the film sequence has

been composed. Similarly, in their analysis of the tabloid press, the authors describe the launch of an appeal by *The Mirror*: ' "Please Save Me" read the headline under a photo taking up most of the front page of a refugee child captioned "the frightened eyes of a child beg for help"' (p.255). Granted there may exist a sentiment that this may be more acceptable in the printed press, where photographs might be considered to have a more simple illustrative function, but certainly this should not be the case with television. Television is primarily a visual medium and much of its meaning is to be gained from the 'language' of the visual image. For the study of television news the balance between 'textual' and 'visual' analysis needs to be re-examined.

The Broader Picture

> Within minutes he was totally lost, as the programme – a love story, he surmised – elided confusingly with the commercials every two minutes, it seemed. ... Eventually he saw the credits roll and he knew that it was over, whatever it had been.
>
> William Boyd, 1984:116

The context of the image is another matter that can seemingly go unnoticed. And the extended definition of genre takes into account the broader picture (beyond the immediate newspaper setting). For example, on 11 April 2000 *The Mirror* newspaper employed 'shock tactics' in order to drive home a significant point by challenging its readers. The paper displayed a front-page photograph of a starving African baby accompanied by the headline 'Go On, Look Away'. However, while this attention-grabbing headline may have fulfilled the function of dramatically confronting a complacent Western public with an African tragedy, the same issue's colour supplement completely undermined this message. It featured a fashion shoot with a glamorous European model dressed in expensive clothes posing amongst the huts and inhabitants of an African village. It appeared that the paper's overall editorial control had not picked up on such stark contradictory messages.

The semiotician Roland Barthes (1977:15) describes the press photograph as a 'message'. Yet it is not one that is self-contained; it is integrally bound into the 'source of emission', 'the channel of transmission' and 'point of reception'. In order to understand the mechanisms determining the 'photographic message', we must also take into account the 'staff of the newspaper': the group of technicians who choose, compose and treat (title and caption) the image. The newspaper's readership is the 'point of reception' – the public who read the paper, who have different expectations of their chosen publication and a different regard for the same photograph in different papers. In our reading of *The Daily Telegraph,* for example, our perception of the photograph will be influenced by our prior knowledge. In common parlance, people often refer to themselves as 'a *Telegraph* reader' or 'a *Guardian* reader', not only suggesting a preconceived allegiance to

the paper but also anticipating certain expectations to be fulfilled during reading. The whole institution of the newspaper operates as a vehicle of communication, transmitting a series of 'lateral' messages which contribute to the understanding of any photograph that may appear in it. In addition the circumstances in which the image appears may also direct the spectator towards meaning. In the wider context, this means that if a photograph appears on an advertisement hoarding, newspaper, gallery wall or family album, the viewer's response may be predetermined, as certain expectations will be required to be fulfilled.

The recent changes in media institutions and working practices have been brought about by the increased speed and availability of media technologies (Neuman, 1996). One consequence is an emerging 'visual culture' that places a new emphasis on the communicative power of visual images. Another is a demand for more simplistic presentation of news items. At the same time, there has been a global increase in the number of displaced persons, while the foreign stories in the media have been subjected to budgetary cut-backs. Together, these factors focus special attention on the ways in which the image of the refugee is constructed through media representation, and create the need to address the reception of these images. In this context not only is the relationship of the image to the text or spoken word paramount, but also the wider editorial and institutional constraints on reporting incidents of forced migration, as well as the wider social and political agendas (W.C. Adams, 1986; Chang and Lee, 1992). This raises questions regarding the social function of refugee images and whether, through the process of categorization, they act as a way of coping with a social 'problem' to provide a sense of absolution of responsibility, or to stimulate empathy and to motivate a public response (Dyck and Coldevin, 1992; Benthall, 1993).

The Next Cave

[T]he inclusion among 'us' of the family in the next cave, then of the tribe across the river, then of the tribal confederation across the mountains, then of the unbelievers across the seas (and, perhaps last of all, of the menials who, all this time have been doing our dirty work). This is a process we should try to keep going. We should stay on the lookout for marginalized people – people whom we still instinctively think of a 'they' rather than 'us'. We should try to notice our similarities with them.

Richard Rorty, 1989:196

Media representations predominate in determining how we see refugees. While there is a marked tendency to categorize them as human types, the selective nature of the visual image frequently objectifies them, dismissing their historical, cultural and political circumstances. The media representation of refugees has received little direct attention. Within the area of refugee studies, media-related issues have been discussed (Gibney, 1999), but no comprehensive study has yet been

undertaken. The most closely related work has dealt with media representations of war (Neuman, 1996; Minear *et al.*, 1996; Allen and Seaton, 1999), while others have examined the media response to more general human catastrophes and disasters (Sanger *et al.*, 1991; Benthall, 1993; Moeller, 1999). Others have considered ethical issues in media representation (e.g. Winston, 1988). In addition other related areas of study on representations of culture and ethnicity have taken place within visual anthropology (e.g. Alexander, 1998; M. Banks and Morphy, 1997; Lutz and Collins, 1993; Marcus, 1995) and media and journalism studies (e.g. Shaheen, 1988; Skovmand and Schrøder, 1992; Hawk, 1992; Gillespie, 1995; Hess, 1996).

The purpose of this chapter has been to provide the foundations for research into the specific problem of the media representation of refugees. Yet in doing so, it has made some general observations on the nature of representation by means of visual images. Although it may be the intention of journalists (using the term in the broadest sense to include editors, camera operators, etc.) to provide 'realistic' images which offer a transparent view – a window on the world – they are constrained in their having to conform to cultural and institutional practices. This should be taken to include not only the long and rich tradition of making visual images – and here I proposed an 'iconography of predicament' which draws upon images derived from the Christian iconographic tradition – but also the 'invisible' political and social constraints on the media. While media representation may result in objectifying 'the refugee' in the role of the 'illegal alien', the feature film image of the refugee as protagonist presents a role that is immediately recognizable to the audience, and one that has a high potential of gaining their sympathy. In this context the whole story is played through from cause to effect. The 'A to B' structure of the 'road movie' genre means that we see the conditions that initiate the migration, the hardships of the road and what is to be found at the journey's end. As such road movies contrast with documentary films (and news footage), where the whole story either remains set in a remote location, or begins when at the refugee's final destination. In future, this point will be examined in detail. In the meantime I propose that this reflects the ways Western society deals with the issue of migration not only from the media perspective but also from the point of view of government and the aid agencies themselves. While this may in part be a product of the media division between 'home news' and 'foreign news', im the UK it mirrors the government's ways of dealing with refugee (as opposed to asylum seeker) issues – the Foreign Office and the Home Office, respectively. It also appears that the many NGOs deal either with crises abroad or with 'home-based' crises in the UK.

A central problem of the feature film is that it is a work of fiction and as such does not have the power of conviction of the news report or documentary. In addition, the genre can result in simplistic portrayals – easily identified heroes and villains (e.g. the trafficker in *Journey of Hope*). On the positive side, the notion of

genre does not suggest that representations remain fixed; rather, they can be modified by subsequent representations. Finally, any complete account of the media representation of refugees must include factors that exist beyond the immediate setting of the visual image. The wider context of the image must be taken into account, which includes accompanying stories, adverts, and so on.

–6–

Collateral Coverage

The only difference between Hollywood and reality is Hollywood has a happy ending, and there's a hero.

Robert Baer,[1] CIA Case Officer for Afghanistan, 1976–1997

The literary term *in medias res* refers to instances where the story begins in the middle of events or a narrative. The term first appears in Horace's *Ars Poetica* of 65–68 BC (Horace, 1929). Directly translated from the Latin it means 'into the midst of things'. It is a narrative device that is regularly used in the cinema, whereby 'a picture may begin with a … sequence of dramatized action designed to hook audience interest' (Swain and Swain, 1988:46).[2] Similarly, with the news stories that followed the World Trade Center attacks, circumstances dictated that as television viewers we were thrown 'into the midst of things'. The story started with a strong action scene that immediately engaged the audience's interest, and before long the attention had shifted from New York to Afghanistan. It was then that the Afghan refugees, who had been at the periphery, found themselves in the midst of things, occupying a position at the centre of the world's stage:

> Overnight, Afghanistan became the focus of global attention. But there was a dreadful irony at work; for years the impoverished state deep in the heart of Central Asia had been the center of the world's largest humanitarian crisis. But the international community, disillusioned with a seemingly insoluble problem in a region, which had once hosted 'The Great Game' between imperial superpowers, had increasingly chosen to ignore it. (Wilkinson, 2001:6)

Consequently, I suggest that the media coverage of the Afghan refugee crisis was 'collateral' to the World Trade Center attacks of September 11, 2001. The coverage of the Afghan refugees was not exactly accidental, nor was it intentional. The refugees were caught, as it were, on the sidelines of the World Trade Center story. It was a humanitarian crisis that had existed for years, yet attracted only minimal coverage. However post-9/11, the refugees became important players in a sub-plot of the lead world story that traced the US reaction to World Trade Center attacks. The events that followed rendered their plight impossible to ignore. This is not to say that before September 11 the media had disregarded the crisis, but during an

interim period – after the dust had settled and before the onset of military action (the bombing of Afghanistan began on Sunday, 7 October) – media attention turned to Afghan refugees. However, as military action increased (towards the end of October), they faded from the news:

> DARREN JORDAN (BBC TV Studio): Fergal, do you think with the start of the ground offensive ... or the start of the war, the spotlight's been taken off the refugees and the refugee crisis – in a way?
> FERGAL KEANE (Quetta): That's war. I've never covered a war yet where the rights of refugees or the human beings who are not combatants are the thing at the top of anybody's agenda – that's not how it works. Military priorities will take priority for the moment. It is afterwards we will only be able to assess the full scale of the damage done to human beings who had no actual part in this.[3]

In this chapter we shall look at the images and construction of some of the 'three-minute special reports' shown on BBC Television News during the year 2001: the year in which the nature of disaster took a new and unexpected turn with the terrorist attacks on the World Trade Center in New York. Examples from other television channels, for instance satellite television's Euronews, are also discussed for purposes of comparison and contrast. BBC News was chosen for two reasons. First, as Britain's public service broadcast station, a particular sense of responsibility is expected in reporting world news. As such one would expect it to be less constrained by commercial factors than the independent sector. Second, it appears that UK television audiences maintain confidence and a loyalty to BBC News. This is evident in Deans' analysis of the audience ratings for the coverage of the World Trade Center attacks on September 11, 2001. He concludes: 'Overall, the old adage that people turn to the BBC in times of crisis was borne out, with BBC1 taking a 33.3% audience share across all hours yesterday – up from 26.4% last Tuesday' (Deans, 2001).

Over the past fifteen years we have experienced an increased emphasis on the significance of the visual image in the news media (T. Wright, 2001, 2002); this trend was particularly noticeable in the coverage of the World Trade Center attacks. This tragic disaster produced an extensive range of visual imagery (M.W. Davies, 2001–2002).[4] On September 11 the extraordinary drama, witnessed by millions on live television, was followed over the next few days by pictures of heroism, which then gave way to atmospheric, almost contemplative, images. When interviewed about their movements, thoughts and actions on September 11, those involved in the media coverage of the World Trade Center attacks for British independent television placed special emphasis on the nature of the visual imagery (Brown, 2001):

> I knew it was a massive story, involving a landmark building, with dramatic pictures, and it was happening in the most TV-friendly city in the world. We were on air and I

was in a taxi going back to the office when the second tower was hit. We went all through with news to 7 p.m. ... concentrating on the pictures. ... All the adverts were dropped. We went for the footage, rather than analysis. On the day we wanted people to see what was happening – it was not the time for Middle East politics, or trying to take the story forward: let the BBC do the discussions. (Steve Anderson, Controller, News and Current Affairs, ITV network)

We are used to Hollywood disaster movies, but this has been far worse, for real. You never thought you'd see a plane slam into a building, or keep seeing the image played from so many different angles. (Trevor McDonald, Independent Television News (ITN) presenter)

The subsequent coverage of the Afghan refugee crisis was not only exceptional, but also contingent upon the World Trade Center. Nonetheless, as news items the two tragedies hardly bear comparison. Refugee crises rarely reach a dramatic climax, and the media treat them more like an insidious encroachment (hence the well-worn adjective 'flood' is used to describe growing numbers of refugees[5]). Nor do they produce action-packed pictures; as images they are more similar to religious paintings (T. Wright, 2002). In April 1999, a report on the Kosovan refugee crisis in the UK's daily newspaper *The Independent* made explicit this analogy. Accompanying a front-page 'Exodus'-style photograph of a landscape peopled by a colourful mass, headlined 'Like an Oil Painting of Hell', part of the copy read:

Through the river mist at dawn it looked like an oil painting of hell, with the added dimensions of smell and sound. The colours came from the clothing of the densely packed human flotsam that filled the wide valley as far as the eye could see. ... As the rising sun of Good Friday started to reveal this awesome panorama, the image of Golgotha, the hill at Calvary, came easily to mind. (Dalrymple, 1999)

An evaluation of a terrorist attack, on the one hand, and a refugee crisis, on the other, produces more contrasts than comparisons. For example, in his article 'Shaking the Foundations', BBC TV News presenter and reporter George Alagiah compares the television coverage of the World Trade Center with his experiences in Somalia and Rwanda.

[O]n September 11th ... the attacks happened so quickly and ... virtually everything was witnessed live on television around the world. In Somalia and Rwanda the question of whether we would see the suffering millions hung on the decisions of news editors – to send TV crews or not. The deaths in Africa took place in the shadows, behind the convenient sanctity of national borders; in America they happened under the full and penetrating gaze of the TV cameras. (Alagiah, 2001:38)

It could be argued that the World Trade Center received greater media attention because it occurred in the world's media capital: the city that occupies the central

focus of America's attention, if not the entire Western world's. Two years before the attacks, Moeller (1999:22) not only expressed succinctly the US attitude to world news, but she did so with an uncanny degree of foresight: 'One dead fireman in Brooklyn is worth five English bobbies, who are worth 50 Arabs, who are worth 500 Africans.'[6] In order to place a contemporary global perspective on Moeller's observation, and while not wishing to minimize the human tragedies involved, whereas up to a million lives were lost in the Rwandan genocide of 1994, 343 New York fire fighters lost their lives as a result of the World Trade Center attacks. These relative news values are common feature of television news. There is an inverse relationship between numbers and distance. To gain news coverage, not only are larger numbers of victims required as we move further away from home, but the sensitivity in representing the plight of others diminishes as the geographical and cultural distances increase. For instance, the wide debate regarding the publication of images of the World Trade Center dead did not take place over the coverage of the Rwandan genocide.

Apart from emphasizing the pre-eminence of the visual image in the reporting of the World Trade Center, Steve Anderson's audacious decision to go 'all through with news to 7 p.m. ... concentrating on the pictures. ... All the adverts were dropped' (see above) points to one of the main dilemmas in the news reporting of disasters: the financial cost. For the commercial channels dropping the adverts means loss of revenue.[7] Even so, there may be a dramatic increase in viewing figures. Seen by 9.4 million viewers, the BBC1 News at 6.00 p.m. on September 11 experienced double the figures of the previous evening. The two main terrestrial channels (BBC1 and ITV) had an audience share of 16 million – over 70 per cent of all UK television viewers (Deans, 2001). On the other hand, editorial budgets had to be expanded to cope with a demand for news that called for UK reporters to be posted over the coming days and weeks to the United States, Afghanistan, Pakistan, Israel and a variety of European countries. Foreign news is expensive, and this is set against a background where recent years have witnessed an overall decline in foreign stories on television.[8] Notwithstanding this, it has been reported that covering the aftermath of the World Trade Center attacks cost BBC News £1 million a week. In November 2001, Greg Dyke, the BBC's Director General, set aside an extra £10 million to cover the subsequent Iraq war (Hodgson, 2001), while ITN (UK's Independent Television News) was spending an extra $125,000 a week. For the independents, the financial burden was made all the heavier by a general reduction in advertising revenue before September 11 in addition to further cut-backs by advertisers after that date. As for the US media, according to Wall Street sources, for the period from September 11 to the end of October 2001, the networks had overspent by $100 million (B. Anderson, 2001).

'Numbing Down': Reporting Disasters

> As for the Western countries that had once been so interested in Afghanistan's fate
> when the Russian invaders were there, they preferred to forget all about it now.
> Afghanistan was no longer a Cold War battleground, so it had ceased to matter. It was
> left entirely on its own.
>
> John Simpson, 2001:108

Like many Third World countries, Afghanistan appears in the British media only
as an adjunct to British/US concerns except when the scale of a disaster is so great
that it is impossible to ignore. The current Afghan refugee crisis can be traced back
to 1978 when the communist regime, which had recently come to power, intro-
duced land reforms that resulted in destabilizing the rural population. The next
year saw the Russian invasion: an attempt to prop up the communist government.
By 1981 there were 1.5 million refugees; by 1986, 5 million (Ruiz and Emery,
2001). If invasions and political upheavals were not enough, Afghanistan had seen
more than its share of natural disasters.[9] For example, on 11 February 1999, an
earthquake measuring 5.8 on the Richter scale hit the village of Shaikhabad, south
of Kabul. The casualties were relatively light: seventy people were killed; many
left their homes having experienced a tremor that preceded the main quake. Yet
30,000 were left homeless. The year before, another earthquake (6.9 on the Richter
scale) occurred in the north-east of the country on 30 May (only three months after
a 6.1 earthquake had hit the same region killing 4,000 people). There, 45,000 were
made homeless. The inhospitable terrain and the poor infrastructure of the moun-
tainous regions compound such problems. It should be added that these factors do
not make the country particularly attractive to journalists and news crews and they
add to the cost of media coverage.[10] This helps to explain the low priority given by
the media to the natural disasters there. Even the CIA, who had been especially
attentive during the period of the Russian occupation, appeared to have lost
interest in Afghanistan after the Soviet pull-out and prior to the events of
September 11, 2001:

'. . . we don't care about Afghanistan.'

The answer was that blunt. That's the kind of culture you're dealing with.

'Afghanistan is a basket case. We don't care about it, it's not coming here, it's not a
problem, we're not going to spend resources or put any time into it.' (Robert Baer,
former CIA Case Officer, interviewed in Pollack 2002)

In contrast to politically motivated disasters, natural disasters are subject to dif-
ferent priorities. The relevance to Western concerns is not so important. Rather, the
question is: will it make 'good television'? In chapter 4 I made reference to the

disparity between the reporting of the Orissa cyclone and the Mozambique floods and how this was reflected in the aid donated to the two catastrophes. Naturally, there are geographical reasons for the media's selectivity. Such factors as availability of access and communications contribute to the decision-making process as to whether a disaster is covered or not (Sanger *et al.*, 1991). In this specific case, the unequal coverage can be put down to the fact that it was relatively easy for journalists to get to Mozambique and news crews experienced less of a time difference than they would in India. This widened the possibilities for live broadcasts to coincide with the prime-time news slots of the European media. Also, in the Mozambique region, there are not only better facilities and access to media technology, but also the availability of more comfortable hotels as well as R & R pursuits for off-duty news crews. In yet another location, Carruthers (2000:225) not only indicates the logistical and organizational obstacles that confronted the journalists covering the Rwandan crisis of 1994, but quotes one member of the press who felt the place to be out of the way and 'boring'. Despite these considerations and the 'creature comfort' attractions (or lack of them), Isobel Eaton (2001) believes it was the power of the visual images that were the overriding factor in determining that the Mozambique floods rather than the Orissa cyclone made it onto our TV screens. Yet even when a disaster does reach our screens, the reaction may be muted. In essence, the repetitious use of TV codes and the reporting of disasters according to predetermined formulae have a numbing effect on the audience. If Marash's theory is correct, despite the audience ratings, they may still be watching, but mentally they have switched off. In the coverage of developing world disasters, it is not only the stereotypical nature of the imagery that has a numbing effect of the audience, but also the repetitious narratives in which the images are placed.

'Wallpaper' Refugees

In viewing the Afghan crisis, 'TV codes' are evident. For example, during an interview on BBC Breakfast Television (28 September 2001) with Clare Short (the UK's International Development Secretary), the visuals cut to non-specific footage of refugees at the Pakistan border. Without introduction, sundry displaced people wandering around in the middle distance appeared on screen.[11] Later in the programme the technique was used again during another live interview, this time with Ron Redmond of the UN High Commission for Refugees in Geneva. The interview visuals cut to two women in burkas, followed by a shot of a group of refugees, two close-ups of children and finally a crowd shot from above. The purpose of cutting to this imagery during the interview's broadcast was most likely to have been illustrative: providing images of the emerging humanitarian crisis. Yet the relation of the image to the commentary was arbitrary. In fact one wonders

whether Redmond was even aware of the images broadcast to accompany his responses to questions. The 'non-specific' imagery comprising a variety of 'TV codes' is usually referred to as a *compilation sequence*. According to the Swains (1988:46), while 'a picture may begin with a ... sequence of dramatized action designed to hook audience interest' (the *in media res* narrative device), would-be scriptwriters are advised to 'follow it with a compilation sequence which introduces the film's topic and emphasizes its scope ... go to a second compilation sequence which establishes the broad outlines of a particular locale ... move on to a continuity sequence which pinpoints a bit of dramatic action in that locale ... and so on'. In feature-film circles, the *compilation sequence* is also known a *newsreel sequence*. Individual shots are edited together bearing no relation to the following action. More concerned with topic than with continuity, they are often used to refer to disasters, though not exclusively: 'Often you'll see it in coverage of a flood, a tornado, a travelogue, a tour of a factory, or the like' (Swain and Swain, 1988:46). One of the problems in running this imagery during studio interviews is that the connection between sound and image is unplanned so it introduces a random factor as to the meaning of the images that become associated with (what is in effect) an *ad hoc* voice-over commentary. If, as media theorists suggest, the viewer makes the mental connection between sound and image, the 'third meaning' created in the mind of the viewer becomes subject to what the interviewee just happens to say. In addition, the use of this formulaic imagery to represent extraordinary events has the end result of reducing humanitarian and environmental disasters to a kind of 'visual wallpaper'. The images just happen to be there, possibly to provide some relief from 'talking heads', but with no specific intention.

The television news technique of talking over the visuals is becoming increasingly common. For example, on Sky News (8 October 2001), while an 'in-studio' discussion was taking place, we saw images of a war-torn Kabul. A man carrying a bundle was shown walking along a road with ruined buildings in the background. This image was accompanied by the headline 'Afghans are fleeing Kabul after military strikes'. There was some discussion about the cause of the damage shown on screen and when the images were taken. The scene changed to Peshawar in Pakistan and the discussion turned to Pakistan's political role in the conflict. We saw protesting crowds. The police moved in, the crowd was on the run, tear gas was used and people panicked. Meanwhile the discussants made a brief reference to rioting and continued to talk about the overall political situation. The scene reverted back to Kabul, this time at night. We saw anti-aircraft fire, a man operating a pump, an outdoor kitchen, and a man leading a donkey cart. The possibility of shooting down cruise missiles was discussed and the Western journalists still operating in Kabul were listed. At the mention of the missing British journalist Yvonne Ridley, the visuals cut to images of a war-torn Kabul. A man carrying a bundle was walking along a road with ruined buildings in the background and we realized we were in a film loop. The only difference being we had a new headline

'Taliban hold emergency cabinet meeting on crisis'. The whole Kabul in daylight sequence was shown again and then we were back in Peshawar. Although we saw the same images, the re-fashioning of the headline had changed the picture of the man carrying the bundle from a refugee image to an image that acted as a back-drop illustration for Kabul, as the location of the Taliban government. Apart from this and the few direct references to the images, there was a sense of the gratuitous use of video footage, leaving the impression of images for images' sake.[12] On the same Sky News broadcast, some ten minutes later, the man with the bundle made a further appearance. This time it was in the context of a live report from Keith Graves in Washington, USA. The subject of the report was Washington's reaction to events in Pakistan. The man appeared yet again, eighteen minutes later, to illus-trate a studio interview on the subject of the effects of the bombing on Afghanistan and speculation as to whether Osama bin Laden was still alive.

The visuals featured a number of stereotypical refugee images: for example, the man with the bundle of possessions heading along the road, passing ruined build-ings (to an uncertain future); and the 'Flight into Egypt'-style image of the man leading a donkey cart. In addition, there were media stereotypes of Islam: angry faces and clenched fists (other images have included veiled women and turbaned sheikhs – symbolizing religious rigidity). Such stereotypes are discussed by Hafez (1999) and Said (1981).[13] Apart from the refugee riot at the Pakistan border, which in any case did not feature the above ingredients,[14] the stereotype of Islamic anger has not been used in the media representations of Afghan refugees. Expressions of anger or forcefulness are not commensurate with the image of 'the victim'. While stereotypes can provide a shorthand frame of reference to indicate a particular group, they can limit understanding to a fixed set of concepts. Needless to say, this is state of affairs commonly exploited in fiction film:

> Arab terrorists, okay, the movie proceeds, whereas if you have a worked out a story simply about a murder or love triangle or revenge, well you've got to know something about the people and invest some time in knowing what makes them tick. This is easy. They've got a turban, we don't need to know what's going on under that turban, just proceed with the story. (Steve de Souza,[15] interviewed in Pollack 2002)

For the news reporter, a way of overcoming such limitations is to interview indi-viduals. However, this raises the problem of ascertaining who is typical or repre-sentative of the general state of affairs. As noted by Siegfried Kracauer (1960:99): '[I]t is precisely the task of portraying wide areas of actual reality, social or other-wise, which calls for "typage" – the recourse to people who are part and parcel of that reality and can be considered typical of it.'[16] The 'wallpaper' refugee images we have seen attempt to provide a general representation that does not allow the viewer to get close enough to the individual behind them. To some extent this changes with special news reports, where we are introduced to individuals as

representatives of the general situation, though they still remain constrained by the three-minute narrative framework.

The reports tend to follow a standard narrative pattern and closely conform to Bill Nichols' analysis of television news in his chapter 'The Documentary Film and Principles of Exposition' (1981:170–207). Nichols uses the CBS evening news as his example. For the purposes of this study we might consider the role of the anchor person – a familiar reliable public figure who can 'command belief and thereby gain credibility' (Nichols, 1981:174). The news is also constructed as a thirty-minute dramatization (T. Wright, 2002) and the anchor person signs-off at the end of the news with resignation and reassurance about states of affairs in the world. For the viewer the actual event is reached via anchor to reporter to inter-viewee to the event itself in the form of a two- or three-minute story. The anchor provides a brief synopsis of the story and turns to the reporter to substantiate (by means of an on-the-spot demonstration) that which has just been stated, and support for this is sought from the interviewee(s). When we cut to the location, we find that the reporter is often situated in front of one or more of Marash's TV codes. In refugee crises we often see the reporter in the foreground, facing square-on to the camera, in front of a crowd of people. Having done the main 'piece to camera', the reporter will angle him/herself to the interviewee, who (unlike the anchor or the reporter) is never allowed a square-on address to the camera. The interviewee's words must be directed towards the reporter, who deflects them to the camera/viewer. The reporter acts as our guide: following a long literary tradition, which depends upon a guide who escorts the traveller through strange lands, inhabited by strange beings. The guide is usually a marginal figure with a foot in both camps, maintaining a safe distance between observers and observed: a pivotal figure, who has a place in 'our world', yet also displays familiarity with the world we are visiting. This has been used to good effect in Sorios Samura's documentary *Exodus* (2000, part of his Channel 4 *Africa* series), where, as a refugee himself, he takes us back to West Africa and on to Europe following the refugee trail he had taken years earlier. In the case of many foreign stories the viewers' familiarity with the reporter is considered to be so important that household names are 'para-chuted' into the disaster area. One could say that the number and calibre of these correspondents provide a good indication of the disaster's magnitude. Stephen Hess (somewhat cynically) describes the parachutists as 'reporters of no fixed address whose expertise was in dropping in on people trying to slaughter each other. This was an economical way of news gathering and one guaranteed to make the world appear more dangerous than it is' (1996:4). However, it would be fair to say that not all of the 'parachuting' special correspondents could be described as generalists. Some, like the BBC's Feargal Keane and Matt Frei, for example, have made humanitarian disasters their 'speciality'.

What's in a Story?

A story describes a sequence of actions and experiences done or undergone by a certain number of people, whether real or imaginary. These people are presented either in situations that change or as reacting to such change. In turn, these changes reveal hidden aspects of the situation and the people involved, and engender a new predicament which calls for thought, action, or both. This response to the new situation leads the story toward its conclusion.

Paul Ricoeur, 1984:150[17]

According to Isobel Eaton (2001), television news stories of natural disasters follow a predictable pattern:

Day 1. Disaster strikes – description of the destruction, numbers of dead and injured. Appeals for international help.

Day 2. Search and rescue, hopefully involving a child/old person being plucked from the rubble by relief workers.

Day 3. The Western aid effort is underway – pictures of planes loading up at British air bases. May also include something about the corruption/inefficiency of the government in the country concerned.

Day 4. The threat of hunger and disease.

Day 5. The final miraculous human interest story – someone rescued after days in the rubble, a baby born in a tree, etc.

She adds: 'Once this familiar narrative has been played out, there is nothing new to report' (p.29). This narrative pattern seems to have been applied to the World Trade Center attacks – which is one reason why (after the post-rescue discussions and speculation had died down) the focus shifted to the Afghan refugees.

The writer and critic Gustav Freytag (1908) devised the notion of the pyramid to illustrate the five-act structural basis of dramaturgy. It is a pattern of storytelling that can be found from the plays of Shakespeare to the *Star Wars* movies. Eaton's five days of news coverage conforms closely (if not exactly) to Freytag's scheme of things. In the typical five-act play we find each act falls respectively under the categories of Exposition, Development, Climax, Resolution, Dénouement.

Briefly, the *Exposition* establishes equilibrium in the state of affairs of the drama that is about to unfold. The *Development* disrupts the equilibrium, gives the story a direction and sets the narrative in motion to reach its *Climax*. The *Resolution* provides the action to bring about the narrative's conclusion in the *Dénouement*, where the plot is unravelled and a new state of equilibrium is achieved, sometimes accompanied by the hint of a new beginning. At this point we might recall

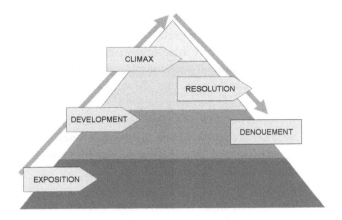

<small>F</small>IGURE 14 Freytag's 'triangle'

Ignatieff's notion of the genre of the news story where, he states: 'News is a genre as much as fiction or drama' (Ignatieff, 1998:26).

In one of BBC Television News broadcasts from Afghanistan, Matt Frei's report of 17 February 2001 shows clear evidence of the five-act structure:[18]

- *Exposition*. Frei introduces the subject, establishes the location and the general state of affairs. That the reporter is flying over Afghanistan in a UN plane enables him literally to give an overview of the situation. He comments on the hostile environment as we see him looking out of the window onto the desolate landscape.
- *Development*. The story is given its initial momentum and is set off in a direction. He indicates what we can't see from the air, which cues a ground shot of the refugee camp, where we see figures partly obscured by clouds of dust. We are given details of the crisis, with close-up and medium-shots of refugees. We are introduced to the problem of the distribution of blankets, together with an expression of the refugees' frustration.
- *Climax*. Then follows a catalogue of 'case-study' disasters, each time stepping up the scale of the crisis with a growing number of voices. Firstly, the refugee Sirijillin shows us his son's grave. He explains that the lack of blankets was responsible for the death. Secondly, we are shown 7-month-old motherless child Marjula. And finally we meet the Muhammad family, who have just lost two children and a third is dying. We are reminded that nightfall is looming, temperatures will drop, there is overcrowding in the available shelter and that more people are arriving. The building-up of more and more people echoes the narrative reaching its climax.
- *Resolution*. Two ways of solving the situation are proposed: one in the form of intention, the other through action. A Taliban representative tells us that the

crisis is so bad that he is prepared to break the regime's strict rule on visual images, and will talk to the camera to alert people to the suffering. Then we see sacks of food aid being moved by three Afghan men.

● *Dénouement.* The unravelling of the plot takes place in Frei's final piece to camera, where he points to the irony that UN sanctions have contributed to the crisis, while UN agencies are providing the aid.[19] As we are left contemplating this dilemma, the report cuts to a shot of the setting sun. This not only indicates nightfall (we have already been told that this is when temperatures drop), but also symbolizes the passage of time, leaving the viewer to ponder what state of affairs will be revealed when the sun reappears.

In a second report by Frei, on 20 November 2001 (i.e. this side of September 11), the basic format remains the same, though there are changes in content.[20] As US bombing had commenced, the Taliban are no longer treated as reluctant informants, but more as if a strange tribe. The reporter's privileged eyewitness view remains. Curiously, though, instead of the reporter looking down onto the location form a plane window, the exposition features the Taliban peeping over a wall 'cut off from the outside world' and climbing trees 'to get a better look' at the film crew, who 'were such a novelty'. The Development, while reminding us of our privileged view, takes us to the Sheikh Rashid refugee camp, 'out of sight until today'. As with the report of 17 February, the piece reaches its Climax by way of three 'case-studies' in ascending order of tragedy: Muhammad, who 'can barely walk'; Abdul Mallik, who 'can't find a doctor to cure his 1-year old daughter'; and bin Muhammad, who 'can't feed his two babies' and who suffers from crippled hands. Worse still, 'the doctors who were treating him also fled the bombing'. The resolution offers us a general view of the camp, panning to a 'piece to camera'. We are offered two possible causes for the thousands of Afghans internally displaced: the American bombing and (during two cutaway shots) the drought. The Dénouement brings us back to the role of the Taliban, with a low-angle shot (that increases the stature) of a soldier, who 'have dreadfully misruled this country; but removing them from power' – cut to a medium shot of another soldier with wind-strewn refugees in the middle distance – 'also has its price'. On this final shot/dilemma, the reporter signs off. Although the structure of this post-9/11 report follows the same pattern as the one filed pre-9/11, there is a subtle 'mirror-ing' of the contents. For example, in the first report it is Matt Frei in the plane who has the advantage of the heightened viewpoint. In the second it is the Taliban who are shown looking down onto the film crew. And it is the film crew who are 'penned in', contrasting with the restricted movements of the refugees in the earlier report. Similarly, on the subject of the status of the filmmaking process, the friendly Taliban man, who was prepared to break his code of conduct to speak to the camera, is replaced by a shadowy figure carrying a Kalashnikov adorned with confiscated audiotape.

In yet another of Frei's reports (28 September 2001), the narrative structure remains. In this case we might consider the context in which the report is framed. Following an in-studio item on the post-World Trade Center investigation, the focus shifts by means of a circuitous route to the Afghan refugees:

> A delegation of religious leaders from Pakistan have said the Taliban regime had no intention of handing over the terrorist suspect Osama bin Laden. They've been meeting Taliban officials in the Afghan city of Kandahar in a last-ditch attempt by the clerics to strike a compromise deal. Also in Afghanistan the Taliban authorities say they've arrested a British journalist in Jalalabad. Yvonne Ridley, who works for the *Sunday Express*, has been accused of entering the country illegally. Over the border the Pakistan government has warned that the refugee crisis caused by millions of people trying to flee Afghanistan could become one of the most miserable chapters in human history. One of the worst-affected areas is Quetta, where our correspondent Matt Frei sent us this report … .

This shows how a refugee crisis is framed within Western concerns. The connections made to the US and Britain through the general narrative almost act as justifications for the refugee story. The World Trade Center investigation leads us to Afghanistan (via Pakistan), where the suspected perpetrator may be found. And with a brief glance towards Britain in the context of the arrested journalist, we are taken to the refugee crisis. The actual report focuses on the Hazara, an ethnic and religious minority in Afghanistan. While their current plight is covered, there is no mention of the prejudice they have suffered from the majority population. Originally from Mongolia, they had settled in Afghanistan around AD 1300. As a disparate group, they have been despised by other Afghans and are often forced to take menial occupations. Not only have they suffered because they belong to the Shi'a Muslim sect (in contrast to the Sunni majority), but their facial characteristics set them apart as targets for discrimination. This type of information might make viewers more aware of the diversity of an Afghan population that cannot be so easily stereotyped. As for the shots themselves, the camera is surprisingly static. In this report there are four pans (two across, two down) and one zoom, but most of the shots amount to a series of stills, as if in a 'slide show' sequence displaying minimal movement of the subjects. The content and composition of the images provide the types of information that contribute to the standard narrative pattern. For example, a long shot to establish the location supports the Exposition, close-ups for the individual case-studies build up to the Climax, and the zoom shot accompanied by the commentary " . . help is on its way. The West is keen to show that it can care for Muslim refugees and destroy terrorism" rounds off the Dénouement. There are ten portraits – one old man, the rest women and children. Children usually receive one special mention in news reports and then are shown in the context of narratives covering more general issues. It is not directly stated,

but implied that children in particular will be affected by the current state of affairs. The statutory 'piece to camera' draws the narrative to its conclusion and acts as an authentification device giving authority to the reporter as witness to events – as if to say 'I am really here!'

It could be argued that this is the way that all news reports are structured. However, it is this style of news reporting structure that serves refugees poorly. In contrast to other minority groups, refugees (especially when on the move or recently displaced) are unable to provide a media-skilled authentic voice to put forward their case. Granted, in the news reports, refugees are 'interviewed', or are invited to make statements to camera, but in these *vox pop* interviews, they can speak about their own personal experience, but are unable to provide a refugee voice that commands a view on the overall picture or the broader political situation. They have to rely upon the media skills of members of the aid agencies, which places the refugees in a child-like state, seemingly unable to stand up for themselves.

'No Comment': Alternative Approaches to the News Story Narrative

Marash points out that on occasions extraordinary events can leave the reporter unable to abide by the conventions of television news. Here he cites a report from Rwanda. 'The crowd of refugees was too vast for the eye, much less the camera, to comprehend. Their terror, stench, *need*, could not be seen.' As the reporters used words to describe their experience of the crisis, 'they communicated it better than pictures could, in part because the lack of pictures said, "Listen closely"' (Marash, 1995:9). From the refugees' point of view, it is a matter not only of attracting media coverage to your crisis, but also of hoping the style of reporting makes people sit up and listen. Perhaps it was the image/voice-over combination in reporting the Ethiopian famine that generated the public response – for example, Michael Buerk's use of the adjective 'biblical' to describe the scene.[21]

In contrast to the mainstream television news format, the Euronews satellite television channel provides a 24-hour news-stream in six languages. The immediate noticeable difference is that it features neither anchor person nor visible reporter, only a constant stream of pictures and interviews accompanied by anonymous voice-overs, which provide translations when appropriate. This allows the same visual material to be shown throughout Europe without incurring additional front-of-camera costs, yet placing a heavy reliance on the continuity of images and visual narrative. This is most evident in its 'No Comment' section: two minutes of news from around the world with no commentary accompanying the pictures shown. 'No Comment – Images speak for themselves: the most striking pictures from around the world, unedited, with original sound: draw your own conclusion' (Euronews, 2001). One of these broadcasts, on 26 November 2001, showed

refugees in an observational documentary style with little contextualization. The editing style is non-intrusive; we see people engaged in everyday activities such as bread-making, talking, undertaking household duties, and so on. We over-hear people in conversation, but their words remain untranslated. As such it offers a different perspective to the 'standard' news story. Although it is evident that a process of editorial decision-making has taken place, 'No Comment' has a sense of being less mediated than the usual presentation of the news. Nonetheless, the lack of commentary and contextualization should not be taken to imply that the footage has neither narrative nor context – there is a strong visual narrative underlying the piece. While the refugee 'No Comment' has a beginning, middle and end, it has no Climax. There is an Exposition: the opening pans and zooms from a wide-shot of a desolate landscape to buildings on the horizon. A shot of a sign indicates the location, 'Welcome to New Shamshatoo Camp'. There follows a series of compilation sequences (without obvious rationale for their sequencing). In contrast to the BBC special reports, the camera is very active: it pans round the refugee camp, zooms in to close-ups on individuals and follows their passage through the camp. The piece concludes with a figure walking into the sunset, which can be identified as the Dénouement as the image conforms to the refugee stereotype of heading towards an uncertain future (T. Wright, 2002). As with the first of Matt Frei's Afghanistan reports, discussed above, this may be designed to leave the viewer to question what the future holds for the refugees.

Summary

Elsewhere alternative strategies have been adopted for the portrayal of refugees. For example, in Norwegian artist Andrea Lange's *Refugee Talks* (1998), filmed in an Oslo reception centre, Middle Eastern refugees were asked to sing to the camera.

> The power of the piece rested not in our understanding of the meaning of the songs that were being performed, but in registering the profound contrast between the tonalities of the voice and the tawdry texture of the sofas on which the refugees sit, the beckoning turns of their hands and the fading surfaces of the walls behind them, the generosity of spirit that is so evident in the eyes of asylum seekers and the meanness of the rooms in which they were confined. (Paperstergiadis, 2001–2002:85)

But only a limited, specialized audience receives the experimental presentations of such 'artworks'. In returning to the broadcast media, which reach a far wider audience, the Channel 4 documentaries *Exodus* (see above) and *Refugee Tales* (both screened in 2000) possessed the most striking features that they enabled refugees to speak for themselves, without the mediation of a third party, and showed both the causes and the effects of forced migration.[22] However, in fairness to the news

reporters, these programmes enjoyed the benefit of a documentary format that enables a far more comprehensive account of a refugee crisis, not limited to the severe time constraints of news. The three-minute news slot operates more like an advertisement for the crisis and primarily is concerned with grabbing the audience's attention and getting a simple point across in the given time-frame. Another approach that stands out is that of *Newsround*, BBC 1's children's news. As it is produced for children (and is often about children), the coverage of Afghan refugee children achieves an innovative reporting style. It appears (in this context) as if the BBC reporters and producers are giving careful thought to both content and narrative strategy, in a serious attempt to make news reports interesting and engaging, instead of merely reproducing the tried and tested formulae used in news reports for the adult audience.

The central issues discussed in this chapter – the iconography of disaster and consequential forced migration, and the television news narratives in which those images appear – are not limited to the portrayal of refugees. Rather, they are symptomatic of the ways the media presents the world to its viewing public. However, in the coverage of refugees, these issues become particularly inflated.[23] An additional problem with these discrete news reports is that they rarely have the scope to extend beyond the immediate issue, and logistically the wider implications cannot be addressed. For example, the viewer is left to connect the internally displaced in Afghanistan to the refugee story of the Norwegian ship *Tampa* (Housden, 2001) or to the Sangatte refugee camp, near the Channel Tunnel.

There are three main constituent factors that contribute to the likelihood of effective media coverage of a particular refugee crisis. Firstly, in order to attract Western press coverage it is necessary for the crisis to be of such a magnitude that it cannot be ignored; or it is necessary for it to have some obvious connection with Western concerns. Second, the story will gain airtime if the nature of the crisis is such that it produces dramatic imagery – pictures with impact. Thirdly, if the style of the media coverage is sufficiently innovative it will stimulate interest in the viewers.

The television news format does not serve refugees well. The very fact that they are displaced often means that they are not able to supply authentic expert voices with first-hand experience in addition to an overall perspective of the situation. This limits the news reporting of the refugee experience to anecdotal accounts – the expert knowledge is usually provided by representatives of the aid agencies. The voice of the refugee remains at the end of a chain of 'framings': contextualized by the anchor person, reporter, NGO representative and (perhaps) translator. As for the future coverage of the Afghan refugee crisis, the media have a central role to play in the efforts to rebuild the country and to achieve political stability. For Afghanistan, the tasks involved include: disarmament, establishing peace and security; providing food, healthcare and education for the population; reviving the economy; repairing the infrastructure; establishing an independent judiciary;

creating a new political environment; and so on. Such activities do not necessarily make 'good television'; nonetheless, the need remains to maintain the interest of the Western world. As Afghanistan moves from receiving short-term relief to building up long-term development, it would benefit the country in future if the Western public were to remain informed, thus concentrating the minds of politicians to retain their interest. In addition, positive coverage of the country may help win back members of the Afghan diaspora, whose professional skills are needed to aid the process of rebuilding. This case-study of the Afghan refugee emergency of 2001 demonstrates that each humanitarian crisis has its unique characteristics and context. It has become clear that despite the catalogue of disasters faced by the Afghan people since the Soviet invasion of 1978, which received minimal media coverage, it took the events of September 11, 2001 to bring their plight to world attention. Despite the individual features of such emergencies, however, the news media 'packages' the unfolding of events to conform to standard formulae. It often takes the experimental approach of artists to break away from such conventions to provide alternative in-depth 'portrayals' of human experience – but then the output of such work can hardly be described as *mass* media. However (on a more optimistic note), we might speculate that such experimental approaches, together with the potential for interactive narratives afforded by the new media technologies (T. Wright, 2003), might provide wider, deeper, multi-dimensional understandings of humanitarian disasters.

−7−

'To Boldly Go'
Digital Media and Interactive Narratives

It is not hard to imagine that every documentarist will shortly (that is, in the next fifty years) have to hand, in the form of a desktop personal video-image-manipulating computer, the wherewithal for complete fakery. What can or will be left of the relationship between image and reality?

Brian Winston, 1995:6

The assimilation of digital imagery into existing practices of visual representation has shifted the emphasis away from the notion of 'traditional' media – photography, painting, drawing, etc. – to a broader consideration of systems of representation. These are characterized by the range of picture-making systems, together with their integration into the particular social and cognitive roles that are found in visual representations functioning in 'other' cultures and different historical periods. In this context, as a linear perspective projecting machine, the camera offers a relatively limited range of projection systems for transcribing three-dimensional space. Rather than limiting photography's ability to record a 'truthful' image, computer manipulation has the potential to broaden the repertoire of the photographic system and to enrich photography's scope and ability to describe the visual world. The dichotomy of photographic 'truth or lies' does not arise: photographs have always been subject to mis-representations – or 'infelicities', as ex-newspaper editor Harold Evans (1978:227) rather coyly has described them. Elsewhere (T. Wright, 2004:83) I proposed that as photographs provide only a more or less 'rough description' , the dichotomy 'truth or lies' is inappropriate. Along with other historical documents, some 'are more reliable, less overtly mediated than others' (Jordanova, 2006:92).

In practice, the introduction of digital manipulation to photography, rather than creating a rupture from existing practices in visual representation – e.g. bringing about the 'death of photography' (Robins, 1995:29) – has led to a more gradual shift of emphasis. This is most clear if digital photography is considered in the broader framework of visual representation. Indeed digital imagery only appears to have brought about the 'radical and permanent displacement of photography' (Mitchell, 1992:19) from the relatively limited viewpoint of an evolutionary

approach to the history of art and a developmental view of culture. The alternative position, taking a wider global overview of the generation of visual imagery, would mean that digital manipulation would not be limited to occupying a disruptive position in the trajectory of Western art. I intend to show that the broader perspective that encompasses 'world art' points to computer-manipulated photography achieving a greater potential through its integration into – rather than its opposition to – to existing visual practices: a gradual incorporation, rather than the heralded revolution in image-making. Alongside other issues concerning the impact of technology on traditional cultural practices, technological change in visual representation is not only inseparable from economic, social and environmental issues, but also results in 'visual syncretism'. In such cases visual representation can be viewed, not as static, but as adaptive systems responding to changes that occur in the fields of technology and existing representational practices. For example, we can consider the work of Judith Gutman (1982) on Indian photography: which entails the compression of space and unique forms of composition; and that of Stephen Sprague (1978:59), which has aimed to show how certain African photographs are 'coded in Yoruba', containing information 'about their cultural values and their view of the world'. In his study of the images emanating from photographic studios in West Africa, Sprague finds that Yoruban traditional cultural values have become integrated into photographic practice and that in some instances photographs have been incorporated into traditional rituals. Although the Western style of studio portrait may predominate in the cities, a particular conventionalized style has emerged in rural areas. Shortly after the invention of photography, the use of the medium spread rapidly, travelling along the established colonial lines of communication. Daguerreotypists were active in Egypt three months after Daguerre had announced his invention to the French Chamber of Deputies in 1839. A year later studios sprang up in South and East Africa, and by the end of the century, accompanying British expansion into Nigeria, photographers had become well established in West Africa. By the 1930s, there is evidence of the profession transferring to a number of indigenous photographers, which appears to have paralleled the practice of using photographs instead of wooden sculptures in rituals. Diedrich Westermann (1939:102), for instance, reports that one Yoruban chief 'thought he could hand on his image more beautifully by means of an enlarged photograph than by a wooden statue'.

Sprague (1978:53) found that the Yoruban photographers of the 1970s could be called upon to photograph almost anything, though there were cultural restrictions: 'ritual objects, masquerades, and ceremonies that some segments of the public are traditionally prohibited from viewing'. While this is one influence on the particular photographic style, what is most important in his findings is that the com-position of Yoruban formal portraits 'embodies ... not only certain traditional cultural values, but also their aesthetic values' – particularly those of Yoruban sculpture (p.54). So the photographs would not just be used to stand in for sculptures, they

would also be expected to take on sculptural attributes. The 'statuesque' poses adopted for the Yoruban 'traditional formal portrait' are partly based upon the traditional manner of sitting at formal occasions – wearing formal dress and sitting square-on to the camera, the legs set apart to display the fall of the fabric of the garments. As in the Victorian studio portrait, objects signifying status are included in the photograph, though naturally these objects are specific to Yoruban culture. A slightly upward reverential camera angle is chosen and the subject is photographed full-frame against a fairly neutral background, giving a minimal indication of pictorial depth: 'The face has a dignified but distant expression as the eyes look directly at and through the camera … the figure gives a feeling of sculptural massiveness and solidarity, and the whole pose is one of symmetry and balance.' (Sprague, 1978:54) This concept of symmetry can be found in Robert Thompson's (1971:374–81) analysis of Yoruban sculpture. He discusses the notion of *jijora*: a mid-way point between individual likeness and complete abstraction. The sculpture should resemble the subject, yet possess ideal characteristics. Another mid-way point is to be found in depicting the subject between infancy and old age. There is also the concept of *ifarahon*, which, in the formal pictorial sense, demands clearly defined form and line. In the representational sense, it is taken to imply clarity of identity. Sprague continues to examine applications of the formal photograph, as memorials to the deceased in the Lagos *Daily Times*. He finds that those whose accomplishments are related to traditional Nigerian values appear in the traditional Yoruban formal style, whereas those who accomplishments identify with the contemporary Nigeria are more casual in Western dress.

A more contemporary perspective on West African photography, tjis time specifically of and by women, has been taken by Hudita Nura Mustafa. She questions the approaches of such authors as Jonathan Crary (1992) and Abigail Solomon-Godeau (1991). In her study of studio portraits taken in Dakar, Senegal, Mustafa finds they resist simplistic classification. While Crary (1992), taking his cue from Foucault, shows how European visual apparatuses (such as the photographic camera) 'emerged from the new disciplinary forms of power that reshaped the relationship between the subject's body and society' (Mustafa, 2002:189) and were used to dominate the 'other', Mustafa finds that 'Dakarois photographs are masks and gifts, archive and fetish, conformity and recuperation' (p.172). This is not to deny that the colonial photography of the past had been used to subjugate the African, but now African women use the medium actively to establish identity and to position themselves. 'Displacing the indexical body of ethnic types, they play with the body surface to weave truth and masking as self-mastery. Portraits position ordinary women as *civilité* enacted through the body' (p.183). Mustafa goes on to suggest that such uses of photography have assisted the move away from colonial legacies. As such it becomes a more exciting and dynamic medium, not simply reflecting the political climate but as a site for renegotiation and reassessment.

Digital Photography

In the field of art criticism, since the 1900s, the artist's expressionist agenda has been supplanted by formalist and structuralist theory which has increased the potential to locate any particular visual image within a general field of relational systems. According to the Russian formalist critics (Lemon and Reiss, 1965), images in poetry have never really changed; what has changed is the form of the poem. And if we are to apply this view to photography, we might suggest that despite technical innovations in photographic equipment and materials, the subject matter of photographs (and that of pictorial representation in general) has changed relatively little. We always have relied on (and continue to rely on) the camera to produce portraits, landscapes, images of war, and so on (see Eastlake, 1857:442). Nonetheless, the style of these images has changed over the years, and the photographer's approach to subject matter has shifted with the tide of social and cultural change, as well as with the introduction of technical innovation.

Photography's latest technical development has been the introduction of digital imagery. The manipulation of the visual array of the photograph that the 'new technology' affords has broken down the distinction between 'mechanical' representation and that brought about by 'human agency'. The *photographic* and the *chirographic* – to use psychologist James Gibson's (1979:272) term – become blurred. There is no longer a clear separation of the image 'captured' by the camera from the 'progressive trace' (J. Gibson, 1979:272) drawn by the hand. In addition, for the present and the immediate future, we find ourselves in a situation where most viewers are likely to be unfamiliar with the procedures involved in processing of digital photographs. So Alfred Gell's (1992:50) proposal that the photographer gains prestige only when 'the nature of his photographs is such as to make one start to have difficulties conceptualizing the process which made them achievable with the familiar apparatus of photography' will not necessarily hold true for digital photography. For the moment, at least, the spectator's attitude to the digital image is likely to remain indeterminate or undefined. Rather than considering 'pure' digital photography in contrast to 'pure' analogue photography, the most interesting area of innovation currently is where the two practices converge. In taking a retrospective view of technical innovation in photography, we can see that it is rarely the case that a new process has immediately supplanted another. A process is introduced (or marketed) and taken up by a few individuals who see the potential and are prepared to take the risk. There can then follow a rapid expansion characterized by everyone 'jumping on the bandwagon' followed by a very gradual tailing off, which may have been caused by the introduction of the next innovation. This process of technological change and innovation has been illustrated by Kubler's notion of the 'battle-ship-shaped' curves (Kubler, 1962), which describe how one social phenomenon runs concurrently with, and then takes over from, another.

It has been suggested that the digital image's most radical departure from photography as we knew it lies in the rejection of the negative, yet the retention of extensive reproduction. In the case of photographs taken with digital cameras, there is no 'original' image and all subsequent copies (unless deliberately altered) will be identical to the first.

> Scholars can often trace back through a family tree of editions or manuscripts to recover an original, a definitive version, but the lineage of an image file is usually untraceable, and there may be no way to determine whether it is a freshly captured, unmanipulated record or a mutation of a mutation that has passed through many unknown hands. (Mitchell, 1992:50)

Nonetheless, even in the case of non-digital works, the question of the 'original' art object is not uncontested, as Richard Wollheim (1968:22) demonstrates. He questions whether the original artwork is the production of an opera, say, or – in the case of a novel – James Joyce's manuscript. He goes on to question how much we can change the production before it ceases to be the same opera or the 'original' idea. Or should we assume that we base our judgement on the initial concept of the writer? Wollheim points out that in literature, music and the performing arts reference to the 'original' version is not significant. It is only in the visual arts that the loss of the original (e.g. the physical commodity of Leonardo da Vinci's *Mona Lisa*) results in a 'lost work'. So, similarly, the lack of an original in digital imagery may result in a shift of emphasis from the art object to the art concept, focusing attention on the underlying principles of creating the visual image as well as its social and cognitive functions.

There is a need to address the importance of cultural differences in media representations, in particular the variety of approaches to the psychology and anthropology of visual communication that have occurred over the past fifty years. Traditionally, in the psychology of visual perception, studies have been polarized between unproblematic realism and conventionalism, neither of these directly addressing the scope and limitations of visual representation. Similarly, anthropological studies, seeing visual representation as having little relevance to 'social facts', took theoretical approaches to visual images, which were identified with those of material culture. These studies became restricted by diffusionist assumptions to dwelling on issues of post-production cataloguing. At the same time, the institutions and practices of the fine arts have categorized and marginalized the aesthetic schemes of 'other' cultures as 'Ethnic Arts' or 'Primitive Art' (see Hiller, 1991). However influential they have proved for Western artists, they are frequently regarded as the product of basic craft skills and as 'primitive' in nature; critical evaluation in this area might be described as having been limited to 'Primitive Formalism'. Since the 1960s, however, not only have indigenous art forms attained new importance and self-consciousness for minority groups, but

also, with the widening of access to the media, cultural traditions, styles and influences are becoming increasingly significant (Graburn, 1976).

Future Images

In an episode of the television series *Star Trek: The Next Generation*,[1] the crew of the starship USS *Enterprise-D* encounter an alien race called 'The Children of Tama' with whom linguistic communication seems to be impossible. Although the starship's 'universal translator' is working perfectly in correctly translating Tamarian into English,[2] the statements made by the Tamarians still do not appear to make sense. It eventually transpires that the Tamarians were speaking entirely through metaphors drawn from their mythology and history. It is only through making retrospective reference to these cultural traditions that they are able to express their feelings and describe events. As deduced by *Enterprise* crew member Data: 'Their ability to abstract is highly unusual. They seem to communicate through narrative imagery by reference to the individuals and places which appear in their mytho-historical accounts.' Data continues: 'The situation is analogous to understanding the grammar of a language but none of the vocabulary.' So when the Tamarian captain Dathon repeats the phrase 'Darmok and Jalad at Tanagra', he is referring to the Tamarian myth in which Darmok, a hunter on planet Shantil III, fought a beast on the island of Tanagra with another hunter named Jalad. In Tamarian the phrase describes an attempt by two people to understand each other by sharing a common experience. Consequently Dathan's utterance of the phrase to the *Enterprise* commander Jean-Luc Picard is, in a sense, a form of greeting that recognizes their attempts to establish some common ground. Data concludes: 'It is necessary for us to learn the narratives from which the Tamarians are drawing these images.' Meanwhile, back on the planet's surface, through his exchange of phrases with Dathon, Picard is beginning to work out the language system. Resorting to Earth mythology he finds common threads with the story of Gilgamesh and Enkidu. This provides the bridge for understanding from 'Darmok and Jalad at Tanagra' to 'Gilgamesh and Enkidu at Uruk'. As the *Enterprise*'s counsellor, Deanna Troi, suggests: 'It's as if I were to say to you "Juliet. On her balcony."' The ship's chief medical officer, Beverly Crusher, recognizes this as an image of romance and adds: 'If I didn't know who Juliet was or what she was doing on that balcony, the image alone wouldn't mean anything.'

There are a number of reasons for citing this storyline from a television science fiction series. In once sense it illustrates the role of popular culture ('the comic book, the docudrama, and ... the novel') in seeing others as 'one of us', as suggested by Rorty (1989:xvi, also quoted on page 79 of this volume). Rorty contends that this is not the role for theory, but it is 'a matter for detailed description of what unfamiliar people are like and a redescription of what we ourselves are like'. Not

only does *Star Trek* (as does the film *The Matrix*) introduce some basic philosophical issues to a broad audience, but the character Jean-Luc Picard solves his dilemma of lack of cross-cultural communication by resorting to one of humanity's earliest myths.[3] As such it amounts to a re-description through establishing a fundamental base-line for commonly held experience. Thus the structure of the myth has three manifestations: the fictional Tamarian myth of 'Darmok and Jalad', the historical myth of 'Gilgamesh and Enkidu', and the *Star Trek* storyline of 'Picard and Dathan'. For present purposes the storyline has the virtue of emphasizing how misunderstanding or incomprehension of an image can arise if the context is not known. At this point we might refer back to Herskovits' Bush woman encountering a photograph where she may not have been fully informed of the context of the experiment, hence displaying puzzlement (see chapter 2, page 41). However, as viewers of *Star Trek*, we are placed in the position of observing the starship crew solve the puzzle with which they have been presented.

Riddles with language and mythology are not limited to television science fiction. Medieval Icelandic literature employs *kennings*. The term, which is based on the Old Norse *kenna* – to know or perceive – implies the necessity for prior knowledge; often a knowledge of the mythology involved.

> Meiti is the name of a sea-god ... [t]he waves on the sea are like hills and slopes on land; therefore called 'Meiti's slopes' (*Meita hliíðir*). ...

> Sometimes kennings may be based on an illusion to a single event in mythological or heroic legend. Óðinn once hanged himself, and so he is not only the god of the hanged, but he is himself the 'gallows load' (*galga farmr*). (Turville-Petre, 1953:29)

The form of this type of metaphorical synonym can become quite complex where (hawk's land flame (*hauka fróns leygr*) means 'gold'. The hawk's land refers to the arm (derived the hawk resting on the arm of a falconer). And the term 'fire of the arm' was a common term for the glittering of a gold bracelet (not too dissimilar from the English term for 'camel' as ship of the desert). In this way, according to Gabriel Turville-Petre, 'the great variation provided by myth, legend, and language enables skilful poets to avoid the stereotyped, and to endow scenes which would be otherwise trite and dull with a vivid brilliance' (p.31). In some cases 'the artistry is in the picture created by the kenning, and not in the meaning which it gives' (p.31). Similarly, though perhaps less poetic, the newspaper headline on Thursday, 14 September 2005 in *The Daily Star* declaring 'Oval the Moon!' at face value could be understood as announcing an astronomical observation. However, with the appropriate cultural knowledge the headline refers to the England cricket team winning the 'ashes' at 'The Oval' cricket ground in South London.[4] This has been combined with the popular sporting metaphor 'over the moon', an expression of extreme joy derived from an English nursery rhyme which contains the line 'The

cow jumped over the moon'.[5] Normally, as we saw in the *Star Trek* story, a metaphor is an abstract reference; however, *The Daily Star* has made a further, more substantial cultural reference, pointing out that its headline makes reference to the last time that England won the trophy in 1969 (despite this being factually incorrect!), the same year that Neil Armstrong walked on the moon. However, apart from illustrating the necessity for a deep cultural understanding to make sense of poetry and newspaper headlines alike, the early Icelandic literature, as known today, was recorded by Christian scribes of the twelfth century, but its roots are in the oral tradition. Kennings and riddles would have been spoken as poetry and in storytelling. Not only would they have depended on the audience having the knowledge necessary for the understanding, but also they would be engaged in a process of interaction with the speaker. This was 'shut off by manuscript and print writing and reintroduced into written messages by the electronic medium, together with other features of oral communication: features such as real-time (synchronous) exchange, spontaneity of expression, and volatility of inscription' (Ryan, 2001:204).

Thus far, all this is very literary. When we address visual images, however, we find common threads in terms of the knowledge that the viewer needs to bring to the picture.[6] For example, in *The Anglo-Irish Hot Potato* by Peter Brookes, the image operates at a number of levels and employs a range of means to achieve this. Firstly, we have an image that has a map-like layout of the British Isles and, at the same time, an *iconic* likeness to the former British Prime Minister, Margaret Thatcher. Ireland is represented as a flaming potato with which the Prime Minister juggles. This implies something of a cruel joke considering Ireland's traditional dependence on the potato crop. The understanding of these significances, as well as a familiarity with the term 'hot potato' (often used in the context of politics to suggest a difficult, controversial or awkward situation), depends upon our pre-possession of certain cultural and historical knowledge. Thatcher's own position with regard to the subject is suggested by the fact that she is running towards the problem and away from it from at the same time (this has the fortunate consequence of enabling the artist to depict Cornwall and Kent as her respective feet). We might further speculate, in line with many of the criticisms that the Thatcher era had created a North/South divide, that it is significant that the handbag (something of a Thatcher trademark) as a repository of wealth is firmly situated on London and the Home Counties.

Interactive Ethnography

While the image itself seems under threat from manipulation, enhancement and/or distortion, the narratives into which the images have been put also now appear to be problematic. For centuries the art of the storyteller (certainly in the Western cultural tradition) has relied on variations of Freytag's pyramid in achieving dramatic

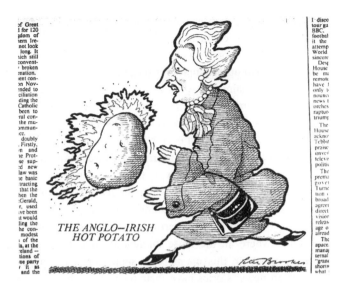

THE ANGLO–IRISH
HOT POTATO

FIGURE 15 *The Anglo-Irish Hot Potato*. Peter Brookes (1985). Illustration courtesy of the artist

effect (see Laurel, 1990; Thomas, 2003). The progression of the passage of the story (and, as we saw in the previous chapter, here we can include news 'stories') from Exposition, Development, Climax, Resolution, to Dénouement has been almost the 'inbuilt' expectation of the viewer since the time of Aristotle. From a conventional standpoint the scheme seems quite logical and straightforward. The *Exposition* informs us as to the who, where and when of what is about to unfold. The *Development* informs us as to the how, and it sets the narrative in motion, releasing new pieces of information until we reach the *Climax* as the central point of the narrative. The *Resolution* helps us to contextualize and rationalize what we have been told, while the *Dénouement* provides a commentary on what we have seen and prepares us for possible subsequent narratives or additional perspectives. For the interactive narrative, the viewer can opt to view the climax up front and allow the details (who, what where, when and how) to be filled in later. This is closer to the newspaper report, which is often represented as an inverted triangle (see Thomas *et al.*, 2005).

The Structure of Soap

The technological determinist view is that the new technologies have provided the means to alter radically the traditional narrative structures with which we are so familiar. However, one might suggest that such changes in narrative patterns had been already been in anticipation for some time, and evidence of this can be found

in structures of television 'soap operas' and the television episode series. I shall briefly describe some of the characteristics of the narrative strategies found within these genres and then seek common elements with the new interactive media. The television (or radio) soap opera employs a serial narrative consisting of a number of separate but linked instalments. A number of storylines can be operating simultaneously with their discrete plots, but these can elide and cross-reference as and when the scriptwriters so decide. Soaps also operate in a type of continuous present, although knowledge of past events in the drama is also important. While details from the past are important to inform the viewer about the significance of current events, it is not the common viewing pattern for soap viewers to watch past episodes. New viewers can fairly easily enter the narrative at any given point, as indeed existing viewers can exit, as the majority of soaps have an 'open' structure in that they do not consist in a 'grand narrative' that leads to a single dramatic resolution of the plot where all the loose threads are tied in or summarized in a Freytagian dénouement. In this manner the soap can create a similar viewing pattern to television news: stories have their own plots, they can be cross-referenced and new developments can take place. For example, in the context of natural disasters, the Asian Tsunami of 2004 had its own 'storylines' that related to past events (e.g. the Mozambique floods of 1999) and, in turn, these gained new relevance when Hurricane Katrina hit New Orleans in 2005. Again this was compared to the Tsunami, but also other stories: the slowness of the US Federal government to respond to Katrina in comparison to the swiftness of its invasion of Iraq; or comparisons between poverty in the most powerful First World industrial nation with that of the so-called 'Developing World', and so on. Similarly reference is made to future events: how responses might be made to future natural disasters and how governments might respond (or not) to the matter of global warming. Soaps and news narratives also intersect in that it is not uncommon for soap opera characters to make reference to contemporary news items.

Neither soap operas nor news narratives are usually subject to the remake, as are films (e.g. the two versions of the film *Psycho*, 1960 and 1998), or repeat performances, as might be found in the theatre (e.g. the plays of Shakespeare). It is unlikely that a group of actors would perform for television or on stage the 25th anniversary episode of *Coronation Street*. In contrast to this narrative pattern, the television series is composed of episodes (e.g. *Star Trek*) where the viewing of any one episode is not contingent upon viewing previous episodes as each episode contains a story in its own right. However, this discrete story does relate to other stories in other episodes and the episodic viewer will be likely to have (or be in the process of acquiring) an accumulated knowledge or user- determined history that may inform and enrich subsequent (or repeated) viewings. In such contexts (see Eco, 1972) each episode generally conforms to Freytag's pyramid, whereby at the end of each episode equilibrium is re-established. In addition the *status quo* is maintained. At the end of each *Star Trek* episode, despite the quite radical

interruptions to starship life that have occurred, Jean-Luc Picard remains the captain and the other characters remain in their fixed positions. Characters are brought in to individual episodes to die or make dramatic departures during the narrative but they leave the *Enterprise* as it was, ready for the future and the next, albeit temporary, disturbance.[7] This also means that the episodes do not depend upon being shown sequentially, as does the soap opera. Similar to the sit-com, we can watch the occasional episode, miss a couple of weeks, but then return to our viewing pattern without losing the plot. As such, even though we see the starship travelling ever onward through space, all the characters and their dramatic location exist in a sort of continuous present. The journeys of the Starship *Enterprise* (to borrow Geertz's phrase from a different context) have 'the look of mobility without its actuality'.[8]

While the individual *Star Trek* episodes have a beginning, middle and end, this is not the case for soap operas. Although they do move through time, there is neither closure nor a sense of building up to any end-point. Despite being broadcast in a linear manner over time, the individual storylines which intersect and diverge are woven together in a non-linear manner.

> The structure of soaps is complex and there is no final word on any issue. A soap involves multiple perspectives and no consensus: ambivalence and contradiction is characteristic of the genre. There is no single 'hero' (unlike adventures, where the preferred reading involves identification with this character), and the wide range of characters in soaps offers viewers a great deal of choice regarding those with which they might identify. All this leaves soaps particularly open to individual interpretations (more than television documentaries). (Buckingham, 1987:36)

The use of stereotypes (or 'typage', as Siegfried Kracauer would have it) becomes necessary in feature films, which can little afford to deal with many complex characters. In the relatively limited duration of a two-hour drama only two or three personalities are able to come across as multi-dimensional; all the rest have to be stereotypical. This is not so in the soap opera. In the example of Britain's longest-running soap, *The Archers*, the everyday tale of country folk broadcast six days a week on BBC's Radio Four, the writers can afford to develop a multitude of in-depth characterizations. For example, Sid Perks, the genial landlord of the village pub, 'The Bull', has featured in the series since the 1960s, yet more recently (in the late 1990s) he has revealed his unease and increasingly reactionary behaviour when in the company of gay characters who have more recently been introduced into the plot. Yet so far, Sid's homophobic tendencies have not been fully explained. Nevertheless, long-time listeners will be aware that Sid had a criminal record, was sent to an approved school at the age of 15 for breaking and entering, but, to all intents and purposes, is now reformed. Could there be something in his past that might explain such unexpected behaviour? Such details

and nuances leave the scriptwriters the luxury of being able to expand on the subject at a time of their own choosing, or leaving listeners guessing or conjecturing as to the causes of his fears. Similarly characters can leave the story(ies) for years. They then can strategically reappear re-charged with new dimensions accrued through their life experiences over the intervening years of absence from the drama.[9]

How does this relate to the new media/new contexts of images? Such narratives especially characteristic of the television age have set the stage for certain types of interactivity and they also can serve to highlight the scope and limitations of interactive media. In fact the structures of soap operas with their multi-strand narratives are proving quite appropriate for transmission to mobile media devices. However, there are problems with simply using television-style production methods for these new media forms, which demand new filming methods. The relative lack of screen resolution of mobile devices requires more close-ups than one would normally find in a conventional television drama. In contrast, broadcast television, in taking a high-definition route, can afford to rely on high-resolution details as contributing to the plot (a character holding a handwritten letter so that it can be read by viewers, for example). However, as with the screen resolution of mobile devices, there are similar concerns: the sit-forward or sit-back modes have an impact on the amount of content details (the PC is normally viewed from a distance of less than half a metre while television viewing is closer to 3 metres).[9] Furthermore, the health-and-safety-conscious might consider the recommended viewing times that a PC can be used without risk to health.[10] So the duration of engagement with an interactive production should be expected to be significantly shorter than television or movie viewing. This casts doubts upon the programme-makers' ability simply to channel the same material through different technological outputs. In addition, the sporadic or interrupted viewing of those using mobile media devices calls for shorter scenes and a narrative structure that enables viewers to leave or resume the story as necessity demands.

A further related dimension to this 'new media hybridity' is the computer games industry's emulation of the episodic nature of television dramas. Games are now sold individually as episodes rather than as games in their complete form. According to Gabe Newell, the president and co-founder of Valve Software: 'Smaller chunks of content should have greater value for consumers' (quoted in *Economist*, 2006). This use of episodic narrative is not, of course, new, however, and had its precedents in nineteenth-century magazines (with their weekly 'cliffhangers'),[12] which, in turn, belong to a longer literary tradition (see Thomas, 2003; C. Thompson, 2006). What *is* new about computer games, however, is their combination of episodic narrative and interactive narrative The attraction of the interactive narrative is that emphasis shifts from the author to the engager so s/he is able to navigate a path through the available information and images to suit his/her own purposes. In contrast for the demand for computers to produce higher

definition and qualities of verisimilitude, it is the quality of engagement that defines the task for digital content producers:

> People don't want the illusion of a perfect world. What they want ... is evidence that they are engaged with other human beings who are struggling and creating and acknowledging each other. The great challenge for artists in this industry is to reintroduce the imperfections of the world, the grit, the smudges and the anomalies. We need that sense of reality. (Robert Greenberg, quoted in Jensen and Heck, 1999:9)

Interaction with Disaster

Interactivity is not confined only to computer gaming, but is also increasingly evident in news coverage, especially in the case of disasters. One of the most noticeable things about the representation of disaster over recent years is the increased amateur contribution. In the example of the devastating Oakland fires of 1991 there seems to have been an inbuilt need to construct a memorial or some other sort of concrete substantiation that would outlast the period of tragedy (see Hoffman, 2002). Perhaps the visual arts are especially important in that they 'objectify' the sentiments of the creator in a way that is neither transitory nor fleeting. Rather like the characters in a soap opera, they can offer models of codes of behaviour, providing an off-the-peg persona (see Walker Gibson, preface p. ix above) that people can assume when events have been so tragic that they are at a loss as to how to react or express themselves: offering the viewer a range of possible survival strageies together with their potential outcomes.

A quite different response to disaster is to do nothing at all. On Saturday, 10 June 1944 in the French village of Oradour-sur-Glane, 642 men, women and children were massacred by soldiers of Der Führer Regiment of the 2nd Waffen-SS Panzer Division. After liberation, the French government decided to leave the village as a memorial as it stood, following the shootings and burning that had occurred. This deliberate act of doing nothing serves as a chilling reminder of historical events. Visitors walk round the village, which contains a sense of immediacy of the tragedy and a feeling of absence marked by everyday items (such as sowing machines) that sit slowly rusting amidst the ruins.

In more recent times, another change that has taken place gives a new meaning to the term 'participant observation'. With the proliferation of smaller, more portable video cameras, mobile phones equipped with cameras and the ease of internet transmission, as soon as disaster strikes there is inevitably someone on location with a camera filming or photographing events as they unfold. This was most evident in the Sumatran Tsunami of 2004. In relation to the five-day disaster sequence, reports at first appeared not to conform to pattern. The media seemed to find it difficult to focus on any fixed point. There was a sense of aimlessness; nobody knew where the 'real' story was happening. However, in retrospect, the

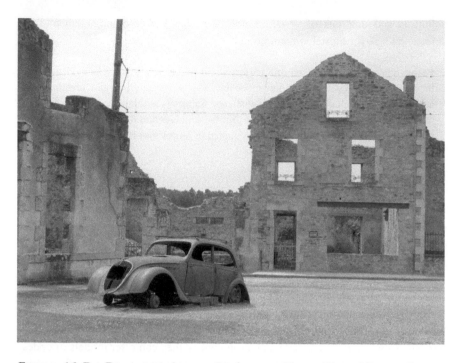

FIGURE 16 Dr Desourteaux's car, Oradour-sur-Glane, Haute-Vienne, France (2007). Photograph courtesy of the author

geographical area of the disaster was so large and communication networks in the affected areas varied so widely that a narrative pattern had emerged that was more akin to that of a soap opera with multiple storylines occurring simultaneously with occasional cross-referencing. This process was echoed in the media response to the London terrorist bombings of July 2005, where the near simultaneous explosions set the media scurrying from one side of London to the other and back again. In both cases some of the first images to emerge were those taken by amateurs caught up in the disaster or situated on the side-lines. In much of the Tsunami amateur footage, there was a distinct impression of the camera operators' sense of detachment from events, only to be woken by the sudden realization that they were finding themselves in considerable danger. As for the visual images themselves, this type of reporting has given rise to an even more casual and shaky 'wobbly-scope' shooting style. A documentary style had already been creeping into feature films and television series and soaps: for example, skilfully choreographed fluid steadycam sequences from those shot in New York's Grand Central Station in Brian de Palma's feature film *Carlito's Way* (1993) to those that accompanying the freewheeling dialogue passages in Warner Brother's *The West Wing* (2002) or the BBC Television series *This Life* (1996).

In the news media such is the demand for amateur news footage that a website, Scoopt, has been established in order to syndicate this type of material. Aimed at those it describes as 'the citizen journalist', Scoopt enquires rhetorically: 'Who will take tomorrow's front-page photograph – a professional press photographer or a passer-by armed with a cameraphone? Virtually everybody now has a mobile phone, and virtually every mobile phone now comes with a camera. This means that somebody, somewhere is in a position to photograph just about anything that happens on the planet.'[13] Nick Danziger (2005:12) agrees that the current techno-logical state of affairs means that 'anyone with a cheap digital pocket or phone camera can produce images that can convey the same sense of outrage or horror as those by talented professionals. They can be broadcast around the world in the time it used to take to reach the developer.' Danziger cites the photos of the pris-oners held in Abu Ghraib and the smoke-filled tube train in the London terrorist bombings of 7 July. This proliferation of amateur footage helped fill the media coverage of the Asian Tsunami, which took over most of the news slots for the entire Christmas/New Year period 2004–2005. So vast was the coverage that it was not long, in the context of the still image, before the entire repertoire of disaster images had been exhausted. We had seen a host of 'madonnas', tear-stained chil-dren, exasperated medics, pleading survivors, desolate landscapes, repeated wave pictures, hordes of maps, diagrams and computer-generated simulations of seismic disturbances beneath the sea-bed. But still the stories kept coming. With the stock of standard imagery exhausted, on Wednesday, 5 January 2005, ten days after the main impact of the disaster, uncharacteristically *The Daily Telegraph* front page featured a child's drawing of the disaster, captioned 'disaster through the eyes of a child', under the headline 'Plight of the tsunami orphans'; *The Guardian* repro-duced a photograph almost in the style of a Giacometti figure sculpture due to the distortion of figures shot through the heat of burning buildings; and, finally, to complete the process of de-materialisation, *The Independent* printed nothing apart from (its banner headline and) the words 'TO REMEMBER THE TSUNAMI VICTIMS ... SILENCE', surrounded by a black border.

Future Stories and the Media to Deliver Them

In 1725 Giambattista Vico proposed that 'primitive' man was far from child-like but possessed an inherent *sapienza poetica*: 'poetic wisdom'. He suggested that responses to the world were not ignorant or barbaric, but rather consisted in struc-tured responses represented in the form of myths, metaphors and symbols: a point of view that is largely shared by contemporary anthropologists. According to Vico (1725: passage 51), 'It follows that the first science to be learned should be mythology or the interpretation of fables.' From a different perspective Clark (1949:29) maintains that 'about the year 1420, some change in the action of the

human mind demanded a new nexus of unity, enclosed space. In an extended sense of the term, this new way of thinking about the world may be called scientific, for it involved the sense of relation and comparison, as well as the measurement on which science is based.' However, we may consider his suggestion that the rise of science called for a radical reassessment of the canons of visual representation as a reactive viewpoint. In contrast, Edgerton (1980:211) had proposed that the visual arts take an active role in bringing about change, in part by providing the means to visualize abstract concepts. This has the effect of classifying Clark as something of a technological determinist. In contrast to theories of the psychology of perception, technological determinism does have the virtue of offering an historical account of picture-making. Nevertheless it devalues the art of the past, with each successive technological development superseding the previous art movement. According to this standpoint, artists of the past have no intrinsic value in themselves, because they have been up-staged by those who follow, possessing greater and greater technical skill in achieving a truer and truer vision. The belief in the ability of a technology suddenly to transform the 'parent' culture has been called into question, however. Richard Rorty (1989:6) argues against the 'determinist' notion:

> As Kuhn argues in *The Copernican Revolution*, we did not decide on the basis of some telescopic observations, or on the basis of anything else, that the earth was not the center of the universe, that macroscopic behavior could be explained on the basis of microstructural motion, and that prediction and control should be the aim of scientific theorizing. Rather, after a hundred years of inconclusive muddle, the Europeans found themselves speaking in a way which took these interlocked theses for granted. ... We should not look within ourselves for criteria of decision in such matters any more than we should look to the world.

In addition to 'technological determinism', another particularly Euro-centric view is that of the 'innocent eye'. From this point of view it is supposed that it is the contamination of culture that prevents the artist from seeing the world as it really is. It is our knowledge and preconceptions that disable us from achieving a direct perception of the world. It was this innocent vision that was the great achievement of the Impressionists – whereby Monet was described by Cezanne as 'only an eye, but what an eye' (Heinrich, 2000:32). It assumes that the history of visual art, rather than becoming embroiled in a more and more complex culture, has consisted in process of deconstruction: shedding cultural attributes to achieve a state of pure perception and representation.

From the 'Citizen Journalist' there exists a demand for images that provide a type of 'innocent eye': unmediated images that can be inserted into pre-existing editorial formats. The future looks to increased viewer participation in shooting images that can be easily broadcast via the internet and the construction

of narratives containing user-determined combinations of sound, text and image. Consequently we might consider whether and how the perception of the visual artist or the storyteller's art will be carried through into these outputs.

The relationship between technology and the society in which it operates is complex. While the internet has been responsible for encouraging and enabling new forms of social interaction (e.g. weblogs and user groups), there is also evidence that 'old habits die hard'. While many people have embraced the interactive and mobile facilities of cellular phones and laptop computers, the high demand for static 'entertain me' types of media remains. Yet despite rapid advances and convergence of technologies, with multi-function television sets operating more like computers and computers offering television-quality viewing, there still remains a strong division of experience and behaviour between television viewers and computer users. As things stand at the moment of writing, despite the rapid proliferation of digital television and broadband internet services, the television market is dominated by (relatively) high-quality professionally made productions. There appears to be little public demand for television interactivity, except for simple 'press the red button' type of operations and text voting for game show contestants, for example (though this is little more 'interactive' than 'phone-ins' that were pioneered by BBC Television's *Swap Shop* 1976–1982). Television viewers seem to prefer the 'sit back and watch' scenario of their own living-rooms. In contrast, the computer has spawned a variety of media productions in both the educational and recreational fields which depend upon users' interactivity and exploration. While there is much talk about 'interactive television', the phrase usually refers to home viewers sending in text messages. In the area of television light entertainment, text messaging allows viewers *en masse* to vote for televised competition contestants, while with factual programmes viewers are encouraged to submit their opinions. Very few of these are actually broadcast and the editorial control remains securely with the programme producers. Consequently television, in its present form, 'is a mildly interactive medium' (Ryan, 2001:205). The programmes themselves are not interactive, and 'by channel-surfing the spectator violates their putative integrity' (p.205). This type of optional engagement is entirely different to that of interactive computer programmes, which depend upon the user's constant engagement and come much closer to the type of active exploratory modes of perception advocated by James Gibson and others. Even the broadband-delivered YouTube, which enables users to upload and share a wide variety of video clips in a scenario where they are encouraged to make 'video responses', has not challenged the high public demand for professional high-quality produced 'sit-back-and-watch' television productions. Rather than a contested territory for viewers'/users' attention, the field appears to have widened, offering an extended range of viewing mode options. The result is that, on the one hand, we have we have the likes of YouTube serving up 100 million video shorts a day,[14] usually characterized by amateur production standards and quality, while, on the other

hand, there has been a market boom for 'home cinema' with its high-definition surround sound experience. Consequently the 'television in every room' phenomenon is disappearing in favour of a viewing experience that is more mobile, yet more static. Individuals are able to view anytime, anywhere via mobile 'phone' devices, yet the living room has become the domestic centre for television/cinema viewing. Of course different media forms make different demands on viewers or engagers. Televisions are extremely simple to operate: switch on and change channel. In contrast, the computer demands the prerequisite of specialized knowledge in order to engage properly with the flow of information. On the one hand this implies a sense of techno-phobia on the part of those who are not used to computer technology; on the other it may therefore suggest that it will be computer users who are most likely to be self-motivated and ready to experiment with novel modes of content delivery. However, future technological development will probably lead to a narrowing of the television/computer divide, and already some hybrid equipment is reaching the consumer marketplace. A convergence between PC hardware and the conventional television set is already underway – a state of affairs that strengthens the technological promise of interactivity and the potential for personalization of media reception. Familiarity with the use of PC- and (via game consoles) television-delivered games may well be heralding a demand and up-take of interactive media.[15]

Current technological developments have given rise to the term 'prosumer'. This term, coined as early as 1970 (in Alvin Toffler's book *Future Shock*), suggests a convergence between 'producer' and 'consumer'. For example, if we compare the processes of documentary filmmaking 30 years ago with those of today if would necessitate a team of expertise involved in lengthy production procedures. An event would be filmed, the film would be sent for processing, then edited and finally distributed. Nowadays, it can be videoed, transferred to a PC for editing and placed onto a website. When making *The Interactive Village* in the Czech Republic, we could capture interviews with the villagers on digital video during the daytime and make a rough edit on a laptop computer back at the hotel room in the evening. At the same time (with the aid of the Czech anthropologists) English subtitles could be created during the same evening while the interviews were fresh in our minds. This had the added benefits of being able to show results to the villagers and, should the necessity arise, it allowed the opportunity for a re-shoot the following day. Theoretically, this means that anyone, without professional training but with a relatively small financial outlay (camera, PC & software), can make a movie whereby the user-generated content (UGC) is shot, edited and uploaded onto websites (such as YouTube) to be 'broadcast' and shared in a relatively short timeframe. Notwithstanding, the type of UGC created by 'citizen journalists' has not supplanted television news. At times it may be brought in as an on-the-spot supplement, yet media organizations and public viewing habits appear to remain fairly entrenched in their demand for professionally made content.

From another perspective there are strong similarities between our contemporary media explosion and the invention and proliferation of the vast number of optical devices that took place in the latter half of the nineteenth century. Then, as now, technological developments were accompanied by a 'democratization' of the media: for example, in 1890 George Eastman's 'box brownie' (literally) placed the photographic camera in the hands of the general public, with the accompanying advertising slogan 'You press the button, we do the rest'. Although one should exercise caution in making close analogies with other periods of rapid historical change, our current era of technological explosion of the PC, internet, mobile communications, Global Positioning System (GPS), etc., has parallels with the plethora of photographic gadgets, fads and fancies of *fin-de-siècle* Europe. Both markets, though 120 years apart, could be characterised by volatility, dynamic rapid change and a short-term future that is extremely difficult to predict. It is equally difficult to predict possible changes in user behaviour. This type of user unpredictability was exemplified in the rapid expansion of mobile phone text messaging (SMS). Initially this facility had been seen as an optional extra, yet users themselves adopted it as a central form of communication.

Yet further, and moving more into the realm of anthropology, interactive audio-visual media have created a greater degree of social interactivity. Users spend considerable amounts of time rating media and exchanging media material: producing and uploading photographs and video-clips to be viewed by other media users. At the same time, there will be a counter-influence. 'Social media' interactivity could lead to a general move away from the passive viewing of professional media content in favour of 'prosumers' interacting with UGC. It is increasingly apparent that a wide variety of factors will determine the nature of future developments in interactive media. These developments depend not only on the technology available but also on the ways in which it blends with social practices, as well as the prevailing economic climate. At the same time we find that the two different viewing modes – sit forward and engage, or sit-back and be entertained – demand different approaches to the gathering and presentation of visual imagery. For example, for the 'sit back' mode, I may adopt a quicker, more dynamic editing style that will have been designed to carry the viewer along with the pre-ordained narrative. In contrast, the 'sit forward' mode may require images with more detail that remain on-screen longer to afford the engager a longer period of investigation of visual material with appropriate length of time for decision-making. For example, from a period engaged in writing questions for BBC Television quiz shows, I noted that producers would prefer contestants who were 'smart' but not too quick. It was generally considered that a contestant who took a few moments to answer allowed viewers at home the opportunity to call out answers during the pause. This trend is now being further exploited through new media technologies: 'On the Discovery Channel, *Mastermind* viewers can now compete with the

contestants on screen – and later this month *Who Wants To Be a Millionaire?* fans will be able to do the same on ITV2' (Douglas, 2001).

In recent years television interactivity has developed from channel-hopping and phoning in to pressing the red button and text messaging. More recently possibilities have opened up for further control of viewing. Experiments have been taking place that enable viewers to select the duration of a production as well as genre or theme. Additionally users' own material (UGC) will be 'slotted in' to existing linear narrative productions. Some of the most innovative approaches to interactivity, meanwhile, have occurred within the field of interactive gaming.[16] However, in the context of this book, it is users' ability to select the images they view and steer the course and duration of the narrative that holds the greatest promise of 'immersive' interactivity. With these thoughts in mind, it is in the field of documentary/factually based television productions that some of the most interesting developments have taken place. To some extent, this had been pioneered on DVD, where viewers can choose not only the language of the film, but also whether they listen to the dialogue or the director explaining the decision-making processes and rationale behind the movie.

In 2001 BBC Television produced *Walking with Beasts,* a follow-up series to *Walking with Dinosaurs* (1999). Both series of programmes (featuring extinct species) relied heavily upon animatronics as well as computer and model animation. An interactive version of the series was produced that enabled viewers to customize their viewing. They could choose from a range of audio and visual components, narrators, fact boxes, clips of scientific details or of how the series had been made (Curran, 2003: 66–69). Further examples of experimental documentary modes have been outlined by Maureen Thomas *et al.* (2007:220). These developments and many of the issues contained in this book provided the foundations for *Interactive Village*: an interactive production which enables viewers to make selections and change location, perspective or duration while they are watching without interrupting or breaking the narrative flow. This is the focus of the final chapter.

–8–

Theory into Practice
The Interactive Village

[S]ince the inception of the telegraph and radio, the globe has contracted, spatially, into a single large village.

Marshall McLuhan, 1964:xii

As an attempt to put theory into practice, *The Interactive Village* is an ethnographic multimedia production that aims to evolve a human-interest documentary-style viewing space through which users can navigate routes of their choice through village material: scenes, interviews, activities and commentary. The production, based on everyday life in a small village in the Czech Republic, was enabled by the NM2 (New Media for a New Millennium)[1] interdisciplinary research project, which had the main goal of creating new production tools for the media industry, in addition to the more ambitious aim of creating a new media genre. The tools were designed for the easy production in technically standardized for[i]mats of non-linear, personalized media genres based on sound and moving images suitable for transmission over broadband networks. The development of software to reorganize media content in order to construct personalized narratives enabled the creation of eight experimental productions. These covered the traditional genres of news, documentary, sports and drama.[2] The productions were made parallel to the development of the tools used to deliver them, with each process cross-informing each other. The production teams would request and negotiate a variety of technical features from the tool developers, and, as new tool capabilities emerged, the productions would be adapted accordingly. In view of some experiments and discussions that are taking place in the field of visual anthropology concerning the potential for ethnographic production afforded by the new media technologies (e.g. Ardèvol Piera, 2002; Barkin and Stone, 2000; Farnell and Huntley, 1995; Stanlaw and Peterson, 2003; also Wand, 2002), the NM2 team from the University of Ulster developed *The Interactive Village*. As for the practicalities, the Czech village of Dolní Roveň was visited on a regular basis over a period of two years in order to identify and collect relevant information.

For the *Interactive Village* the production took its primary frame of reference from three sources, and we can address them in reverse order to those adopted in

this book. We considered current strategies employed in interactive media documentary productions (chapter 7; also T. Wright, 2003: 165–194) and existing narrative structures used in television news and other factually based programmes (see chapters 5 and 6). Theoretical issues and debates arising from the fields of anthropology and ethnographic film provided guidelines with regard to our approach to the subject matter (i.e. the village population) and a wide range of issues regarding cultural approaches to visual representation (chapters 3 and 4). Finally an assessment was made of information-gathering processes and speculations were made as to users' engagement with the subject matter informed by 'ecological' theories of visual perception. By these means, the production has aimed to achieve a unique blend of active and exploratory investigation of material, both in the gathering of video footage and in the subsequent viewing of that material (chapters 1 and 2). My own work in the field of interactivity and the new technologies began in 1995 making 'The Batwa 1905', an ethnographic/archive production for the *From Silver to Silicon* CD-ROM project, which was concerned with critical and creative responses to digital photography.[3] This production enabled users to explore images, events and issues surrounding the visit of the Batwa tribespeople who were brought from the Belgian Congo to London in 1905. Not only were they subject to 'scientific' examination, but they were expected to perform on the stage of the London Hippodrome as public entertainment. This led to their achieving something of celebrity status in the Edwardian era (see T. Wright, 1990).[4] NM2 provided the opportunity to continue the interactive ethnographic theme, with the project offering the additional possibility of freedom from existing media genres.

Research and Production

During these early stages of the production we were concerned with making an 'interactive profile' of the village and the villagers' activities. From discussions with the NM2 partners (and initial collaboration with Malmö University's K3 news and sport production),[5] we felt it important to pursue a local news/ethnographic agenda. Combined with our concept of a 'profile' of the village, the production might evade the pre-existing concepts of the 'documentary', 'film', 'portrait', 'programme', and so on. Additionally the potential development of narratives with flexible content and time durations meant that users might be presented with 30-second 'news headline'-style information, and from these tightly summarized storylines choose to extend the narratives into 30-minute documentary-type productions. At the same time they would have the capability of steering the content of the stories to suit their personal tastes and interests. Thus we could question, in the context of new media: do the dividing lines applied to the existing genres of news, documentary and ethnography still retain any relevance? And do

existing documentary genres, such as Observational, Didactic and Journalistic (see below), continue to have any weight or meaning in the digital age? Consequently, the production questioned existing professional working methods and viewer expectations of past and contemporary media formats.

At the time of the project's formation, the highest potential for interactivity could be achieved though broadband delivery to the personal computer sit-forward and respond scenario (Leurdijk *et al.*, 2007). In this mode, as the length of engagement is user-defined, we questioned the necessity for the production to have a finite beginning and/or end. We could adopt a narrative structure similar to that of the soap opera with its endless storyline which continues to be broadcast while future plots are still being determined and written. As such, the user's relationship to the material is akin to that of researching an archive or library which is continually expanding as material is added to it. Consequently, these thoughts impacted on *The Interactive Village*'s working methods and led to a reconsideration of interactive media production scheduling. For example, was it to be the same as 'traditional' filmmaking entailing three distinct processes of pre-production, production and post-production? In any case, we believed the production should take a hands-on approach. Not only did this entail shooting original material, but also we sought to ensure that the production saw the whole process through: from the initial encounter with the subject, to video recording, to editing footage in the NM2 tools, to getting feedback from subjects (and subsequent revision), to the final end-user experience. So from the outset the production shot original location-based material in order to test whether the pre-existing shooting strategies (normally employed in television documentaries) were appropriate for interactive media productions. The production adopted a low-budget, low-tech approach that might be used by an 'information-gathering' academic or a 'talented' amateur. This was characterized by little technological intrusion from a one- or two-person film crew providing the flexibility to capture quickly and cheaply new material that could be adapted in the light of technical and theoretical insight gained through the programming and software development processes. Shooting our own material also had the added benefit of avoiding future complications arising from issues of copyright.

The studies of narrative strategies employed in television news that formed the basis of *The Interactive Village* are described in this book – particularly in chapter 6 as well as other sources (e.g. Smith, 1985). An initial structure for the production was based on Freytag's 'triangle'. With its origins in Aristotle's *Poetics* and adaptation for interactivity by Brenda Laurel (1990:82), it provided a useful starting point. Another important influence was ethnographic film, which also helped to form the rationale and strategy for the production (Loizos, 1993; T. Wright, 1992). However, bearing in mind the structures frequently adopted by ethnographic film, the system was modified to cope with an experimental interactive documentary. For example in Granada Television's *Disappearing World* series

film *The People's Land* (although made back in 1975), the linear narrative does not tell a story as such.[6] Rather, the film builds up an impression of life in the Inuit village. Elsewhere (T. Wright, 1992) I have described this narrative as proceeding in a similar way to that of the knight chess-piece (with its two steps forward and one to the side) which can be moved to cover the board, in contrast to our usual expectations of a story that (metaphorically) starts at Square 1 and takes the listener/viewer along a straightforward linear path to Square 64 (prescribed by the King of Hearts in Lewis Carroll's *Alice in Wonderland*: 'Begin at the beginning ... and go on till you come to the end; then stop'). In contrast to the Freytagian/Aristotelian narrative scheme, ethnographic film can be structured without rising to a climax, thus lending itself to be an episodic and potentially reconfigurable narrative. A more historical source of inspiration was Humphrey Jennings' documentary film *Spare Time* (1939). Not only did we find useful Jennings' approach to filmmaking, characterized by its locative episodic character with a loose 'dawn to dusk' storyline (drawn across three industries: coal, cotton and steel), but his *I Was a Fireman* (1942) provided a useful frame of reference to some key subjects of the *Interactive Village*: the village firefighters. *Spare Time* was made as part of the Mass Observation (MO) project of the 1930s. Some of the idiosyncratic methods used by the MO observers were also of interest, as were the influences of the anthropologist Bronislaw Malinowski, adviser to MO, and his concept of 'an anthropology at home' (McClancy, 1995; Stanley, 2001; Wright, 1994). This and other documentary narrative structures helped to form an additional field of common interest to Cambridge University's NM2 production *City Symphonies* (Alifragkis and Penz, 2006), which in turn was based on a detailed study of Dziga Vertov's *Man with a Movie Camera* (*Chelovek s kino apparaton*) (1929). In the planning of *The Interactive Village*, production attention was also paid to the particular style and humour of the feature films of the Czech 'New Wave' cinema of the 1960s, e.g. Jirí Menzel's *Closely Observed Trains* (*Ostre sledovane vlaky*) (1966) and Miloš Forman's *Firemen's Ball* (*Horí, má paneko*) (1967).

Ethnographic film has been described as 'documentary's avant-garde' by Jim Hoberman, film critic for New York's *The Village Voice* (Barbash and Taylor, 1997). With this sentiment in mind, it was a concern of *The Interactive Village* production that visual ethnography should play a central role in exploring and redefining documentary practice in relation to the new media technologies. In ethnographic film, all the 'conventional' documentary issues become heightened. Not only do we find distinct differences in cultural settings, but invariably the power relations between filmmaker and subject are asymmetric, which opens up the potential for exploitation and voyeurism. In addition, there are translation issues – not just in terms of language, but in culture and in issues of visual representation too. The particular approach taken to ethnography in *The Interactive Village* was intended to address specific *issues* pertinent to 'human interest'

productions: about 'the common humanity of all peoples' (Singer, 2002). Its purpose was not to offer a type of television programme formula as such; rather, it was to test out a variety of factors that could be easily adapted to future programming scenarios. So instead of proposing an interactive version of existing television formats – e.g. *Big Brother, The Time Team* or Ray Mears' *Extreme Survival* – we hoped to have a production that clearly demonstrated the potential of interactive media and the NM2 media tools. For the purpose of *The Interactive Village* was not to make a commercially viable programme, but to demonstrate how NM2's production tools may be adopted and adapted to the purposes of future media producers (professional and amateur alike).

The production method was partly informed by the aforementioned study of narrative structures and ecological theories of perception. On the perceptual side, the video material was gathered in such a way that it aimed to anticipate and mirror the user's viewing and active exploration of *The Interactive Village* program and website. Naturally there are inherent differences between the perceiver's exploration of 'real' space and 'artificial' displays For example:

> [I]f we compare navigation in the functional spaces of programmed devices with the way we navigate in the real world, the difference is one of substantiality and continuity. Instantaneous jumps from one location to another are simply impossible in the real world, and when we move from one place to another, the scenery changes continuously and in a way that automatically and unambiguously informs us about our whereabouts during the transition. We rarely need a sign giving 'feedback' information about our position. (Bærentsen, 2000:41)

Nonetheless, James Gibson's theory of ecological visual perception proved especially useful (see chapter 1; also Norman, 1999a+b; Soegaard, 2007; Wright, 1986). Consequently we abandoned the traditions of the carefully planned documentary and threw ourselves (*in medias res* – see chapter 6, p. [57][7]) into an exploratory process which entailed the immediate gathering of audio-visual material. This rapid assemblage of footage provided a loose collection of material from which loose narrative structures could be organized and built in a 'hands-on' manner. So, in the gathering of material for the production, rather than shooting a definitive storyline (or -lines), we found ourselves looking for 'story potentials' in the style of the early stages of investigative journalism – bearing in mind that it is a 'story' does not have to be finally 'written up' in a definitive manner. Consequently it is up to the user to develop the narrative building blocks provided by the media tools into the 'story' of his or her own choice. Working in this way (more akin to the methodology of the anthropologist than that of the filmmaker), the material was gathered to form an organic cell-like structure consisting in nuclei of information (resembling a mini-version of the World Wide Web). The shooting took a 'forensic' approach, whereby evidence was gathered and roughly assembled, recognizing that its significance

would not be fully recognized until navigated by the user.[8] Gibson's notion of *affordances*, combined with a basic narrative structure, provided rough guidelines as to how the video-clips might be assembled to 'offer, provide for and furnish' the viewer with appropriate access to information for future realization in the form of their personalized story.

> The *affordances* of the environment are what it *offers* the animal, what it *provides* or *furnishes*, either for good or ill. The verb *to afford* is found in the dictionary, but the noun *affordance* is not. I have made it up. I mean by it something that refers to both the environment and the animal in a way that no existing term does. It implies the complementarity of the animal and the environment. (J. Gibson, 1979:127)

Apart from the ethnographic/perceptual theoretical rationale, the village of Dolní Roveň in Eastern Bohemia, Czech Republic, had been chosen to be the subject of the production for very practical reasons. The village had been the subject of a number of academic studies since 1937. This provided a depth of historical insight and factual credibility. It also provided unique historical perspectives from which the present-day village could be viewed. The studies had covered dramatic periods of social and political change, from the First Republic (1919–1938) and Second Republic under Nazi occupation (1938–1945); the Communist period to the Prague Spring and again through to the Velvet Revolution (1989–92); up to the final Dissolution of Czechoslovakia (1993) with the separation of Slovakia and the establishment of the Czech Republic; and in May 2004 (just before our filming began) the Republic's membership of the European Union. This meant that we could establish a solid foundation drawn from the disciplines of history and anthropology on which to base the production (e.g. Galla, 1939). In addition to historical material the production was based on the on-going research of contemporary anthropologists (Novotná, 2004, 2005; Skalník, 2004, 2005) who came to work closely on *The Interactive Village* production. The expertise and experience of Petr Skalník and Hana Novotná from the University of Pardubice (15 kilometres from the village) proved invaluable in arranging and conducting interviews in Czech; providing translation and assisting with the subtitling of filmed material; and offering further insights into village customs and social relationships. They paved the way for easy access to villagers as they had already gained the confidence and trust of the village community. This reduced the likelihood of a film crew imposing itself on a culture, only concentrating on the strange or 'exotic' or making simplistic 'family of man' representations. The anthropologists secured the co-operation with the villagers that enabled the shooting of some initial footage, thus establishing a useful precedent for return visits and video shooting. They also made contact with specialist anthropologists to help explain more specific local cultural phenomena: for example, Martina Bromová provided detailed information and commentary on the footage of the annual village masquerade.

On a more practical level, we wanted to test the efficacy of the NM2 media tools in terms of handling language translation and subtitling (see MacDougall on subtitling, 1998:165–178). One potential application for the program that excited us was the creation of a European-wide network of *Interactive Villages* that could share, discuss and act upon issues of common interest (e.g. closure of rural post offices; unemployment; lack of public transport; etc.). It soon became apparent that the tools would have to ensure (visual) subtitles, inextricably linked to the appropriate verbal soundtrack, that would always overlay whatever other visual material had been selected for viewing by users. However, a much more practical concern was a financial one. Travel and accommodation in the Czech Republic was relatively inexpensive and the location could be easily accessed by means of cheap and regular direct flights between Belfast and Prague.

The Interactive Village's Structure

Essentially *The Interactive Village* is a non-linear ethnography with a user-driven reconfigurable narrative structure. It can be explored and personalized by the user choosing observational or didactic modes to access his or her chosen topics. As for the production's wider aspirations, it constitutes an experiment in building a sense

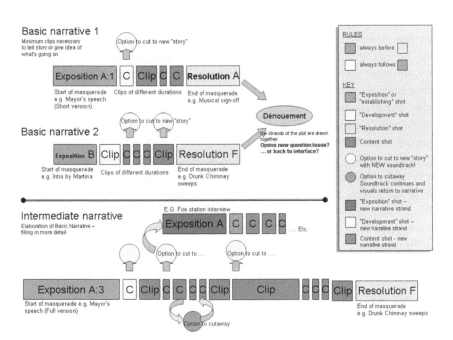

FIGURE 17 *The Interactive Village* presents different narrative strategies for the interactive ethnography

of community via 'new technologies' and can facilitate an additional social dimension through the possible addition of visual material, visual diaries and other contributions from the local community or through the use of mobile media devices to create video diaries/access to local histories.

In the context of the theory of visual anthropology, *The Interactive Village* takes the three central approaches traditionally taken by ethnographic film as broadcast on British television. According to Paul Henley (1985), these are: Didactic, Journalistic and Observational. Didactic, the most prevalent model, usually involves a David Attenborough type of presenter who acts as a guide for the viewers explaining and contextualizing what they are seeing. The Journalistic mode provides a specific point of view, 'typically built up around a particularly dramatic story or issue' (Henley, 1985:7). The Observational approach has the superficial appearance of the filmmakers taking a 'back seat'. It attempts to allow the viewer direct access to the filmed material with as little 'third-party' intervention as possible. For *The Interactive Village*, we re-ordered and revised these models into Observational–Didactic–Journalistic. Rather than being the sub-genres presented to the viewer, subject to the interactive user's choice, respectively, the user can decide whether to: watch and listen in Observational mode; access the Didactic anthropologist's commentary explaining, guiding and informing; or 'take issue' by accessing a particular point of view on a subject or issue, e.g. threat to rural transport issues – viability of train service, village communication. *The Interactive Village*'s Journalistic mode re-models Henley's concept of journalistic away from the film director/journalist to the user becoming the journalist: piecing together program material into a narrative structure that reflects his/her own interests. As a result, *The Interactive Village* interface has been designed to give the end-user access to these three modes. The production format offers a range of unique interactive experiences on a sliding scale from 'high' to 'low information', from news headline presentation to in-depth documentary to user-explored/contributed-to ethnography. Each configuration provides a personalized interactive experience, where the source sequences are configured seamlessly in real time to suit the personal wishes and needs of engagers. The Observational mode comprises loosely ordered video-clips linked through personal, topical or locational associations and presented as an endless loop. When the user, watching the program, running uninterrupted in default Observational mode, engages (e.g. via a single click) to select, explore or play, the system registers the clip currently being played back, and chooses a property of that clip to engage with a new loop of associated clips. If the user does not interact, the system will automatically engage a new loop when media files satisfying the current criteria have been exhausted. *The Interactive Village* employs a 'nuclear' structure that enables the user to access material along a variety of classified thematic (topic) threads and at a number of graded levels, within the three main modes, Observational (view), Didactic

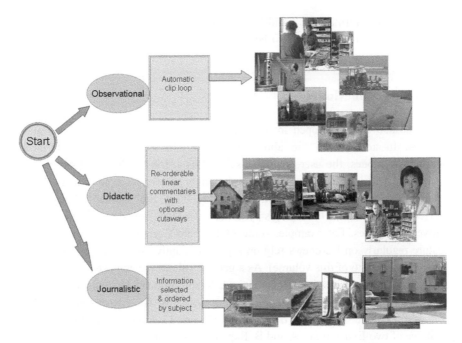

FIGURE 18 *The Interactive Village* modes: Observational (view), Didactic (select), Journalistic (search and compile)

(select), Journalistic (search and compile). Configuration of individual programs is seamless, through sensitive dependence on initial conditions set by the engager via direct interaction with the moving image material or via a topical graphical interface. The tool enables the user to switch between modes as s/he engages with the material. So if the user is in Observational mode, s/he can change to Didactic if/when contextualizing information/voice-over narration is required. Or, at any stage, the user may decide to 'take an issue' and gather information about a particular subject.

For example, in Figure 18 the user is watching the clip carousel and requires more information about the village location. She switches to Didactic mode where anthropologist Hana Novotná provides a commentary with appropriate cut-away sequences. Then the viewer becomes interested in the rural rail network and takes the Journalistic mode, and so pieces together a seamless documentary compilation sequence of the railway material. In this project description the example cited is that of rural infrastructure – in particular the small railway that connects the villages to the larger towns in the Czech Republic. Possessing its sense of slippage between 'soft' news and in-depth documentary, *The Interactive Village* aims to present the unique character of Dolní Roveň and issues specific to that village, while maintaining a sense of village universality. At the same time the production

has developed a format that could be applied to other locations. In some senses *The Interactive Village* could also be Marshall McLuhan's 'global village' – *Any Village Anywhere*.

The Interaction Modes

The interface was developed to present the user with a range of options and choices. In addition to the above-mentioned Observational, Didactic and Journalistic modes, the user is able to select Basic, Intermediate and Advanced narratives. And it is in this context that the study of television news and ethnographic documentary narratives comes into play. While the 'standard' BBC News stories tend to conform to Freytag's pyramid, other television channels offer alternative approaches. For example, some of the 'No Comment' experiments that feature regularly on Euronews rely on a predominantly visual narrative (see pp. [64-5] in chapter 6 of this volume). As a general rule, these achieve no Climax as such, instead the Exposition, Development, Resolution and Dénouement remain on either side, flanking a *compilation sequence* of clips. The consequence for *The Interactive Village* is described if we return to Figure 17. For example, the user has a choice of two Expositions: A and B. Exposition A is shown having two possible durations: A1 and A3 (implying the possibility of a third: A2 – not shown in the plan). Exposition A1 is a very tightly edited version of the mayor's speech delivered at the beginning of the village masquerade, while A3 is her speech in its entirety. Not only can the user choose the Exposition's duration, but by choosing the more Didactic Basic Narrative 2, Exposition B is accessed. Consequently an anthropologist's commentary replaces the mayor's introduction. While all this is taking place, the user can choose to follow cut-aways that can lead either to new narrative strands, or to a snippet of additional information followed by a swift return to the narrative as initially selected. A simple rule system ensures that a Development clip follows the Exposition. The colour coding reflects the study of narrative patterns commonly employed in television news stories. A variable-length compilation sequence replaces the Freytagian Climax. Similar choices can be made with regard to Resolutions and Dénouements. This conscious revision of Freytag's pyramid, and indeed Laurel's (1990:86) variation on this scheme of things (Thomas *et al.*. 2005), reflects some of Aarseth's misgivings (1997:139) in adopting the Aristotelian model for interactive media. However, these issues will be addressed in detail at a later date.

Interface Design

The Interactive Village has adapted and developed a new programme format for interactive delivery and access based on the tools to be developed as part of the

NM2 project. From a psychological perspective, the viewer's interaction with the ethnography has been informed by James J. Gibson's *Ecological Approach to Visual Perception* (see J. Gibson, 1979; Heft, 2001; Ingold, 2000; Neisser, 1989; T. Wright, 1992). In particular Gibson's notion of the affordance – 'an action possibility available in the environment to an individual, independent of the individual's ability to perceive this possibility' (McGrenere and Ho, 2000:179) – has a bearing on both the 'direct' perception of the village environment and the interface used to explore the village production. Elaborating on Gibson's original concept of the affordance as outlined at the beginning of this chapter. Harry Heft (2004:7) continues: 'With its emphasis on value-laden features of the environment, the concept of affordances implicitly carries with it recognition of the affective dimension of perceiving from the standpoint of the individual, and in doing so acknowledges the central place of feelings in acts of perceiving.' Nonetheless, the central concern of the interface is to explore the village by two visual systems: lens-based images and a map-like projection (each system possessing its own particular attributes – Gombrich, 1975). The interdependence of image and location means that the user can select a thumbnail from a collection of images. The location of the chosen activity is highlighted on the village map. Conversely the user can select a map location and the image bank will fire up a selection of thumbnails linked to the chosen location. Because of the peculiar layout of the village (Dolní Roveň is 8 kilometres long and at most only three streets wide), it was necessary to produce a scrolling schematic map with key locations (pubs, fire stations, shops, churches, etc.) and activities (masquerade, fire practices) highlighted. *The Interactive Village*

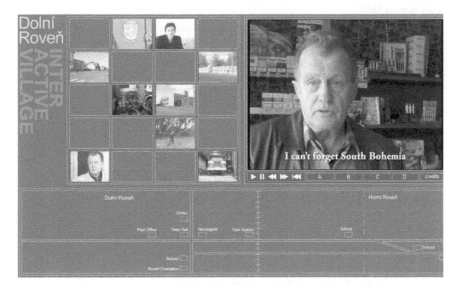

FIGURE 19 *The Interactive Village* interface

production has been designed to handle the component elements of video interviews), shots of village activities (such as fêtes and festivals), establishing shots, archive images: still photographs (and, in some instances, paintings made by local children), video diaries and cut-away details.

Each active button on the map takes the user into the corresponding narrative structure as defined by the NM2 tools. So the 'Newsagency' location on the map leads to the newsagent's (Mr Zevl's) interview and corresponding narrative arc. Each map item triggers the grid to populate it with its associated thumbnails, which in turn link to various narrative strands. So once the newsagent has been selected on the map, the grid is populated with the corresponding thumbnails. This gives the user the option to view various strands of the newsagent's narrative. Those are: Interview 1 short version; Interview 1 medium version; Interview 1 long version; *or* Interview 2 short version; Interview 2 medium version; Interview 2 long version; *or* the anthropologist discussing the newsagent. If the user selects any of these thumbnails, the interface activates the corresponding narrative strand within the 'Mr Zevl' category and his related narrative arcs. Screen prompts inform the user that a narrative choice can be made at a particular point, to decide which version of the narrative s/he wishes to see, short, medium or long. At other points a decision can be made to view cut-away details or to leave that narrative by switching to a different, but related, narrative strand. Below the Viewing Window are A, B, C and D buttons that enable users to steer the narrative in terms of its duration – button A extends the narrative; button B reduces it. In addition the narrative pathways can be steered by responding to on-screen prompts by selecting button C or you can choose a voice-over explanation with button D.

Most of the narrative arcs contained within each narrative group were constructed using multiple layered structures, either as stand-alone elements, or contained within narrative groups with a specified selection rule, all held together as part of an overall link structure. A typical layer structure contains the following:

a main video layer;
a main audio layer;
a video cut-away layer – a linked structure with place-holders and items specifying video without audio; and
a subtitle layer – a linked structure of place-holders with a specified time and text to be rendered on screen.

Each link structure starts with a decision point to control user interaction or prevent repetition if users do not interact; it then proceeds to an introductory layer structure, where users will always receive ABCD choice interaction to decide on the level of detail they require and/or the particular part of this narrative arc they'd like to explore. At various points throughout each arc they have

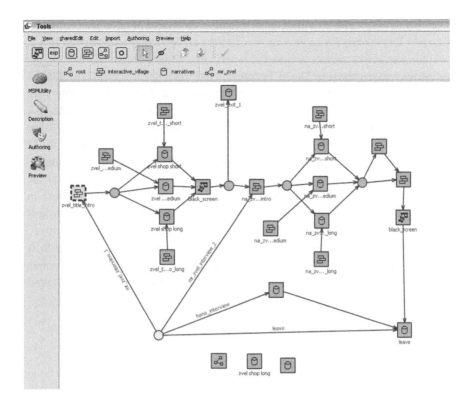

FIGURE 20 NM2 media tools: bin structure

an ABCD choice of interactions to lead to a different narrative arc or, if users reach the end a controlled randomized choice, the program will move to the next narrative arc.

Community Relations

In addition to the aforementioned Observation, Didactic or Journalistic modes, the project aims for a multi-vocal approach whereby the user can select from different perspectives on village life. For example, s/he can choose an 'unofficial' view of the village from Mr Zevl, the newsagent or the 'official' view of the mayor, Mrs Vinarova. Similarly the user may wish to perceive these points of view in the context of the expert 'outsider's' view and select anthropologist Peter Skalník, who comments on recent social and political change. Or yet another view of the village can be selected, perhaps from a female anthropologist. In this case, Hana Novotná can present a different perspective and considers the role of Mr Zevl in the village community. The anthropologists supplied valuable routes of access to the village.

Their involvement had the attraction of adopting the model of good practice set by Granada Television's *Disappearing World* series (1969–1993) (see Loizos, 1993): not only was each programme based on a particular anthropologist's fieldwork, but the series was overseen by David Turton as 'Anthropological Consultant'. On the ethical side, the anthropologists helped to preserve a degree of integrity with regard to the subjects of the production. On the practical side, it meant that our *Interactive Village* filming commenced on the first visit to the village thanks to the anthropologists' good offices encouraging villagers to take part in the enterprise.[9] The involvement of key figures in the village community proved to be an important public relations exercise. While some remained naturally suspicious of the filmmaking process, all were invited to a series of public screenings of work in progress. These were followed by lively debate, suggestions as to how the project could be improved, as well as recommendations for future 'photo opportunities'. Such discussions included the future potential for villagers to incorporate their own personal video diaries and image-capture using camcorders and/or mobile devices and the inclusion of an added dimension whereby the villagers could discover, create and access family and local histories.

Conclusion

The central focus of this book has been directed to the ways we obtain information from visual images. It has proposed that any full account of pictorial communication must take into account two wider contexts: how pictures relate to our 'everyday' perception of the world around us; and the narrative contexts within which we encounter them. By narrative, I not only mean the immediate 'stories' that surround the image, but the wider social and cultural framework in which it functions. The book began by asking fundamental questions about the nature of visual representation. Considering the wide range of systems of representation that have taken place throughout history and across cultures, why are visual images so important and what are their social and cognitive functions? The early chapters examined the complex relationship between our 'everyday' visual perception of the environment and how this relates to the perception of pictures. In doing so, they re-examined psychological experiments that aimed to pinpoint the degree of knowledge or learning one needs in order to achieve full understanding of a picture. In this arena it became apparent that the type of exploratory active theories of perception espoused by James Gibson and his followers not only shed new light on visual images and their perception, but also had a significant bearing on the contemporary development of interactive media forms. It is proposed that the two crucially important areas of investigation in this endeavour are understandings of the communicative function of pictures and the narrative strategies within which they are placed.

Then the existing media narrative structures of television news were considered. While these productions aim to provide an understanding of how large proportions of the population receive up-to-date information about the world they inhabit, it appears that, despite social change and technological innovation, pictorial images themselves change very little. Similarly, objective attempts at providing factual information (the examples of disasters and migration were examined) remain tightly bound by 'classical' storytelling patterns and narratives. Some deviations from the norm were addressed in the form of artists' provision of alternative imagery and experimental narrative strategies. However, in comparison to mass media news broadcasts, these remain very much 'narrowcasts' to specialized audiences.

Finally this broad range of theoretical perspectives were brought together to assess the current state of interactive media in an attempt to predict the future

directions of visual communication. In this context the experimental *Interactive Village* production aimed to explore some of the possible production strategies that might be taken in documentary and indicated a possible erosion of traditional media genres in future. It also served as a 'micro-paradigm' of how media content and technological development can counter-inform one another to result in new media innovation. While Janet Murray (1997) proposes that new media will continue to deliver traditional narratives, in such a way as to create a new art form, Marie-Laure Ryan (2004:356) calls for greater understanding of digitality: 'what themes and kinds of plots take proper advantage of the built-in properties of the medium'. It was to this type of sentiment that *The Interactive Village* and the NM2 project responded, but with a shift in standpoint – that the methods of storytelling themselves could contribute to shaping the characteristics of the new medium. As ever, new forms of visual media will continue to evolve and *visual impact* will continue to be determined by the ways we perceive our environment, by cultural tradition and by technological development.

Notes

Preface

1. Gibson coins the term 'mock reader', who can most obviously be identified in 'subliterary genres crudely committed to persuasion, such as advertising and propaganda'.
2. Interviewed on ITV's *This Morning*, Tuesday, 5 October 2004.
3. 'In mugs and medals, as in music and magnificence, the last quarter of the nineteenth century was a golden age of "invented traditions" ... venerable and decayed ceremonies were revived, and the new institutions were clothed with all the anachronistic allure of archaic but invented spectacle' (Cannadine, 1983:137).
4. Particularly interesting on this subject is Smith (1985).
5. While the film director Lindsay Anderson (1954:1) described Jennings as 'the only real poet the British cinema has yet produced', Chapman (1998:168) finds 'focus on [*Listen to Britain*'s] aesthetic qualities ... has tended to obscure its status as a propaganda text'.
6. BT, UK; Sony Netservices (SNS), Austria; Malmö University, Sweden; University of Art and Design, Helsinki, Finland; Illuminations Television, UK; Eurescom, Germany; Goldsmiths College, University of London, UK; Cambridge University Moving Image Studio, UK; TNO, Netherlands; Telefónica, Spain; Joanneum Research, Austria; Aristotle University of Thessaloniki, Greece; University of Ulster, UK.

Introduction

1. '[T]hese primitive hunters thought that if they only made a picture of their prey – and perhaps belaboured it with their spears or stone axes – the real animals would also succumb to their power' (Gombrich, 1950:23).
2. Gombrich (1950:20), for example, in his *Story of Art*, suggests: 'All that is needed is the will to be absolutely honest with ourselves and see whether we, too, do not retain something of the "primitive" in us.'
3. Quote from Gay-Lussac's report to the Chamber of Peers, 30 July 1839, from Eder, 1945:242.
4. For example, Kühn (1923) has suggested that illusionism in the arts results from social systems based upon exploitation and consumption.

Chapter 1 Perception and Representation

1. An example of an earlier re-evaluation of visual representation is that of the Gestalt psychologists of the 1920s. In many respects they paved the way for Gibson and his followers.
2. A situation not dissimilar from the state of affairs in the fiction film *The Matrix* which we shall explore on page [tbc].
3. According to Sontag (1977:3), it is the 'insatiability of the photographing eye changes the terms of confinement in the cave, our world'.
4. The notion of the *tabula rasa* (Latin for 'scraped tablet') refers to the belief that human beings are born with no innate mental contents. Consequently our entire repertoires of knowledge about the world and survival strategies have been gathered gradually from our experiences and perceptions of the world. See Plotkin (1997:174): 'The notion of a *tabula rasa* learner is biologically inconceivable.'
5. For a detailed analysis of the centrifugal and centripetal theories, see Lindberg (1976).
6. This sentiment had been expressed by Dewey (1896:357) some eighty years earlier, proposing that it is 'the movement of body, head and eye muscles determining the quality of what is experienced. *In other words, the real beginning is with the act of seeing; it is looking, and not a sensation of light*' (my emphasis). The latter sentence has strong links to Gibson's approach.
7. However, this was the view of perception held by the ancient Greeks (see Lindberg, 1976:2).
8. For the wider significance of Gibson's theories in the visual arts see Kennedy, 1974; T. Wright, 1986, 1992.
9. By way of a simple analogy, if we tried to understand how a horse gallops by examining the movement of each leg in turn, we would not get very far in explaining the animal's locomotion. See also Gibson's 'Observations on Active Touch' (1962)
10. 'And what's a film? It's just a window someone peeps through' (D.A. Pennebaker, documentary filmmaker, interviewed in Levin, 1971:235).
11. This view, espoused by Bishop Berkeley (1709), has been perpetuated in photography textbooks: 'as new born babies we had not only to learn to focus our lenses, but also grow used to the inverted images they form' (Langford, 1978:123).
12. An optical illusion used by psychologists to demonstrate how a drawn line can *appear* longer or shorter by the addition of arrows pointing inwards or outwards, respectively.
13. Or indeed the photographer – a photograph of a building with strong converging lines can give the illusion of the photo appearing to have a trapezoid format and/or frame.
14. Indeed, Harry Heft (2001:116–119) gives a brief account of some biographical details that may account for Gibson's 'phenomenological leanings. More detailed accounts can be found in Glotzbach and Heft (1982), who link Gibson to Merleau-Ponty's phenomenology.
15. Bach-y-Rita is now working at the Center for Neuroscience and Department of Rehabilitation Medicine at the University of Wisconsin-Madison Medical School.

Chapter 2 Perceiving Images

1. It may be the cause of further speculation to consider that in French a photographic 'negative' is a *cliché*. Indeed *prendre un cliché* is 'to take a snap-shot'.
2. McLuhan's point about the 'arrested eye' will be taken up later (see p. 000).
3. See Alberti (1435) and John White (1967:123) for the characteristics of artificial perspective.
4. The episode is from the second series, *Blackadder II*, first broadcast on BBC 1.
5. Quoted by Poignant (1992:63). Flower (1894:769–770) points out 'the difficulty, if not impossibility, of classifying them'.
6. Julian Hochberg, personal communication (2006).
7. Fick's further exploits are outlined in Dubow (1995).
8. See Dubow (1995) for a more complete account, esp. chapter 6, 'Mental Testing and the Understanding of the "Native Mind", pp. 197–245.
9. I remember once hearing a story about missionaries bringing a consignment of bibles to an African village. As soon as the tribespeople saw the volumes, they instantly recognised the 'word of God' and took the books straight to their homes. The alternative interpretation was that they had never seen such neat manufactured identical objects before and were quite fascinated by the technological processes that could have produced such novelties. Although this is another unattributed anecdote, it is in accord with Kennedy's suggestion of photographs being regarded as 'special objects'.
10. In their paper 'Too Good to be False: An Essay in the Folklore of Social Science', they examine a supposed correlation between fluctuations in the price of cotton and lynchings in the Southern United States during the 1930s, which became a popular illustration of 'frustration-aggression theory'. Subsequently, despite serious criticism of the correlation 'it continues to wander, zombie-like, through the social science literature' (Reed *et al*, 1987:5).

Chapter 3 Cultural Representation

1. 'Moving the camera across an imaginary line between two or more performers so that the camera reverses its position. When shots are edited together from the different positions, the audience may lose its bearings and become confused' (Konigsberg, 1987:68).
2. An editing technique of inserting 'still lifes' amidst the narrative flow that creates 'intermediate spaces'. These have been cited as characteristic of the Zen Buddhist tradition (Schrader, 1972).
3. Although, apparently, during an eclipse, images of the sun can be cast onto the ground through the foliage of trees (Minnaert, 1993).
4. It was during the Counter-Reformation that the special status of the Virgin Mary gained significance.
5. 'The religious art inspired by the Counterreformation offers the concrete expression of the spirituality of Ignatius. The brightly colored interior of Baroque churches, their illusionist paintings, tonitruous organ music, burning incense, alabaster statues that invite caressing, and even relics (or their containers) occasionally offered to the

touch speak to all of the sense that Ignatius wanted to involve in the religious experience' (Ryan, 2001:291)

Chapter 4 News Media and Pictorial Tradition

1. According to the National Hurricane Center, 'Andrew' was the most expensive disaster in US history, causing $25 billion of damage. Such was the scale of the hurricane that the following year it became the subject of a low-budget feature film, *Triumph over Disaster* (1993). The story, based on 'real events', employed actual news footage of the aftermath to support a tediously wooden account of the human struggle against forces of nature. However, the final cost of Hurricane 'Katrina' (2005), estimated to be $200 billion, is likely to put 'Andrew' into the shade (http://www.msnbc.msn.com/id/9281409/, accessed 15 June 2008).

2. A scandal had ensued as the government of the time interpreted the painting as a political comment on governmental mismanagement. Géricault had begun by sketching several alternative moments of the disaster: *Mutiny, Cannibalism, Sighting of the Argus, Hailing the Approaching Rowing-Boat* and the *Rescue*. As we shall see later in the chapter, it appears that he was following the classical five-act narrative pattern as outlined in Aristotle's *Poetics*. However, for the actual painting the artist has chosen a type of 'decisive moment' that does not depict the obvious dramatic climax – the act of cannibalism – but shows the frantic attempts of the survivors to attract the attention of a passing ship. Although the events in the painting have been stage-managed and dramatized for the sake of making a 'good picture', Géricault himself did interviews with some of the survivors of the shipwreck to add a sense of accuracy to his painting.

3. For example, the Aberfan disaster of 1966 is one such example when a mud slide from the local coal tip engulfed twenty houses and the village school in the Welsh valleys. A year later (3 August 1967) the *Report of the Tribunal Appointed to Inquire into the Disaster at Aberfan on October 21st 1966* concluded: '[T]he Aberfan Disaster is a terrifying tale of bungling ineptitude by many men charged with tasks for which they were totally unfitted, of failure to heed clear warnings, and of total lack of direction from above. Not villains but decent men, led astray by foolishness or by ignorance or by both in combination, are responsible for what happened at Aberfan' (E. Davies, 1967).

4. Also the scale of the disaster is evident in the mountains of bones left over from Cambodia's 'killing fields': 'It is most visible in the piles of skulls and bones across the country. But it can also be seen in the countless unexploded landmines and the psychological problems suffered by many who cannot forget whey they saw' (Havely, 1998).

5. The story also has a pagan–Christian theme in that Hrapp's ghost is finally laid to rest by the Christian King Olaf, implying something of a triumph of Christianity over pagan beliefs and superstitions (Magnusson and Pálsson, 1969:103).

6. Erwin Panofsky (1953:254) describes the Madonna in van der Weyden's painting as seated in 'an ideal throne room'.

7. It has been suggested that the legend strengthened the early Christian debate on the status of images in religious worship. On the origins of this legend, see Williamson

(2004). As Cormack (2000:61) has pointed out, the Luke legend emerged during a period of iconoclasm: 'One opportunist idea to surface during iconoclasm was that St Luke himself was a painter, and had produced portrait icon of Mary and Jesus from life.'

8. http://www.calvin.edu/minds/vol02/issue02/images/fsa/migrant_mother.jpg (accessed 15 September 2008).

9. This adds a new slant to Roland Barthes' observation: 'In front of the lens ... I am neither subject nor object but a subject who feels he is becoming an object.' (1980:13).

10. For further discussion see Warner's chapter 'The Milk of Paradise' (1977:192–223). Apart from the proliferation of the image, Warner also discusses its decline: 'One of the few contemporary survivals ... is a popular German wine – Liebfraumilch; it is the end of the road of one of Christian mysticism's more potent images' (p.204).

11. My thanks to Professor Peter Gatrell for drawing my attention to this image (see Gatrell, 1999).

12. Mathews points out that the donkey or ass also makes numerous appearances in the Old Testament, e.g. Samson and the jaw-bone of an ass (p.46)

13. '[W]hether carrying Hephaistus, the divine smith ... or Silenus, Dionysus' aged mentor. Both of these a drunk, and both might bear a remote comparison with Christ in that they are figures of wisdom, albeit of a very earthy kind' (p.45)

14. http://www.archweb.it/arte/artisti_M/Masaccio_G/images/Masaccio%20-%20The%20Expulsion%20from%20Paradise.JPG (accessed 15 September 2008).

15. Psalm 23: 5.

16. Psalm 11: 6.

17. It could also be noted that such details as the upturned cup have their own trajectory in the history of art. For instance, in Hogarth's engraving *Gin Lane*, we not only have a Madonna and Child image – though in this case the drunken Madonna has lost hold of the child in favour of her addiction – but there is an anti-St Luke figure with paper and quill clasping an upturned glass. http://www.tate.org.uk/britain/exhibitions/hogarth/images/works/gin_lane.jpg

18. The second commandment forbids the making of 'graven images' (Exodus 20: 4–6).

19. http://news.bbc.co.uk/olmedia/1170000/video/_1172503_afghan22_frei_vi.ram (accessed 12 August 2008).

20. Discussion of Salgado's photographs of the Serra Pelada goldmine from *Looking Back at You, Omnibus*, BBC Television programme broadcast on 14 December 1993.

21. The *vesica piscis* – the almond-shaped body halo used as an architectural feature and as an aureole enclosing figures such as Christ or the Virgin Mary in medieval art.

22. http://www.nd.edu/~agutting/Ofili.jpg (accessed 15 September 2008).

23. These protests, however, did not affect the popularity of the video, which at the 1989 MTV Video Music Awards won the Viewers Choice Award, and was nominated for Best Video of the Year.

Chapter 5 The Representation of Refugees

1. According to an eye-witness account:

A lot of people would go alongside the river and watch the fighting. They would stand and watch like damn fools. They killed a little boy who was standing right close to me. He got hit and started crying, and I knew goddamn well he got hit! Deader than hell, a little boy about six or seven years old, standing there watching them. (quoted in Vanderwood and Samponaro, 1988: 131)

2. 'When the UN did decide to summon up an intervention force, the US delayed over the despatch of armoured vehicles – the arguments ranged from what colour to paint the vehicles to who would be paying for the painting' (*When Good Men Do Nothing*, BBC *Panorama*. 7 December 1998).
3. The scene change has echoes of the contrast between McCullin's 'black Madonna' and van der Weyden's *St Luke*.

Chapter 6 Collateral Coverage

1. Interviewed in Pollack (2002).
2. One such example is the opening sequence the film *Carlito's Way* (1993). The story begins with an attack on the Al Pacino character in the New York subway. Once the audience has been thrown into the story, the explanation for the attack is revealed as the film progresses.
3. BBC News 24, 27 October 2001, 8.50.
4. So dramatic were the images that avant-garde composer Karlheinz Stockhausen was tempted to describe the World Trade Center attacks as 'the greatest work of art imaginable for the whole cosmos', and consequently provoked a media outrage. See B. Carter and Barringer (2001) and Sorkin (2002).
5. We find a catalogue of aqueous metaphors: a 'trickle' of refugees who 'stream' over the border; 'floods' of refugees that 'swamp' neighbouring countries; and this is only 'the tip of the iceberg'!
6. In the previous decade William C. Adams (1986:122) had come up with a different set of figures: 'The globe is prioritized so that the death of one Western European equaled three Eastern Europeans equaled 9 Latin Americans equaled 11 Middle Easterners equaled 12 Asians.'
7. It is estimated that running without adverts post-September 11 cost the US commercial TV stations $300 million in lost revenue (David Peeler, quoted in 'US TV ad sales crash', 1 October 2001. http://www.advanced-television.com/2001/2001_newsarchive/1-8oct.html).
8. This is part of a general trend in British terrestrial broadcasting. In monitoring non-news/current affairs factual programmes in 1989–1990 there were 1,0137 hours, in 1998–1999 there were only 728.6 hours (Stone, 2000) .
9. Looking back over recent years there was an extreme cold wave that coincided with an earthquake, in February 2001. This was preceded by a drought in April 2000 following earthquakes in 1991, 1994, 1996, 1998, 1999, 2000 and flash floods in 1992. In addition, mudslides have caused further damage and destruction to homes and have contributed to the spread of disease.
10. Maximizing on resources, CNN made two special reports documenting the difficulties they experienced in getting their news crews to remote areas of Afghanistan once

military action had started.

11. http://news.bbc.co.uk/olmedia/1565000/video/_1568055_aid_short08_vi.ram (accessed 15 July 2008).

12. The overall effect is similar to the pictures of the World Trade Center attacks with the near perpetual repetition of the same shots of the planes hitting the towers.

13. '[I]f the Iranian crisis is regularly rendered by television pictures of chanting "Islamic" mobs accompanied by commentary about "anti-Americanism," the distance, unfamiliarity, and threatening quality of the spectacle limit "Islam" to those characteristics; this in turn gives rise to a feeling that something basically unattractive and negative confronts us. Since Islam is "against" us and "out there," the necessity of adopting a confrontational response of our own towards it will not be doubted' (Said, 1981:44).

14. http://news.bbc.co.uk/olmedia/1590000/video/_1591700_refugees22_keane_vi.ram (accessed 15 July 2008).

15. Screenwriter of films *Die Hard* and *Die Hard II.*

16. This also highlights a characteristic of film as a medium of cultural representation. When using the written word, one can generalize, as can be found in 'classic' ethnography: 'Nuer are very largely dependent on the milk of their herds. ... Their carcasses also furnish Nuer with meat, tools, ornaments. ... Women are more interested in the cows. ... Men's interest in the cow is, apart from their value for breeding, rather for their use in obtaining wives' (Evans-Pritchard, 1956:248). In contrast, a photograph or a film has to deal with specifics and the shot has to concentrate on the individual: not the Nuer; but this Nuer, whose name is *x.* We can see his photograph representing a 'class' of people in Evans-Pritchard's ethnography on Plate XIV titled 'Leopard-skin priest': certainly an individual, yet in this context he remains unnamed.

17. Paraphrasing W.B. Gallie's notion of a story.

18. http://news.bbc.co.uk/olmedia/1170000/video/_1172503_afghan22_frei_vi.ram (accessed 17 July 2008).

19. There are resonances here with Aristotle's notion of *anagnorisis*, the moment when a character moves from ignorance to knowledge, realizes their tragic error, *hamartia* – ignorance or mistaken judgement: the 'tragic flaw'.

20. http://news.bbc.co.uk/olmedia/1665000/video/_1666902_kandahar22_frei_vi.ram (accessed 15 July 2008).

21. See preface, p. x. Michael Buerk's special report from Ethiopia stimulated the massive Live Aid public response. Live Aid was watched by 1.4 billion people worldwide in over 170 countries. The event raised donations of £70 million.

22. A more comprehensive discussion of television documentaries is beyond the scope of this chapter, but see T. Wright (2002).

23. In the attempts of visual anthropologists to document 'other' cultures, the logistical and ethical issues encountered by the more general documentary filmmaker become considerably exaggerated (T. Wright, 2002).

Chapter 7 'To Boldly Go': Digital Media and Interactive Narratives

1. *Star Trek: The Next Generation*, 8 July 1991. 'Darmok' #40275-202. Written by Joe Menosky. Directed by Rick Kolbe.

2. There is an anecdote concerned with correct translation giving rise to misunderstanding. Accordingly at a European Union summit, the delegation from Northern France assured the meeting not to worry as the problem would be solved by 'sagesse Normande', at which point the British delegation fell about laughing. The translators had quite correctly translated the phrase as Norman wisdom, whereby the image of Norman Wisdom (a British comedian who usually plays the part of an inept buffoon) had immediately sprung to mind!

3. Indeed a version of the Gilgamesh story survives on twelve stone tablets written around 2000 BC by Shin-eqi-unninni: the oldest author known by name. Gilgamesh lived around 2700 BC and was king of Uruk, Babylonia (modern Iraq). The Gilgamesh story also includes an account of a flood that threatened to engulf the world. This has been cited as predecessor to a universality of flood myths (including Noah's ark).

4. Of course the whole cultural phenomenon of 'the ashes' themselves requires further explanation. In 1882 after the first English cricketing defeat to the Australians, *The Sporting Times* announced the death of English cricket in the form of a satirical obituary. They declared that the body was to be cremated and the ashes taken to Australia. On the next victorious English tour of Australia the team were presented with a funereal urn containing the ashes of the bails. These came to be known as 'the ashes' and have been fought over ever since.

5. It has been suggested that the 'Hey Diddle Diddle' nursery rhyme described the state of the royal court during the reign of Elizabeth I, or that it provides a description of Richard III's rise to the throne of England.

6. This not only holds true for Western visual images, but also is key to the understanding of Australian Aboriginal painting.

7. Interestingly, this is not so much the case with the *Star Trek* feature films, which adopt more of a linear narrative strategy.

8. Geertz's phrase, taken from his description of the Balinese cock-fight (1973:443), is not an entirely dissimilar state of affairs: 'Men go on allegorically humiliating one another and being allegorically humiliated by one another day after day, glorying quietly in the experience if they have triumphed, crushed only slightly more openly by it if they have not. *But no one's status really changes*.'

9. *The Archers* has the additional luxury of being able to continue the lives of characters even when the actors have died or left the series. As a radio soap, characters do not have a visible identification with any particular actor – the producers appear to consider that after a reasonable period of absence even central characters can be replaced.

10. In fact, it is the recommendation of the Canadian Association of Optometrists that a 42 inch television is viewed from a distance of 15 feet (c. 4.5 metres), bearing in mind that the viewing distance is relative to the screen size (the recommended distance is five times the width of the television picture) (http://www.opto.ca/en/public/, accessed 22 July 2008).

11. The UK's Health & Safety Executive (2006:5) recommend a number of 'short frequent breaks' when using a PC to prevent eye strain and arm injury.
12. 'The cliffhanger is essentially a technological invention – a direct result of the movable-type press' (C. Thompson, 2006).
13. http://proofpositive.com/articles/113/1/SELL-YOUR-PHOTOS-TO-THE-PRESS/ Page1.html
14. http://www.usatoday.com/tech/news/2006-07-16-youtube-views_x.html.
15. For a further more detailed account of the state of play, see Leurdijk *et al.* (2007).
16. Computer games fall outside the main focus of this book; however, for further discussion, see Aarseth (1997), Atkins (2003) and Gee (2003).

Chapter 8 Theory into Practice: *The Interactive Village*

1. NM2 was an Integrated Project under the European 6th Framework Programme in the thematic priority of Information Society Technology. It ran from September 2004 to August 2007.
2. http://www.ist-nm2.org/media_productions.html (accessed 25 July 2008).
3. In association with ARTEC Arts Technology Centre, London. Shown at Milia (interactive industry forum) in Cannes; Paris; ICA and the Photographer's Gallery, London; ISEA, Montreal; and Watershed, Bristol.
4. An update on this enterprise took place in 2007 in the form of the Channel 4 Television production *Meet the Natives*. See G. Adams (2007) and Khaleeli (2007), who was less enthusiastic about the programme.
5. School of Arts and Communication/K3: Konst, Kultur och Kommunikation (http://www.mah.se/templates/Pages____13026.aspx accessed 15 September 2008).
6. According to the Royal Anthropological Institute's film catalogue (Woodburn, 1982):

> A sophisticated 'observational' style is used, with long takes, few pans, no commentary or formal interviews and full subtitling. Caption cards are used to good effect, conveying necessary information without intruding on the narrative. These 'technical' factors have important consequences for the film's anthropological value, not least because one of the aims was to enable the Eskimos to 'speak for themselves'. Although it would be naive to suggest that the 'people's voice' manages to override the exigencies of making such a film for a 52 minute television slot, the Eskimos did have a say in the making of the film, and one of them was also involved in the editing.

7. The literary term *in medias res* refers to instances where story begins in the middle of events or a narrative. The term first appears in Horace's *Ars Poetica* of 65–68 BC (Horace 1929). Directly translated from the Latin it means 'into the midst of things'.
8. This is reminiscent of the anthropologist Malinowski's notion of 'imponderabilia', in which the 'imponderable yet all-important facts of everyday life are part of the real substance of the social fabric' (Malinowski, 1922:19). In Edmund Leach's words (1957:120), 'Malinowski trained his fieldworkers to observe the apparently unimportant minute detail.'

9. In comparison the makers of the University of South Carolina project '*Promises Made*' – *A Video Documentary in Rural South Carolina* found themselves having to approach the community 'cold'; consequently it took six months before any villagers would agree to appear in front of the camera (Hogue and Waring, 2005).

References

Aarseth, E. (1997) *Cybertext: Perspectives on Ergodic Literature*. Baltimore: Johns Hopkins University Press

Adams, G. (2007) 'Strange Island: Pacific Tribesmen Come to Study Britain', *The Independent*, 8 September

Adams, W.C. (1986) 'Whose Lives Count? TV Coverage of Natural Disasters', *Journal of Communication* 36 (2):113–122

Alagiah, G. (2001) 'Shaking the Foundations', in J. Baxter and M. Downing (eds), *The Day That Shook the World*. London: BBC

Alberti, L.B. (1435) *Della Pittura*, ed. H. Janitschek. London: Routledge & Kegan Paul, 1956

Alexander, L. (1998) 'Palestinians in Film: Representing and Being Represented in the Cinematic Struggle for National Identity', *Visual Anthropology* 10 (2–4):319–334

Alifragkis, S. and Penz, F. (2006) 'Spatial Dialectics: Montage and Spatially Organized Narrative in Stories without Human Leads', *Digital Creativity* 17 (4):221–233

Allen, T. and Seaton, J. (eds) (1999) *The Media of Conflict: War Reporting and Representations of Ethnic Violence*. London: Zed Books

Alter, J. (1997) 'Genuflect Journalism', *Newsweek*, 22 September

Anderson, B. (2001) 'War Coverage Costing Millions Extra', 30 October. CNN. http://www.cnn.com/2001/WORLD/europe/10/30/gen.media.costs, accessed 25 July 2008

Anderson, L. (1954) 'Only Connect: Some Aspects of the Work of Humphrey Jennings', *Sight and Sound* 23 (4):1

Ardèvol Piera, E. (2002) 'Teaching Anthropology Virtually: Learning Communities at Work', *Anthropology in Action* 9 (2):32–42

Aristotle (1927) *Problemata*, ed. W.D. Ross, Oxford: Oxford University Press

Aristotle (1961) *Aristotle's Poetics*, ed. F. Fergusson, trans. S.H. Butcher. London: Hill & Wang

Arnheim, R. (1956) *Art and Visual Perception*. London: Faber & Faber

—— (1987) 'The Perception of Images', in R.L. Gregory (ed.), *The Oxford Companion to the Mind*. Oxford: Oxford University Press

Ash, R. (1990) *Sir Lawrence Alma-Tadema*. New York: Harry N. Abrams

Aslin, C., Blake, R. and Chun, M.M. (2002) 'Perceptual Learning of Temporal Structure', *Vision Research* 42:3019–3030

Atkins, B. (2003) *More Than Game: The Computer Game as Fictional Form*. Manchester: Manchester University Press

Auden, W.H. (1940) '*Musée des Beaux Arts*', in *Another Time*. London: Faber & Faber

Aumont, J. (1997) *The Image*. London: British Film Institute

Austin, M. (2000) 'Would We Care without the Tide of TV Images?', *The Sunday Times*, 5 March

Australian Museum and Ecowatch (2004) *Skills for Nature Conservation: Minibeasts*. Factsheet. Western Australia: Swan Catchment Centre

Bach-y-Rita, P., Tyler, M.E. and Kaczmarek, K.A. (2003) 'Seeing with the Brain', *International Journal of Human–Computer Interaction* 15 (2):285–295

Bærentsen, K.B. (2000): 'Intuitive User Interfaces', *Scandinavian Journal of Information Systems* 12:29–60

Banks, M. and Morphy, H. (eds) (1997) *Rethinking Visual Anthropology*. New Haven and London: Yale University Press

Banks, M.S., Aslin, R.N. and Letson, R.D. (1975) 'Sensitive Period for the Development of Human Binocular Vision', *Science* 190:675–677

Barbash, I. and Taylor, L. (1997) *Cross-Cultural Filmmaking*. Berkeley and Los Angeles: University of California Press

Barkin, G. and Stone, G.D. (2000) 'Anthropology: Blurring the Lines and Moving the Camera – The Beginnings of Web-Based Scholarship in Anthropology', *Social Science Computer Review* 18 (2):125–131

Barnes, J. (1989) *A History of the World in 10½ Chapters*. New York: Vintage

Barthes, R. (1977) 'The Photographic Message', in *Image Music Text*. London: Fontana

—— (1982) *Camera Lucida*, trans. R. Howard. London: Jonathan Cape

—— (1997) *Sade/Fourier/Loyola*. Baltimore: Johns Hopkins University Press

Bazin, A. (1967) *What Is Cinema? Vol. I*, trans. H. Gray. Los Angeles: University of California Press

Beardsley, M.C. (1966) *Aesthetics: From Classical Greece to the Present*. Tuscaloosa: University of Alabama Press

Beattie, L., Miller, D., Miller, E. and Philo, G. (1999) 'The Media and Africa: Images of Disaster and Rebellion', in G. Philo (ed.), *Message Received: Glasgow Media Group Research 1993–1998*. Harlow: Longman

Benthall, J. (1993) *Disasters, Relief and the Media*. New York: I.B. Tauris

Berger, J. (1972) *Ways of Seeing*. Harmondsworth: Penguin

Berkeley, G. (1709) 'An Essay towards a New Theory of Vision', in C.M. Turbayne (ed.), *Works on Vision: Berkeley*. New York: Greenwood, 1963

Boas, F. (1927) *Primitive Art*. New York: Dover, 1955

Bovet, D. and Vauclair, J. (2000) 'Picture Recognition in Animals and Humans', *Behavioural Brain Research* 109:143–165

Bower, T.G.R. (1977) *The Perceptual World of the Child*. Cambridge, MA: Harvard University Press

Boyd, W. (1984) *Stars and Bars*. Harmondsworth: Penguin

Bradbury, R. (1950) 'There Will Come Soft Rains', in F. Pohl (ed.), *Beyond the End of Time*. New York: Permabooks, 1952

Braun, T.E.D. and Radner, J.B. (eds) (2005) *The Lisbon Earthquake of 1755: Representations and Reactions*. Oxford: Voltaire Foundation

Bronson, B.H. (1968) 'Strange Relations: The Author and His Audience', in *Facets of the Enlightenment: Studies in English Literature and Its Contexts*. Berkeley and Los Angeles: University of California Press

Brown, M. (2001) 'Terror, tears, talk', *The Guardian,* Monday 17 September, http://www.guardian.co.uk/media/2001/sep/17/mondaymediasection.september 112001 (accessed 15 September 2008)

Bryson, B. (1999) *Notes from a Big Country*. London: Black Swan

Buckingham, D. (1987) *Public Secrets: EastEnders and Its Audience*. London: British Film Institute

Cairncross, F. (1997) *The Death of Distance: How the Communication Revolution will Change Our Lives*. London: Orion

Cannadine, D. (1983) 'The Context, Performance and Meaning of Ritual: The British Monarchy and the "Invention of Tradition', c.1820–1977', in E. Hobsbawm and T. Ranger (eds), *The Invention of Tradition*. Cambridge: Cambridge University Press

Carruthers, S.L. (2000) *The Media at War: Communication and Conflict in the Twentieth Century.* London: Macmillan

Carter, B. and Barringer, F. (2001) 'In Patriotic Time, Dissent is Muted', *The New York Times*, 28 September

Carter, B.A.R. (1953) 'The Perspective of Piero della Francesca's "Flagellation"', *Journal of the Warburg and Courtauld Institute* 16:292–302

Castells, M. (2000) *The Rise of the Network Society*. 2nd edition. Oxford: Blackwell

Chang, T.-K. and Lee, J.-W. (1992) 'Factors Affecting Gatekeepers' Selection of Foreign News: A National Survey of Newspaper Editors', *Journalism Quarterly* 69 (3):554–561

Chapman, J. (1998) *The British at War: Cinema, State and Propaganda, 1939–1945*. London: I.B. Tauris

Clark, K. (1949) *Landscape into Art*. Harmondsworth: Pelican

Connolly, S. (trans.) (1995) *Bede: On the Temple*. Liverpool: Liverpool University Press

Cormack, R. (2000) *Byzantine Art*. Oxford: Oxford University Press

Crary, J. (1992) *Techniques of the Observer: On Vision and Modernity in the Nineteenth Century*. Cambridge, MA: MIT Press

Curran, S. (2003) *Convergence Design*. Gloucester, MA: Rockport

Cutting, J.E. and Massironi, M. (1998) 'Pictures and Their Special Status in Perceptual and Cognitive Inquiry', in J. Hochberg (ed.), *Perception and Cognition at Century's End: History, Philosophy, and Theory*. San Diego: Academic Press

Dalrymple, J. (1999) 'War in the Balkans: Like an Oil Painting of Hell – and Still the Dispossessed Flood In', *The Independent*, 3 April

Danziger, N. (2005) 'History in the Raw', *The Times*, 3 September

Davenport, R.K. and Rogers, C.M. (1971) 'The Perception of Photographs by Apes', *Behaviour* 39:318–320

Davies, E. (chairman) (1967) *Report of the Tribunal Appointed to Inquire into the Disaster at Aberfan on October 21st 1966* , HL 316, HC 553. London: HMSO

Davies, M.W. (2001–2002) 'September 11: The Visual Disaster', *Third Text: Critical Perspectives on Contemporary Art and Culture* 57:13–22

Deans, J. (2001) '16m Glued to News as Tragedy Unfolds', *The Guardian*, 12 September

Deloache, J.S., Pierroutsakaos, S.L., Uttal, D.H., Rosengren, K.S. and Gottlieb, A. (1998) 'Grasping the Nature of Pictures' *Psychological Science* 9:205–210

Descartes, R. (1637) 'The Dioptrics', in E. Anscombe and P.T. Geach (eds), *Descartes: Philosophical Writings*, London: Nelson, 1970

—— (1641) *Meditations on First Philosophy*, trans. J. Cottingham, Cambridge: Cambridge University Press, 1996

Desser, D. (ed.) (1997) *Ozu's Tokyo Story*. Cambridge: Cambridge University Press

Dewey, J. (1896) 'The Reflex Arc Concept in Psychology', *Psychological Review* 3:357–370

Dick, P.K. (1981) *VALIS*. New York: Bantam

Doob, L. (1961) *Communication in Africa*. London and New Haven: Yale University Press

Douglas, T. (2001) 'Interacting with Beasts', 15 November, BBC News Online, http://news.bbc.co.uk/1/hi/entertainment/tv_and_radio/1658575.stm (accessed 23 July 2008)

Dubow, S. (1995) *Scientific Racism in Modern Africa*. Cambridge: Cambridge University Press

Dubrey, F. and Willats, J. (1972) *Drawing Systems*. London: Studio Vista

Dyck, E. and Coldevin, G. (1992) 'Using Positive vs. Negative Photographs for Third-World Fund-Raising', *Journalism Quarterly* 69 (3):572–579

Eastlake, E. (1857) 'Photography', *Quarterly Review* 101:442–468

Eaton, I. (2001) 'A Choice of Disasters: BBC Television News Coverage of Earthquakes, Storms and Floods'. Oxford, Reuters Foundation, Green College

Eco, U. (1972) 'The Myth of Superman', *Diacritics* 2 (1):14–22

Economist, The (2006) 'Gaming's Next Episode?', 21 September

Eder, J.M. (1945) *History of Photography*, trans. E. Epsteam. New York: Columbia University Press

Edgerton, S.Y. (1980) 'The Renaissance Artist as Quantifier', in M.A. Hagen (ed.), *The Perception of Pictures*. New York: Academic Press

Ehrlich, L.C. (1997) 'Travel Toward and Away: *Furusato* and Journey in Tokyo Story', in D. Desser (ed.), *Ozu's Tokyo Story*. Cambridge: Cambridge University Press

Euronews (2001) 'No Comment'. http://www.euronews.net/en/nocomment (accessed 6 September 2008)

Evans, H. (1978) *Pictures on a Page*. London: Heinemann

Evans-Pritchard, E.E. (1956) *Nuer Religion*. Oxford: Clarendon

Fahrmeier, E. (1973) 'The Validity of the Transactionalist's Assumed World: A Critical Reinterpretation of Experiments in Size Constancy', *Journal of Phenomenological Psychology* 4:261–270

Farnell, B and Huntley, J. (1995) 'Ethnography Goes Interactive'. *Anthropology Today* 11 (5):7–10

Fielding, H. (1994) *Cause Celeb*. London: Picador

Firth, R. (1992) 'Art and Anthropology', in J. Coote and A. Shelton (eds). *Anthropology, Art and Aesthetics*. Oxford: Clarendon

Flores, T. (1985) 'The Anthropology of Aesthetics', *Dialectical Anthropology* 10:27–41

Flower, W. H. (1894) Presidential Address to Section H, Anthropology. *BAAS Transactions* 64:769–770

Forge, A. (1966) 'Art and Environment in the Sepik', *Proceedings of the Royal Anthropological Institute for 1965*. London: Royal Anthropological Institute, 23–31

—— (1970) 'Learning to See in New Guinea', in P. Mayer (ed.), *Socialization: The Approach for Social Anthropology*. London: Tavistock

Frei, M. (2001) BBC News http://news.bbc.co.uk/olmedia/1170000/video/_1172503_afghan22_frei_vi.ram (accessed 15 September 2008)

Freytag, G. (1908) *Freytag's Technique of the Drama: An Exposition of Dramatic Composition and Art*. Chicago, Scott, Foresman and Co

Galla, K. (1939) *Dolní Roveň: Sociologický obraz české vesnice*. Prague: Spolek péče o blaho venkova

Gatrell, P. (1999) *A Whole Empire Walking: Refugees in Russia During World War I*. Bloomington: Indiana University Press

Gee, J.P. (2003) *What Video Games Have to Teach Us About Learning and Literacy*, London: Palgrave Macmillan

Geertz, C. (1973) 'Thick Description: Toward an Interpretive Theory of Culture', *The Interpretation of Cultures*. New York: Basic Books

Gell, A. (1992) 'The Technology of Enchantment and the Enchantment of

Technology', in J. Coote and A. Shelton (eds), *Anthropology, Art and Aesthetics.* Oxford: Oxford University Press

Gibney, M.J. (1999) 'Kosovo and Beyond: Popular and Unpopular Refugees', *Forced Migration Review*, August:28–30

Gibson, J.J. (1962) 'Observations on Active Touch', *Psychological Review* 69 (6):477–491

——— (1966) *The Senses Considered as Perceptual Systems.* Boston: Houghton Mifflin

——— (1967) 'Autobiography', in E. Reed and R. Jones (eds), *Reasons for Realism: Selected Essays of James J. Gibson.* Hillsdale, NJ: Erlbaum, 1982

——— (1974) 'Ecological Optics', in E.S. Reed and R.K. Jones (eds), *Reasons for Realism: Selected Essays of James J. Gibson.* Hillsdale, NJ: Erlbaum, 1982

——— (1979) *The Ecological Approach to Visual Perception.* Boston: Houghton Mifflin

Gibson, Walker (1950) 'Authors, Speakers, Readers, and Mock Readers', in J.P. Tompkins (ed.), *Reader-Response Criticism: From Formalism to Post-Structuralism.* Baltimore: Johns Hopkins University Press, 1980

Gibson, William (1984) *Neuromancer.* London: Gollancz

Gillespie, M. (1995) *Television, Ethnicity and Cultural Change.* London: Routledge

Gioseffi, D. (1957) 'Perspective', in *Encyclopaedia of World Art, Vol. II.* New York: McGraw-Hill Education

Glotzbach, P. and Heft, H. (1982) 'Ecological and Phenomenological Contributions to the Psychology of Perception', *Nous* 16:108–121

Goldberg, R. (1989) 'Voltaire, Rousseau and the Lisbon Earthquake', *Eighteenth-Century Life* 13 (2):1–20

Goldberg, V. (1991) *The Power of Photography.* New York: Abbeville Press

Gombrich, E.H. (1950) *The Story of Art.* London: Phaidon

——— (1960) *Art and Illusion.* London: Phaidon

——— (1975) 'Mirror and Map: Theories of Pictorial Representation', *Philosophical Transactions of the Royal Society of London*, Series B, Vol. 270, No. 903:119–149

Goodman, N. (1967) *Languages of Art: An Approach to a Theory of Symbols.* Indianapolis: Hackett Publishing. New edition, 1988

Graburn, N. (ed.) (1976) *Ethnic and Tourist Arts*, Berkeley, University of California Press

Grau, C. (ed.) (2005) *Philosophers Explore the Matrix.* Oxford: Oxford University Press

Graves, R. (1934) *I, Claudius: From the Autobiography of Tiberius Claudius.* London: Arthur Barker

Gregory, R. (1972) *Eye and Brain: The Psychology of Seeing.* London: Weidenfeld and Nicolson

Gutman, J.M. (1982) *Through Indian Eyes: 19th- and Early 20th-Century Photography from India.* New York: Oxford University Press

Hafez, K. (ed.) (1999). *Islam and the West in the Mass Media: Fragmented Images in a Globalizing World.* Cresskill, NJ: Hampton Press

Hagen, M.A. (1986) *Varieties of Realism: The Geometries of Representational Art.* Cambridge: Cambridge University Press

Harmetz, A. (1992) *Round up the Usual Suspects: the Making of* Casablanca – *Bogart, Bergman, and World War II.* New York: Hyperion

Havely, J. (1998) 'Masters of the Killing Fields'. 24 July. BBC News Online. http://news.bbc.co.uk/1/hi/special_report/1998/07/98/cambodia/135476.stm, accessed 15 July 2008

Hawk, B. (ed.) (1992) *Africa's Media Image.* New York: Praeger

Hayes, K.J. and Hayes, C (1953) 'Picture Perception in a Home-Raised Chimpanzee', *Journal of Comparative Behaviour* 46:470–474

Health and Safety Executive (2006) *Working with VDUs.* December. Leaflet INDG36

Heft, H. (2001) *Ecological Psychology in Context: James Gibson, Roger Barker and the Legacy of William James's Radical Empiricism.* Hillsdale, NJ: Erlbaum

Heinrich, C. (2000) *Claude Monet 1840–1926.* Cologne: Taschen

Henley, P. (1985) 'British Ethnographic Film', *Anthropology Today* 1 (1):5–17

Herrnstein, R.J. and Loveland, D.H. (1964) 'Complex Visual Concept in the Pigeon', *Science* 146:549–551

Herskovits, M.J. (1948) *Man and His Works.* New York: Alfred A. Knopf

Hess, S. (1996) *International News and Foreign Correspondents.* Washington: Brookings Institute

Hiller, S. (ed.) (1991) *The Myth of Primitivism: Perspectives on Art.* London: Routledge

Hochberg, J. and Brookes, V. (1962) 'Pictorial Recognition as an Unlearned Ability', *American Journal of Psychology* 75:624–628

Hodgson, J. (2001) 'BBC Puts Investigations Unit on Hold', *The Guardian*, 26 November

Hoffman, S.M. (2002) 'The Monster and the Mother: The Symbolism of Disasters', in S.M. Hoffman and A. Oliver-Smith (eds), *Catastrophe and Culture: The Anthropology of Disaster.* Oxford: James Currey

Hogarth, W. (1973) *Engravings*, ed. S. Shesgreen. New York: Dover

Hogue, S. and Waring, L. (2005) *'Promises Made' – A Video Documentary in Rural South Carolina.* Paper presented at 2005 Hawaii International Conference on Arts and Humanities, Honolulu, Hawaii. 16 January

Horace (1929) *Horace: Satires, Epistles, and Ars Poetica*, trans. H.R. Fairclough. London: Loeb Library

Horne, K. (2000) 'Mozambique: An Aid Worker's View', 3 March. BBC News

Online. http://news.bbc.co.uk/1/hi/world/africa/665140.stm, accessed 25 July 2008

Housden, T. (2001) 'Tampa Case Highlights Afghan Crisis', 4 September. BBC News Online. http://news.bbc.co.uk/1/hi/world/south_asia/1525264.stm, accessed 25 July 2008

House of Representatives (2006) *Final Report: U.S. House of Representatives Select Bipartisan Committee to Investigate the Preparation for and Response to Hurricane Katrina* (Tom Davis, Chairman), http://a257.g.akamaitech.net/7/257/2422/15feb20061230/www.gpoaccess.gov/katrinareport/execsummary.pdf (accessed 29 September 2008)

Hughes, C.J. (1861) 'On Art Photography', *American Journal of Photography* 3:260–263

Hudson, W (1967) 'The Study of the Problem of Pictorial Perception among Unacculturated Groups', *International Journal of Psychology* 2:89–107

Ignatieff, M. (1998) 'Is Nothing Sacred? The Ethics of Television', in *The Warrior's Honor: Ethnic War and the Modern Conscience*. London: Vintage

—— (2001) *Virtual War: Kosovo and Beyond*. London: Chatto and Windus

Ingold, T. (2000) *The Perception of the Environment: Essays in Livelihood, Dwelling and Skill*. London: Routledge

—— (2004) 'Culture on the Ground: The World Perceived through the Feet', *Journal of Material Culture* 9:315–340

Isherwood, C. (1939) *Goodbye to Berlin*. London: Hogarth

Jaar, A. (1998) *Let There Be Light: The Rwanda Project: 1994–1998* Barcelona: Actar

Jenkins, H. (2006) *Convergence Culture: Where Old and New Media Collide*. New York: New York University Press

Jenks, C. (1995) 'The Centrality of the Eye in Western Culture: An Introduction', in C. Jenks (ed.), *Visual Culture*. London: Routledge

Jenssen, H. and Heck, A. (1999) *Interactive Design 1: The International Collection of New Media*. New York: Graphis

Jordanova, L. (2006) *History in Practice*. 2nd edition. London: Hodder Arnold

Kennedy, J.M. (1974) *A Psychology of Picture Perception: Images and Information*. San Francisco: Jossey-Bass

Kerouac, J. (1957) *On the Road*. Harmondsworth: Penguin

Khaleeli, H. (2007) 'Channel 4's *Meet the Natives*: Part of TV's New Cultural Voyeurism?', *The Guardian*, 11 September

Kidd, D. (1904) *The Essential Kafir*. London: A & C Black

Konigsberg, I. (1987) *The Complete Film Dictionary*. London: Bloomsbury

Kracauer, S. (1960) *Theory of Film: The Redemption of Physical Reality*. New York: Oxford University Press

Kubler, G. (1962) *The Shape of Time: Remarks on the History of Things*. New Haven: Yale University Press

Kuchler, S. (1987) 'Malangan: Art and Memory in a Melanesian Society', *Man* 22:238–255

Kühn, H. (1923) *Die Kunst der Primitiven.* Munich

Landau, P.S. (2002) 'An Amazing Distance: Pictures and People in Africa', in P.S. Landau and D.D. Kaspian (eds), *Images and Empires: Visuality in Colonial and Postcolonial Africa.* Berkeley and Los Angeles: University of California Press

Landau, P.S. and Kaspin, D.D. (eds) (2002) *Images and Empires: Visuality in Colonial and Postcolonial Africa.* Berkeley and Los Angeles: University of California Press

Lange, A. (1998). Video Art Installation *Refugee Talks.* Melbourne International Biennial

Lange, D. (1960) 'The Assignment I'll Never Forget: *Migrant Mother*', *Popular Photography* 46 (2):42–43

Langford, M.H. (1978) *Basic Photography.* 4th edition. London: Focal Press

Laurel, B. (1990) *Computers as Theatre.* New York: Addison-Wesley

Layton, R. (1981) *The Anthropology of Art.* 2nd edition. London: Granada, 1991

Leach, E. (1957) 'The Epistemological Background to Malinowski's Empiricism', in R. Firth (ed.), *Man and Culture: An Evaluation of the Work of Bronislaw Malinowski.* London: Routledge & Kegan Paul

Lemon, L.T. and Reiss, R.J. (eds) (1965) *Russian Formalist Criticism: Four Essays.* Lincoln: University of Nebraska Press

Leurdijk, A., de Boer, J., Esmeijer, J., Limonard, S., Mevissen, F., Pals, N. and van der Duin, P. (2007) 'Envisioning the Future of ShapeShifted TV NM2 Scenario's for 2012' (D7.12). http://www.immovator.nl/files/images/NM2_D7-12_Envisioning-the-future-of-ShapeShifted-Media.pdf, accessed 25 July 2008

Levi, C. (1947) *Christ Stopped at Eboli.* Harmondsworth: Penguin, 1982

Levin, G.R. (1971) *Documentary Explorations: 15 Interviews with Film-makers.* New York: Doubleday

Levine, L. W. (1988) 'The Historian and the Icon: Photography and the History of the American People in the 1930s and 1940s', in C. Fleischhauer and B.W. Brannan (eds), *Documenting America 1935–1943.* Berkeley and Los Angeles: University of California Press

Levy, E. (2004) *Propaganda and the Jesuit Baroque.* Berkeley and Los Angeles: University of California Press

Lewis-Williams, J.D. (2003) *A Cosmos in Stone: Interpreting Religion and Society through Rock Art.* Walnut Creek, CA: AltaMira Press

Life magazine (1966) 'The Voices of the Photograph', 23 December

Lindberg, D.C. (1976) *Theories of Vision from Al-Kindi to Kepler.* Chicago: University of Chicago Press

Livingstone, M. (2002) *Vision and Art: The Biology of Seeing.* New York: Harry N. Abrams

Lloyd, A.B. (1904) 'Alcholi Country: Part 2', *Uganda Notes* 5:18

Lodge, D. (1996) *Therapy.* Harmondsworth: Penguin

Loizos, P. (1993) *Innovation in Ethnographic Film: From Innocence to Self-Consciousness, 1955–1985.* Manchester: Manchester University Press

Longinus (1953) *On the Sublime,* trans. W. Hamilton Fyfe. London: Loeb Library

Loomis, J.M. and Lederman, S.J. (1986) 'Tactual Perception', in K. Boff, L. Kaufman and J. Thomas (eds), *Handbook of Perception and Human Performance.* New York: Wiley

Lübbe, H. (1960) 'Positivism and Phenomenology: Mach and Husserl', in T. Luckman (ed.), *Phenomenology and Sociology.* London: Penguin

Lukowski, P.D. (1988) Archaeological Survey Report No. 135. Center for Archaeological Research, University of Texas at San Antonio, San Antonio, Texas

Lutz, C. and Collins, J. (1993) *Reading National Geographic.* Chicago: University of Chicago Press

MacClancy, J. (1995) 'Brief Encounter: The Meeting, in Mass Observation, of British Surrealism and Popular Anthropology', *The Journal of the Royal Anthropological Institute* 1 (3):495–512

MacDougall, D. (1998) *Transcultural Cinema.* Princeton, NJ: Princeton University Press

McGrenere, J. and Ho, W. (2000) 'Affordances: Clarifying and Evolving a Concept', in *Proceedings of Graphics Interface 2000.* Montreal, Canada

McLuhan, M. (1964) *Understanding Media: The Extensions of Man.* New York: McGraw-Hill

—— (1970) *Counterblast.* London: Rapp & Whiting

Magnusson, M. and Pálsson, H. (trans.) (1969) *Laxdaela Saga.* London: Penguin Classics

Malinowski, B. (1922) *Argonauts of the Western Pacific: An Account of Native Enterprise and Adventure in the Archipelagoes of Melanesian New Guinea.* London: Routledge & Kegan Paul

Malkki, L. (1995) *Purity and Exile: Violence, Memory and National Cosmology among Hutu Refugees in Tanzania.* Chicago: University of Chicago Press

Maniura, R. (2003) 'The Icon is Dead, Long Live the Icon', in A. Eastman and L. James (eds), *Icon and Word: The Power of Images in Byzantium.* Aldershot: Ashgate

Marash, D. (1995) 'Big Story, Small Screen', *Columbia Journalism Review* July/August:9

Marcus, G. (1995) 'The Modernist Sensibility in Recent Ethnographic Writing and the Cinematic Metaphor of Montage', in L. Devereaux and R. Hillman (eds), *Fields of Vision: Essays in Film Studies, Visual Anthropology and Photography.* Berkeley University of California Press

Martin, L. (1986) 'Eskimo Words for Snow: A Case Study in the Genesis and Decay of an Anthropological Example', *American Anthropologist* 88 (2):418–423

Martínez, O.J. (1983) *Fragments of the Mexican Revolution: Personal Accounts from the Border*. Albuquerque: University of New Mexico Press

Mathews, T.F. (1993) *The Clash of the Gods: A Reinterpretation of Early Christian Art*. Princeton, NJ: Princeton University Press

Miller, J.G. (1999) 'Cultural Psychology: Implications for Basic Psychological Theory' *Psychological Science* 10 (2):85–91

Miller, R.E., Caul, W.F. and Mirsky, I.A. (1967) 'Communication of Affects between Feral and Socially Isolated Monkeys', *Journal of Personality and Social Psychology* 7:231–239

Miller, R.J. (1973) 'Cross-Cultural Research in the Perception of Pictorial Materials', *Psychological Bulletin* 80:135–150

Minear, L., Scott, C. and Weiss, T.G. (1996) *The News Media, Civil War, and Humanitarian Action*. London: Lynne Rienner

Minnaert, M.G.J. (1993) *Light and Colour in the Outdoors*, trans. and revised by L. Seymour. New York: Springer-Verlag

Mitchell, W.J. (1992) *The Reconfigured Eye: Visual Truth in the Post-Photographic Era*. Cambridge, MA: MIT Press

Moctezuma, E.M. (1988) *The Great Temple of the Aztecs*. London: Thames and Hudson

Moeller, S.D. (1999) *Compassion Fatigue: How the Media Sell Disease, Famine, War and Death*. New York and London: Routledge

Moore, A. (1998) 'Alfredo Jaar's Rwanda project', 21 May. Artnet. http://www.artnet.com/magazine_pre2000/reviews/moore/moore5-21-98.asp, accessed 26 July 2008

Morphy, H. (1980) 'What Circles Look Like', *Canberra Anthropology* 3 (1):17–36

—— (1989) 'On Representing Ancestral Beings' in H. Morphy (ed.), *Animals into Art*. London: Unwin Hyman

Moser, S. (1998) *Ancestral Images: The Iconography of Human Origins*. Stroud: Sutton Publishing

Mundy-Castle, A.C. (1966) 'Pictorial Depth Perception in Ghanaian Children', *International Journal of Psychology* 1:195–211

Munn, N. (1973) *Walbiri Iconography: Graphic Representation and Cultural Symbolism in Central Australian Society*. Ithaca, NY: Cornell University Press

Murray, J. (1997) *Hamlet on the Holodeck: The Future of Narrative in Cyberspace*. Cambridge, MA: MIT Press

Mustafa, H.N. (2002) 'Portraits of Modernity: Fashioning Selves in Dakarois Popular Photography', in P.S Landau and D.D. Kaspin (eds), *Images and Empires: Visuality in Colonial and Postcolonial Africa*. Berkeley and Los Angeles: University of California Press

Neale, S. (1990) 'Questions of Genre', *Screen* 31 (1):45–66

Neisser, U. (1989) *Concepts and Conceptual Development: Ecological and Intellectual Factors in Categorization*. Cambridge: Cambridge University Press

Neuman, J. (1996) *Lights, Camera, War: Is Media Technology Driving International Politics?* New York: St Martin's Press

Nichols, B. (1981) *Ideology and the Image: Social Representation in the Cinema and Other Media.* Bloomington: Indiana University Press

Nicholson, M. (1999) 'Thousands Dead in India' – Not Many Interested', *The Evening Standard*, 5 November

NIPR (1958) 'Annual Report for the Year 1 April 1957–31 March 1958. Johannesburg: NIPR Archives

Norman, D.A. (1999a) *Invisible Computer: Why Good Products Can Fail, the Personal Computer Is So Complex and Information Appliances Are the Solution.* London: MIT Press

—— (1999b) 'Affordances, Conventions, and Design', *Interactions* 6 (3):38–41

Novotná, H. (2004) 'Global versus Local: Share of Global Culture on the Village Culture', in P. Skalník (ed.), *Dolní Roveň: Research at Half-Time.* Pardubice: University of Pardubice

—— (2005) 'Ethnography of Popular Culture: Problem of Method', in P. Skalník (ed.), *Anthropology and Europe: Teaching and Research.* Prague Studies in Sociocultural Anthropology. Prague: SET OUT

Panofsky, E. (1924–1925) 'The Concept of Artistic Volition', trans. K. Northcott and J. Snyder, *Critical Inquiry* VIII, Autumn 1981:17–33

—— (1953) *Early Netherlandish Painting: Its Origin and Character.* New York: HarperCollins

Paperstergiadis, N. (2001–2002). ' "Everything That Surrounds": Theories of the Everyday, Art and Politics', *Third Text: Critical Perspectives on Contemporary Art and Culture* 57:71–86

Philo, G and Beattie, L. (1999) 'Race, Migration and Media', in G. Philo (ed.), *Message Received: Glasgow Media Group Research 1993–1998.* Harlow: Longman

Pinker, S. (1997) *How the Mind Works.* London: Penguin

Pirenne, M.H. (1952) 'The Scientific Basis of Leonardo da Vinci's Theory of Perspective', *British Journal for the Philosophy of Science* 3:169–185

—— (1967) *Vision and the Eye.* 2nd edition. London: Chapman and Hall

—— (1974) *Optics, Painting and Photography.* Cambridge: Cambridge University Press

Plotkin, H. (1997) *Evolution in Mind: An Introduction to Evolutionary Psychology.* Harmondsworth: Allen Lane

Poignant, R. (1992) 'Surveying the Field of View: The Making of the RAI Photographic Collection', in E. Edwards (ed.), *Anthropology and Photography, 1860–1920.* New Haven: Yale University Press

Pollack, R. (2002). 'A Warning from Hollywood', *Panorama.* London, BBC, 24 March

Poulet, G. (1972) 'Criticism and the Experience of Interiority', in J.P. Tompkins

(ed.), *Reader-Response Criticism*. Baltimore and London: Johns Hopkins University Press, 1980

Pozzo, A. (1693) *Perspective in Architecture and Painting: An Unabridged Reprint of the English-and-Latin edition of the 1693 'Perspectiva pictorum et architectorum'*. New York: Dover Publications, 1989

—— (1707) *Rules and Example of Perspective*. Reprint. London and New York: Benjamin Bloom, 1971

Pullum, G.K. (1991) *The Great Eskimo Vocabulary Hoax: And Other Irreverent Essays on the Study of Language*. Chicago: University of Chicago Press

Putnam, H. (1990) *Realism with a Human Face*. Cambridge, MA: Harvard University Press

Rawski, E.S. and Rawson, J. (2006) *China: The Three Emperors 1662–1795*. London: Royal Academy

Reed, J.S., Doss, G.E. and Hurlbert, J.S. (1987) 'Too Good to be False: An Essay in the Folklore of Social Science', *Sociological Inquiry* 57:1–11

Reingold, H. (1990) *Virtual Reality* New York: Touchstone

Ricoeur, P. (1984) *Time and Narrative*. Chicago and London: University of Chicago Press

Ritchen, F. (1991) 'The End of Photography as We Have Known It', in P. Wombell (ed.) *Photo-Video: Photography in the Age of the Computer*. London: Rivers Press

Roberts, J. (1998) *The Art of Interruption: Realism, Photography and the Everyday*. Manchester: Manchester University Press

Robins, K. (1995) 'Will Image Move Us Still?', in M. Lister (ed.), *The Photographic Image in Digital Culture*, London: Routledge

Rohner, R. (1984) 'Toward a Conception of Culture for Cross-Cultural Psychology', *Journal of Cross-Cultural Psychology* 15:111–138

Rorty, R. (1989) *Contingency, Irony and Solidarity*. Cambridge: Cambridge University Press

Rosaldo, M.Z. (1980) *Knowledge and Passion: Ilongot Notions of Self and Social Life*. New York: Cambridge University Press

Rosaldo, R. (1989) *Culture and Truth: The Remaking of Social Analysis*. London Routledge

Ross, J. and Davidson, I. (2006) 'Rock Art and Ritual: An Archaeological Analysis of Rock Art in Arid Central Australia', *Journal of Archaeological Method and Theory* 13 (4):304–340

Ruiz, H. and Emery, M. (2001). Afghanistan's Refugee Crisis. MERIP Press Information Note 70, US Committee for Refugees, 24 September

Ryan, M.-L. (2001) *Narrative as Virtual Reality: Immersion and Interactivity in Literature and Electronic Media*. Baltimore and London: Johns Hopkins University Press

—— (ed.) (2004) *Narrative across Media: The Languages of Storytelling*. Lincoln and London: University of Nebraska Press

Said, E. (1981). *Covering Islam: How the Media and the Experts Determine How We See the Rest of the World.* London: Routledge

Sander, A. (1933) 'Photography as a Universal Language', trans. A. Halley, *Massachusetts Review* XIX (4), 1978:674–675

Sanger, E., Endreny, P. and Glassman, M. (1991) 'Media Coverage of Disasters: Effect of Geographic Location', *Journalism Quarterly* 68 (1):48–58

Sarason, S.B. (1990) *The Challenge of Art to Psychology.* New Haven and London: Yale University Press

Sartre, J.-P. (1940) *The Psychology of the Imagination*, trans. B. Frechtman. London: Methuen, 1972

Schrader, P. (1972) *Transcendental Style in Film: Ozu, Bresson, Dreyer.* Berkeley : University of California Press

Segall, M.H., Campbell, D.T., and Herskovits, M.J. (1966) *The Influence of Culture on Visual Perception.* Indianapolis, IN: Bobbs-Merrill

Sekula, A. (1982) 'On the Invention of Photographic Meaning', in V. Burgin (ed.), *Thinking Photography.* London: Macmillan

—— (1986) 'The Body and the Archive', *October* 39:3–64

Shaheen, J.G. (1988) 'Perspectives on the Television Arab', in L. Gross, J.S. Katz and J. Ruby (eds), *Image Ethics: The Moral Rights of Subjects in Photographs, Film and Television.* Oxford and New York: Oxford University Press

Sherrington, C.S. (1937–1938) *Man on His Nature.* Cambridge: Cambridge University Press

Shklovsky, V. (1917) 'Art as Technique', in L.T. Lemon and R.J. Reiss (eds), *Russian Formalist Criticism: Four Essays.* Lincoln: University of Nebraska Press, 1965

Shukman, D. and Nutt, D. (2001) 'Journalist vs Aid Worker. A Special BBC News Online Debate between World Affairs Correspondent David Shukman, Who Has Questioned the Media's Role in Covering Disasters, and Dominic Nutt, an Aid Worker for Christian Aid', 3 May. BBC News Online. http://news.bbc.co.uk/1/hi/world/africa/1306897.stm, accessed 12 June 2008

Silver , H.R. (1978) 'Ethnoart', *Annual Review of Anthropology* 8:267–307

Simpson, J. (2001) 'Afghanistan's Tragedy', in J. Baxter and M. Downing (eds), *The Day That Shook the World.* London, BBC

Singer, A. (2002) 'Beyond Primetime: Anthropology and Television at War', The Forman lecture. University of Manchester, http://www.socialsciences.manchester.ac.uk/disciplines/socialanthropology/visualanthropology/events/forman_lecture/documents/forman2002-singerfinal.pdf (accessed 15 September 2008)

Skalník, P. (ed.) (2004) *Dolní Roveň: Research at Half-Time.* Pardubice: University of Pardubice

—— (ed.) (2005) *Social Anthropology of Village Dolní Roveň.* Scientific Papers. Pardubice: University of Pardubice

Skovmand, M. and Schrøder, K.M. (eds) (1992) *Media Cultures: Reappraising Transnational Media*. London: Routledge

Slater, D. (1995) 'Photography and Modern Vision: The Spectacle of "Natural Magic"', in C. Jenks (ed.), *Visual Culture*, London and New York: Routledge

Smith, M. (1985) 'Narrative and Ideology in *Listen to Britain*', in J. Hawthorn (ed.), *Narrative: from Malory to Motion Pictures*. London: Edward Arnold

Soegaard, M. (2007) 'Object Orientation Redefined: From Abstract to Direct Objects and toward a More Understandable Approach to Understanding', *Interaction-Design*, 23 December. http://www.interaction-design.org/mads/articles/object_orientation_redefined.html, accessed 26 July 2008

Solomon-Godeau, A. (1991) *Photography at the Dock: Essays on Photographic History, Institutions and Practices*. Minneapolis: University of Minnesota Press

Sontag, S. (1977) *On Photography*. New York: Farrar, Straus and Giroux

—— (2003) *Regarding the Pain of Others*. London: Hamish Hamilton

Sorkin, M. (2002) 'Collateral Damage: Assessing the Cultural and Architectural Aftermath of September 11th', *Metropolis Magazine*, http://www.metropolismag.com/html/content_0102/sor/index.html (accessed 29 September 2008)

Sprague, S. (1978) 'Yoruba Photography: How the Yoruba See Themselves', *African Arts* 12 (1):52–59

Stallabrass, J. (1999) *High Art Lite: British Art in the 1990s*. London: Verso

Stanlaw, J. and Peterson, M. (2003) 'To Be (Online) or Not to be (Online)...Is THAT the Question?', *Anthropology News* 44 (4):50–51

Stanley, L. (2001) 'Mass Observations' Fieldwork Methods', in Paul Atkinson (ed.), *Handbook of Ethnography*. London: Sage

Steinberg, L. (1953) 'The Eye is a Part of the Mind', *Partisan Review* 20 (2):194–212

Stone, J. (2000) 'Losing Perspective: Global Affairs on British Terrestrial Television 1989–1999'. London, Third World and Environment Broadcasting Project (3WE)**:31**

Swain, D.V. and Swain, J.R. (1988) *Film Scriptwriting: A Practical Manual*. Boston and London: Focal

Telotte, J.P. (1999–2000) 'Verhoeven, Virilio, and "Cinematic Derealization"', *Film Quarterly* 53 (2):30–38

Thomas, M. (2003) 'Beyond Digitality: Cinema, Console Games and Screen Language – The Spatial Organization of Narrative', in M. Thomas and F. Penz (eds), *Architectures of Illusion: From Motion Pictures to Interactive Navigable Environments*. Bristol: Intellect Books

—— (ed.) (2007) 'Practice-Led Research in (Non-Linear) Interactive Narrativity: Factual and Entertainment'. EC Report NM2 D.5-12 NM2:220

Thomas, M., Lindsedt, I. and Wright, T. (2005) 'An Introduction to Narrativity in

the Interactive Screen Environment'. EC Report NM2 D2.1 – Public Deliverable. http://www.ist-nm2.org, accessed 26 July 2008

Thompson, C. (2006) 'Tune in Next Week for Gaming Fun', *Wired magazine*, 19 June

Thompson, R.F. (1971) *Black Gods and Kings, Yoruba Art at U.C.L.A.* Occasional papers of the museum and laboratories of ethnic arts and technologies. Vol. II. Los Angeles: University of California Press

Thomson, J. (1885) *Through Masai Land: A Journey of Exploration among Snowclad Volcanic Mountains and Strange Tribes of Eastern Equatorial Africa.* London: Frank Cass, 1968

Toffler, A. (1970) *Future Shock.* London: Pan

Trachtenberg, A. (1988) 'From Image to Story: Reading the File', in C. Fleischhauer and B. W. Brannan (eds), *Documenting America 1935–1943.* Berkeley and Los Angeles: University of California Press

Trachtenberg, M. (1977) *The Statue of Liberty.* Harmondsworth: Penguin

Turville-Petre, G. (1953) *Origins of Icelandic Literature.* Oxford: Clarendon

Ucko, P.J. and Rosenfeld, A. (1967) *Palaeolithic Cave Art.* London: Weidenfeld and Nicolson

Vanderwood, P.J. and Samponaro, F.N. (1988) *Border Fury: A Picture Postcard Record of Mexico's Revolution and U.S. War Preparedness, 1910–1917.* Albuquerque: University of New Mexico Press

Van Rensburg, J. (1938) *The Learning Ability of the South African Native Compared with that of the European.* Pretoria

Vico, G. (1968) *The New Science*, trans. T.G. Bergin and M.H. Fisch. Ithaca and London: Cornell University Press

Virilio, P. (1989) *War and Cinema: The Logistics of Perception*, trans. P. Camiler. London: Verso

Vogel, C. (1999) 'Chris Ofili: British Artist Holds Fast to His Inspiration', *The New York Times*, 28 September

Voltaire (1759) *Candide.* Harmondsworth: Penguin, 2001

Wald, G. (1950) 'Eye and Camera', *Scientific American* 183 (August):33

Wall, A. (1996) *About Vision: New British Painting in the 1990s.* Oxford: Museum of Modern Art

Wand, E. (2002) 'Interactive Storytelling: The Renaissance of Narration', in M. Rieser and A. Zapp (eds), *New Screen Media: Cinema/Narrative.* London: BFI

Warner, M. (1977) *Alone of All Her Sex: The Myth and Cult of the Virgin Mary.* London: Picador

Wartenberg, T. (2003) '*The Matrix Reloaded*', *Philosophy Now* 42 (July/August). http://www.philosophynow.org/issue42/42wartenberg.htm, accessed 26 July 2008

Westermann, D. (1939) *The African Today and Tomorrow.* London: Oxford University Press

White, J. (1967) *The Birth and Rebirth of Pictorial Space*. London: Faber & Faber

White B.W., Saunders, F.A., Scadden, L., Bach-y-Rita, P. and Collins, C.C. (1970) 'Seeing with the Skin', *Perception and Psychophysics* 7:23–27

Wilkinson, R. (2001). 'After the Terror ... The Fallout', *Refugees* 4 (125):5–13

Willats, J. (1997) *Art and Representation: New Principles in the Analysis of Pictures*. Princeton, NJ: Princeton University Press

Williamson, B. (2004) *Christian Art: A Very Short Introduction*. Oxford: Oxford University Press

Winston, B. (1988) 'The Tradition of the Victim in Griersonian Documentary', in L. Gross, J.S. Katz and J. Ruby (eds), *Image Ethics: The Moral Rights of Subjects in Photographs, Film and Television*. Oxford and New York: Oxford University Press

—— (1995) *Claiming the Real: Documentary Film Revisited*. London: British Film Institute

Winterbottom, J.M. (1948) 'Can We Measure the African's Intelligence?', *Rhodes–Livingstone Journal* 6:53–59

Woldering, I. (1963) *The Art of Egypt: The Time of the Pharaohs*. New York: Greystone Press

Wollheim, R. (1968) *Art and Its Objects*, Harmondsworth: Penguin

Woodburn, J. (ed.) (1982) *The Royal Anthropological Institute Film Library Catalogue* Volume I. London: Royal Anthropological Institute. http://www.therai.org.uk/film/diss_world.html#eskimos (accessed 29 September 2008)

Wright, T. (1986) The Self-Reflexive Approach to Photography: Photography Considered as a System of Representation. Unpublished Ph.D. diss., University of London

—— (1990) 'Sir Benjamin Stone: Photography and Cultural Theory', in M. Hallet (ed.), *Rewriting Photographic History*. Birmingham: The ARTicle Press

—— (1992) 'Television Narrative and Ethnographic Film', in D. Turton and P.I. Crawford (eds), *Film as Ethnography*. Manchester: Manchester University Press

—— (1994) 'The Anthropologist as Artist: The Trobriand Photographs of Bronislaw Malinowski', in T. van Meijl and P. van der Grijp (eds), *European Imagery and Colonial History in the Pacific*. Nijmegen Studies in Development and Cultural Change

—— (1999) *The Photography Handbook*. London: Routledge

—— (2001) 'Reflections on "The Looking Glass War": Photography, Espionage and the Cold War', *Visual Sociology* 16 (1):75–88

—— (2002) 'Moving Images: The Media Representation of Refugees', *Visual Studies* 17 (1):53–66

—— (2003) 'The "Creative Treatment of Actuality" – Visions and Revisions in Representing Truth', in M. Thomas and F. Penz (eds), *Architectures of Illusion – from Motion Pictures to Navigable Interactive Environments*. Bristol: Intellect Books

—— (2004) *The Photography Handbook*. 2nd edition. London: Routledge

Wright, W. (1975) *Six Guns and Society: A Structural Study of the Western*. Berkeley and Los Angeles: University of California Press

Yacowar, M. (1977) 'The Bug in the Rug: Notes on the Disaster Genre', in B.K. Grant (ed.), *Film Genre: Theory and Criticism*. London: The Scarecrow Press

Young, M.W. (1999) *Malinowski's Kiriwina: Fieldwork Photography 1915–1918*. Chicago: University of Chicago Press

Filmography

Badlands. 1973 (95 minutes) colour. Director: Terrence Malick. Feature. USA

Barry Lyndon. 1975 (184 minutes) colour. Director: Stanley Kubrick Feature. UK

Boy Who Stopped Talking (The) (*De Jongen Die Niet Meer Praatte*). 1997 (110 minutes) colour. Director: Ben Sombogaart. Feature. Netherlands

Carlito's Way. 1993 (141 minutes) colour. Director: Brian de Palma. Feature. USA

Casablanca. 1942 (102 minutes). Director: Michael Curtiz. Feature. USA

Cleopatra. 1934 (100 minutes). Black and White. Director: Cecil B. DeMille. Feature. USA

Closely Observed Trains (*Ostre sledovane vlaky*). 1966. (89 mins) Black and White. Director: Jiri Menzel. Feature. Czechoslovakia

Diary for Timothy. 1945 (40 minutes) black and white. Director: Humphrey Jennings. Documentary. UK

Dirty Pretty Things. 2002 (97 minutes) colour. Director: Stephen Frears. Feature. UK

Down by Law. 1986 (107 minutes) black and white. Director: Jim Jarmusch. Feature. USA

Easy Rider. 1969 (94 minutes) colour. Director: Dennis Hopper. Feature. USA

El Norte (*The North* – English title). 1983 (141 minutes) colour. Director: Gregory Nava. Feature. USA/Mexico

El Sur. 1983 (95 minutes) colour. Director: Víctor Erice. Feature. Spain

Firemen's Ball (*Horí, má paneko*). 1967 (73 minutes) colour. Director: Miloš Forman. Feature. Czechoslovakia

Gandhi. 1982 (195 minutes) colour. Director: Richard Attenborough. Feature. UK/India

I Was a Fireman. 1942 (71 minutes) black and white. Director: Humphrey Jennings. Documentary. UK

Intolerance: Love's Struggle Throughout the Ages. 1916 (163 minutes) black and white. Director: D.W. Griffith. Feature. USA

Journey of Hope (*Reise der Hoffnung*; *Umud'a Yolculuk* – Turkish title). 1990 (111 minutes) colour. Director: Xavier Koller. Feature. Switzerland

Listen to Britain. 1942 (20 minutes) black and white. Directors: Humphrey Jennings and Stewart McAllister. Documentary. UK

London Can Take It! 1940 (9 minutes) black and white. Directors: Humphrey Jennings and Harry Watt. Documentary. UK

Man with a Movie Camera (*Chelovek s kino apparaton*). 1929 (68 minutes) black and white (silent). Director: Dziga Vertov. Documentary. USSR

Matrix (The). 1999 (136 minutes) colour. Directors: Andy Wachowski and Larry Wachowski. Feature. USA

Midnight Cowboy. 1969 (113 minutes) colour. Director: John Schlesinger. Feature. USA

Night of the Hunter. 1955 (93 minutes) black and white. Director: Charles Laughton Feature. USA

Psycho. 1960 (109 minutes) black and white. Director: Alfred Hitchcock. Feature. USA

Psycho. 1998 (105 minutes) colour. Director: Gus Van Sant. Feature. USA

Ran. 1985 (160 minutes) colour. Director: Akira Kurosawa. Feature. Japan

Sound of Music (The). 1965 (174 minutes) colour. Director: Robert Wise. Feature. USA

Spare Time. 1939 (14 minutes) black and white. Director: Humphrey Jennings. GPO Film Unit. Documentary. UK

Ten Commandments (The). 1923 (1936 minutes) black and white. Director: Cecil B. DeMille. Feature. USA

Thelma and Louise. 1991 (130 minutes) colour. Director: Ridley Scott. Feature. USA

Tokyo Story (*Tôkyô monogatari*) 1953 (136 minutes) black and white. Directors: Yasujiro Ozu Feature. Japan

Towering Inferno (The). 1974 (165 minutes) colour. Directors: John Guillermin and Irwin Allen. Feature. USA

Triumph over Disaster: The Hurricane Andrew Story. 1993 (90 minutes) colour. Director Marvin J. Chomsky. TV Movie. USA

Index